# THE ART OF
# HAND-LETTERING

HELM WOTZKOW

# The Art of Hand-Lettering

## ITS MASTERY & PRACTICE

DOVER PUBLICATIONS, INC.
NEW YORK

Standard Book Number: 486-21797-3

Library of Congress Catalog Card Number: 67-18095

Manufactured in the United States of America
Dover Publications, Inc.
180 Varick Street
New York, N. Y. 10014

*to Erna,*
*for her loving patience*

# Publisher's Note

FOR SOME TIME now we have been seeking a general text and reference book on lettering — a book sufficiently broad and comprehensive to appeal, on the one hand, to those who wish to *do* creative lettering, and, on the other, to the *buyers* or *users* of hand-lettering, with their need to appreciate and evaluate the creations of others.

When Helm Wotzkow's manuscript for "The Art of Hand-lettering" recently came along, we knew that our search was over. For here is a book admirably meeting our specifications. Not only is its author a highly skillful letterer and designer — now Foreign Art Director of the Colgate-Palmolive-Peet Company — but he is a natural-born teacher, the sort who delights in analyzing the needs of his prospective readers, and in catering to those needs. Through his many years of combined teaching and professional experience he has learned precisely what kinds of information and inspiration are most valuable to the student, the teacher, the professional letterer and the buyer of lettering. Also, he has developed rare skill in presenting this pertinent material in the most readily assimilated word and picture form.

His illustrations, while not flashy or dramatic, are superb, as a thumbing through of these pages will reveal. Note that these illustrations do not consist primarily of the copy plate type of alphabet, or of the miscellaneous lettering examples, which some lettering books feature almost in overabundance. Instead, while alphabets and examples are by no means neglected, each of his numerous and diversified illustrations has been drawn especially for this book, to serve some specific purpose which is brought out by the accompanying text.

This text, by the way, is exceptionally well-handled, leading the reader by easy degrees from the most elementary of matters — such as the selection of the needed drawing materials — to, and through, numerous professional considerations. In various instances the author dramatizes his arguments by comparing the appropriate with the inappropriate, the right with the wrong.

Especially commendable is his effort to aid his reader to become a good self-critic. Having thoroughly acquainted him with the Roman alphabet — the basis of practically all good lettering — he

then leads him to *all* the other well-known lettering styles: Italic,
Script, Block and the far-too-often-neglected Gothic. Also,
through a simple "Formula," he establishes a means of judging
hand-lettering.

Useful, indeed, are his instructions on methods of assembling
and adjusting different letters to form words, and different words
to form complete units of lettering. Revealing, too, are his discus-
sions of layout, of reproduction, of congruity of lettering style to
purpose, and a hundred other things. The section of expertly
set type faces will likewise prove most helpful.

In all of this there is no hint that skill in lettering can be ac-
quired without persistent study and practice. On the contrary,
just as the art of lettering is stressed throughout the book — the
need for holding ever to high esthetic standards — so is the craft.
One learns how to manipulate his pencil, pen and brush, how to
overcome errors or defects, how to work white on black, how to
letter in perspective and on curves.

But why go on stressing the obvious? The book is here for all
to see. We present it with the belief that, as a basic work, it will
serve many types of readers. As already hinted, for the student,
the teacher, the letterer, the designer and the layout man — those
who *do* hand-lettering or *teach* it — it can well prove practically
indispensable. It will be invaluable, also, to *buyers* or *users* of
lettering: the art directors and art editors, the advertising agen-
cies and art studios, the advertising departments of companies
both large and small — also publishers, typesetters and printers.
In fact, who in this entire field cannot profit through a broader
knowledge of this great art-craft?

# Acknowledgment

For the many hours they generously spent in making drawings, offering constructive criticism and encouraging me when I most needed it, my special gratitude to Rodulfo Garcia, Aino Murk and Alex. G. Highton.

And to those many good friends, both here and abroad, who went to so much trouble to get me the various specimens of handwriting, my sincere thanks. I'm sorry I couldn't use them all; they are most interesting.

# Contents

# Introduction

THIS BOOK IS WRITTEN for those who wish to learn the art of hand-lettering. Hand-lettering is a fascinating art, and, while being a useful one, it can and will afford the artist a great deal of pleasure and satisfaction not only from the standpoint of technical skill but also from that of creative ability and inventiveness.

"How to" books have been written on practically every imaginable human activity under the sun, and I have read many of them. I have found, however, that a lot of these books, while telling you *how* to do certain things, more often than not omit to tell you *why* they should be done that way.

I readily admit that this telling you why is not always the easiest thing in the world, for the simple reason that the teacher-author generally knows so many things about his subject which have become second nature to him that he probably often unconsciously forgets to mention them to his invisible student-reader. On the other hand, the invisible student-reader is not in a position to suddenly ask a pertinent question which might prove inspirational to the teacher and, properly answered, save the student a great deal of disappointment and experimenting.

To learn *how* is certainly not always to learn *why*, but to *know why* is the surest way of *learning how* and finally *knowing how*.

If I had not felt a definite need for this book I obviously would not have undertaken to write it. There are a great many excellent works showing various examples of hand-lettering at their imaginable best. There are also many exceptionally useful books containing all kinds of complete alphabets, ancient and modern, utilitarian and decorative, as well as beautiful and otherwise. A number of these books are so good that I would be proud to have been their producer, but their usefulness is restricted almost entirely to those who already know how to do lettering. The first group mentioned consists mostly of inspirational books, good to have on one's bookshelf to get ideas from or for purely esthetic enjoyment. As a rule, however, it is left to the reader's imagination how most of the masterpieces reproduced were done, as well as why they were done this way. The other group, which I admit can at times be of some help to the student, may on the other hand lead him to become nothing more than a copyist. Just picking out

letters from an existing alphabet and rearranging them into words is about as artistic as playing dominoes. Many an alphabet, designed as such, and forming a complete picture in itself, may give a very pleasing impression; but those identical characters taken out individually and rearranged with spaces between words and lines can, and surprisingly often do, give most shockingly amateurish results. This does not mean to say that the characters or letters themselves are badly formed, but that as a rule the copyist has been unable to grasp fully the original designer's intentions. I speak here of really well-designed alphabets and not of the hundreds of phantastically misshapen oddities which are periodically presented as "modern" alphabets.

A "how to" book without examples is inconceivable, so I have endeavored to include as many as seemed necessary within reasonable limits. On the other hand I have presented only a few complete alphabets, my object being to inspire the student to "get the feeling" of the examples rather than give him something cut-and-dried to copy. The many comparative renderings offered of the ever-recurring theme, "Always endeavor to find some interesting variation," demonstrate what the lettering is trying to express a great deal better than would a compilation of all the varieties of alphabets involved.

Yet the feeling for appropriateness for a particular purpose is something which has to be acquired and which cannot be taught as one can teach that two plus two makes four. Individual taste plays a large and important role, and, in the final summary, it will be found that, as far as appropriateness goes, there will never be one single and unique solution to any problem of lettering. The best I can do is to show extreme examples of inappropriateness which I have no doubt the student will understand and consequently avoid. Between the obviously appropriate and glaringly inappropriate there is always a golden mean. This golden mean very often happens to be far more acceptable than the obviously appropriate, and, to find this, many factors have to be taken into account. I hope my efforts will enable the student to do just this.

In dealing with the evolution of certain forms and styles I have found it useful to give short historical sketches to explain how certain changes came about. In doing this I have allowed myself considerable license for the sake of clarity and brevity, even omitting certain kinds of manuscript writing because they have had

little or no influence in shaping our present day alphabets. It seemed to me to be more important to the student to know, for instance, why the Italics are formed the way they are and how these forms are made, rather than give a lot of historical dates, countries of origin, etc., hardly any of which would be of much use or interest to the practicing letterer.

My aim is to give the lettering artist pertinent material in text-book manner, together with such worth-while knowledge as will enable him to quickly grasp the fundamentals of correct lettering. At the same time the examples presented are purely for inspirational purposes without pretending to be models worthy of copying. As a manual, I am offering this book as a handy reference always ready to remind the student of the correct form of every individual letter and to give ideas of layout, arrangement, style, etc., for selection at a glance.

Correct form is essential in good lettering and far more important than any amount of decoration, which is one reason why I have shown very few examples of ornamental lettering. In fact, good hand-lettering should strive to be decorative in itself. Without wishing to "date" this book, I believe I can safely say that today's trend in design, most especially in the graphic arts, is towards perfect simplicity or simple perfection. Today's commercial artist must often of necessity endeavor to make his lettering serve two purposes: that of being functional — that is, strictly readable — and at the same time so well-designed as to make further decoration superfluous.

# THE ART OF
# HAND-LETTERING

You cannot help
men permanently
by doing for them
what they could
and should do for
themselves Lincoln

# *Materials*

DOING ALL THE styles of lettering mentioned in this book calls for a multitude of implements and tools; but, being a believer in an uncluttered worktable and in the advisibility of using as few tools as necessary, and of demanding that those few, through skillful manipulation, serve more than one purpose, I shall recommend only the ones I use all the time.

Most lettering is best done on a sloping surface at more or less a right angle to the line of vision. A small tilt table drawing table is of course very useful, but by no means essential, so do not buy one until you have enough steady work to make the investment pay. But two or three light drawing boards are indispensable. My favorites measure about 15″ x 12″ and 20″ x 16″. Occasionally I need much larger ones, but they are a nuisance unless really needed. Well-seasoned cedar boards ⅝″ to ⅞″ thick are excellent, as I have found that they are light and do not have the tendency to shrink within the mortised ends

Figure 1. *Shrinkage will distort your drawing board.*

as ordinary deal or pine boards often do. This shrinkage is most troublesome when you get accustomed to applying your T square on all four edges, as you will when speed counts. Cedar is also pleasantly soft for pressing in and removing thumbtacks, whose heads should be as thin as possible. The use of adhesive cellulose tape (Scotch tape) as a substitute for thumbtacks is recommendable in general, but a trial should be made first in the case of some special papers whose surface textures might be ruined when pulling off the tape — forming unsightly blemishes on work which is

1

to be presented in the original, such as addresses, illuminated manuscripts, greeting cards, etc. Where thumbtacks seem called for they should not pierce the paper but should be pressed into the board outside the paper's edges so that only the heads hold the paper — firmly of course.

It is a matter of taste whether you prefer a T square with a double "head" or crosspiece — that is, two crosspieces, one fixed permanently at right angles to the "blade" or ruler and the other adjustable to any angle — or one with a single adjustable crosspiece. I use the latter because it is handier, and, find it no particular bother to fix it at a right angle when needed. The one I have used for more than twenty years looks like this:

Figure 2. *An adjustable T square is indispensable.*

The cross section of its ruler is its most important feature. The fact that the transparent plastic edges are raised from the surface of the paper is an enormous advantage, as you can use any type of pen without the ink running under them as so often happens with the customary transparent-edged rulers. It is a good idea to

Wood

Transparent Plastic

Figure 3. *Cross section of blade (ruler) of T square.*

buy a T square of this kind with the ruler about 30″ long, and then to cut off an end of about 10″ which you will find the most handy supplementary ruler imaginable, particularly for small work. I never use draftsman's triangles (set-squares) as I find that the near-enough right angle of the drawing boards is sufficient for every lettering job that I can think of.

For all work done with reproduction in mind, use very white paper if you can get it, but if you are compelled to choose between a white second-quality and a slightly cream first-quality paper, take the latter. Although it is exceedingly difficult — I might say almost impossible — to recommend, in writing, any particular brands of paper, I think I should warn the beginner not to be deceived by every beautifully white or exquisitely smooth kind. Even the holding of a sheet up to the light — a good paper is generally clear and translucent and the visible structure is only very slightly cloudy — is not always a sure test of quality. Bending over a corner of a sheet and only slightly pressing the crease is nearly always a reliable test, however; if the paper allows itself to be flattened out again with little or no trace of a crack it can be said to be good. If, though, the inner structure cracks, "splinters," or shows a thick and perhaps fluffy crease after flattening out, the paper is not to be recommended. Another test is to try the paper's erasing qualities, first with a pencil rubber, then with an ink eraser and finally with a very sharp erasing knife or scalpel. The rubber test should be practically unnoticeable, the ink eraser should do no more damage than a *slight* roughening of the surface; and the knife-scraped portion should, after a little cleaning with the rubber and smoothing over with some kind of burnisher of ivory or bone (even a glass stirring rod will do), still take a fine ink line without spreading as on blotting paper. From which it will be seen that quality is not merely skin deep.

Some cheap papers, on the other hand, have delightful surface finishes but are suitable only if you work straight on them with little or, better still, no preliminary sketching and, later, definitely no erasing. Sometimes it is even dangerous to erase the faintest pencil marks on such papers. I hope, however, that this book will make you so sure of yourself that you will soon be able to use them for at least a part of your work.

Bristol boards, unless you are a paper expert, are very difficult to judge either by look or feel, and I have found dozens of qualities between excellent and poor, all with more or less promising surfaces. The trouble with many of these boards is that they are artificially surfaced with a coating entirely unsuitable to receive any aqueous ink. If such ink is applied, the coating immediately dissolves or at least perceptibly softens. With steel pens, with which we shall have to do a great deal of our work, this annoying

3

quality is not so noticeable at the beginning of a job, but after a few strokes you will find your pen dragging along quite a load of mud-like substance which makes fine or clean-cut lines impossible. For brushwork, most of the Bristol boards are good and they can also be recommended for writing with plumes (see Figure 4), as both these techniques call for less preliminary preparation and more direct execution.

All in all, the problem of buying the right paper is one that can be solved only by experience. Really good papers are expensive but for quality work only the best are good enough.

Use pencils that do not smudge easily and whose marks can be erased with ease. The draftsman's grade is recommended. I manage with an F pencil most of the time, and use a B to blacken the backs of tracings and a 7H for pressing such tracings onto the job; that's all.

You will need erasers, of course, for pencil and ink, as well as a kneaded eraser for cleaning. And no letterer should be without a very sharp knife for careful erasing jobs, together with a small oilstone for keeping it razor-sharp.

Now for the tools to write with:

Lots of comfortable penholders and a selection of steel pen nibs to go with them. For a start, some fine-pointed drawing pens, both hard and rigid, and soft and flexible — you will learn that different papers need different pens, and that you may have a heavy or a light hand and find it hard to work with one or the other pen.

And then a whole range of square-cut lettering pens. Just ordinary ones which look somewhat like our illustrations, and which come with a little clip (preferably only on the underside) to hold a reasonable load of ink. At this point, let me advise you always to fill your lettering pens (which from now on I shall call *plumes* to distinguish them from sharp-pointed pens) with an old pen or

*Note:* This book cannot possibly recommend any particular makes or brands of implements or materials. My experience with American, English, French, Belgian, German and other nationally made materials has naturally made me prefer some to others. But realizing that all students will not have access to the well-stocked artists' supply stores of the great cities, I can only recommend their getting the best they can, wherever they can. During the war in 1939-42 I used ordinary writing pen points and sharpened them on my oilstone to crow-quill needle points or broad plume edges. They made excellent tools.

small discarded brush (which you can leave in the bottle while writing), and never to dip them.

The lettering pens you buy will probably be square-cut or slightly canted, and of course in various widths. If the cant is not more than in our illustration it makes no great difference to the beginner which type he uses.

Figure 4. *Typical lettering pens, referred to as "plumes" in this book.*

A small assortment of high quality sable brushes, with good points, will complete your indispensable writing equipment. You will also need black India ink, some best quality black tempera paint and some white tempera.

When it comes to compasses, buy two if you can, one for pencil and the other for ink. Those made for draftsmen are the best. If you have but one compass, the constant changing of the working points will prove a nuisance.

As you gain experience you will find there are other lettering tools available in most well-equipped artists' supply stores. Whether you need them will be for you to decide.

# Good Lettering

AN ALPHABET is always more or less a lifeless thing — a collection of signs and symbols not much more interesting than a box of building blocks. It is in the hands of the letterer (who, of course, should also be able to remodel these blocks to suit his purposes) that this material begins to live and gain expression.

It is something rather wondrous to contemplate not only the ingenuity in this set of man-made symbols but also the magnitude of their immeasurable power. A child finally arrives at the point when it can scribble the symbols

*cat* CAT

and know that they mean (at least) a furry animal with four legs, a long tail, etc., although these symbols have not the slightest optical or other resemblance to the animal itself. But it will take that same child several more years to realize and understand the meaning of its rearrangement of those same three signs into

*act* ACT

which may represent quite a number of things, most of them being abstractions or notions. One is almost tempted to enlarge at great length on this idea, but I have said enough to initiate a train of thought.

The letters we form represent sounds which we would otherwise generally have to utter to express ourselves to other persons. But even these sounds bear no resemblance to the things or notions they are supposed to represent. A most extraordinary transformation has to take place before the very words, which I am at this moment writing with a fountain pen, finally express to the reader what I was thinking even before I wrote them.

There is sheer magic in this metamorphosis. I think of something and begin to formulate that idea more or less in terms of words. These words, originally known to me as sounds, must now be translated by me into symbols on paper, which I proceed to do in a more or less tedious, old-fashioned manner by writing them longhand. Nowadays, I could dictate them into a recording machine or type them on a typewriter, but in either case sooner or

later some helpful spirit in the shape of a typesetting machinist —
a "compositor," or, in the case of this particular book, a "linotype
operator"— would have to get down to the business of finally uti-
lizing in the form of metal type our lettering symbols used to print
this book. My living thoughts have now become nothing but dead
signs, a mass of little black strokes and dots, which would not
mean a thing, say, to an Eskimo.

But they do to you. That is, if you take the trouble to retrans-
form the little black strokes and dots into thoughts which would
be peculiarly similar to the ones I had. And it is remarkable to
ponder that you would have to do so by imagining the sounds
which these symbols represent. And even still more remarkable to
realize that a good interpreter would be able to translate the
words into almost any civilized tongue even directly by word of
mouth only.

The medium of this magic is not the spoken word, which dies
immediately after its birth, but the symbol which perpetuates it;
and to conclude my digression I would like to say that it pleases
me to imagine that scribes and letterers throughout the ages have
always felt some kind of subconscious pride in the making of such
symbols *because of* the symbols' inherent powers to help express
and perpetuate thoughts.

How else can one explain the early scribe's practice of embel-
lishing his lettering? Or at least of giving it the most beautiful
form within the limits of his traditional writing tools? The ques-
tion of legibility — I should rather say *quick* readability — seldom
seems to have been the early scribe's first and most important con-
sideration. The few people who were able to read had apparently
enough leisure to do so slowly, and furthermore enjoy the pretty
decorations in passing.

Pure functionalism is a modern doctrine, but while it has left
its mark on the shape of a few of our daily utensils and gadgets, it
has left our lettering — even the most modern of our type faces —
practically untouched. To say that some of our modern type faces
are functional merely because they have been shorn of every trace
of ornamentation, is hardly true. From a purely decorative stand-
point they are often excellently proportioned and, at times, even
beautiful, but it is a remarkable fact that the tendency to simplify
the letter forms has also resulted in making quite a number of
letters look surprisingly alike. Certainly no help to readability.

7

Now where, between the two extremes — excessively decorated lettering on the one hand and purely functional on the other — are we to find *good* lettering?

The golden mean is not the answer, as we shall discover later. Good lettering deserves a place among the esthetic arts; but is it possible to arrive at a near standard of beauty likely to appeal to a majority? For it is hardly conceivable that a lettering artist would ever be commissioned with a job solely for the benefit of one single reader.

In an effort to find an answer to this question, I decided to do what is generally done nowadays to find out what the majority wants or likes: namely, conduct a test.

As far as a statistical result was concerned the test turned out to be a waste of time. The twenty samples of lettering shown herewith (pages 10 and 11) were submitted to several persons who were asked which style appealed to them most. Every research expert will smile at my naïveté and I cannot blame him.

The result I expected from this test never materialized but two other very significant facts did emerge. I was unable to find out which style was overwhelmingly preferred, because practically each style was liked by somebody, for some reason or the other.

It was just this "reason or the other" that became significant. The interviewees, in the majority of cases, seemed desirous of applying the style they preferred to some project which was at that time consciously or subconsciously occupying their minds. For instance, the bride-to-be was picturing her wedding announcements; the young doctor his new shingle; the commercial artist his latest poster; the manufacturer his new product-container; and the ceramic artist a plate or bowl decorated with lettering.

The second significant fact was that the sex of the interviewee had nothing whatsoever to do with his or her preference. There seems to be nothing particularly feminine or masculine about any style of lettering, and I personally was gratified with this finding because it confirmed my side of an argument which I have been trying to expound for many a year. Women no more prefer thin graceful Script than men heavy Block letters. On the contrary, I contend that women lean towards severe functionalism a lot more than men do. That they should prefer formal Script on a wedding announcement is merely their way of demonstrating that the occasion itself calls for marked formality. On the whole, however, I

found that women seemed to prefer the styles that were readable at a glance regardless of any so-called beauty in design, while men seemed to look for this characteristic of beauty first.

In summarizing these findings, a very logical, simple and obvious truth emerged. Good lettering, to have the widest general appeal, should be both beautiful and readable at the same time.

But we are often confronted with the fact that some lettering serves as nothing but a message carrier, and in cases like this any pretense to beauty would be almost ridiculous. Readability — preferably *quick* readability — would have to be our first concern and beauty would have to give way to pure functionalism. In other words, the forms of the letters would no longer be required to express beauty; they would now have to be adapted to express other characteristics or at least be as neutral as possible by expressing nothing. On pages 31 to 33, Figures 19 through 23, are shown five distinct styles of lettering. They all carry the same message, but some effort was made to keep the forms of the individual letters as stylized as possible. One of the reasons for doing this was to demonstrate that the styles used in this particular case have no inherent powers to express anything bearing on the message itself.

But if lettering must not be beautiful for certain reasons, there is no justification whatsoever for making it downright ugly. It can and should possess character, or, to be a little more specific, a personality of its own capable of being judged on its own merits.

Now what is character in lettering?

It can be compared with character in human beings. You may admire a person because he is refined, or strong and forceful or even happy-go-lucky; or because she is dainty and delicate, or perhaps neat and orderly. Such characteristics are generally recognizable almost at first glance. But so also are weakness, vulgarity, sloppiness, artificiality and overbearing grandiloquence, to mention but a few.

But can all these characteristics be expressed in the mixture of little strokes and dots which we call lettering?

Hardly; except it be through that strange medium of interpretation mentioned at the beginning of this chapter. But this time the eye is not required to translate the symbols into sounds but to regard them as more or less pictorial symbols of some memory capable of being illustrated or at least symbolized.

9

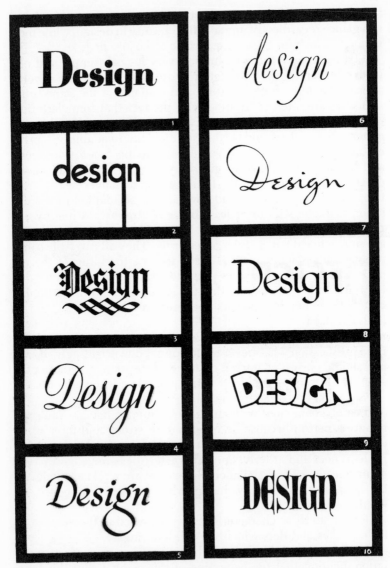

Figure 5. *Ten of a series of twenty comparative examples prepared for a "make your choice" test. (See page 8.)*

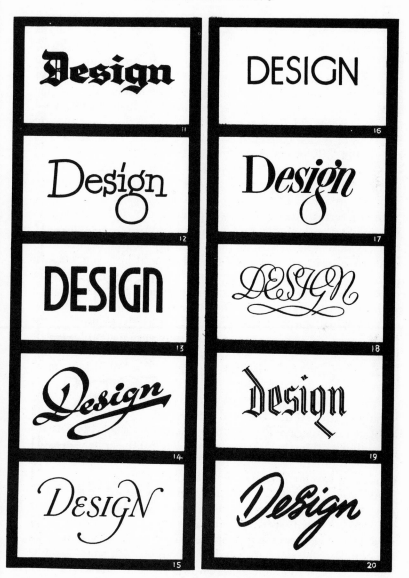

Figure 6. *The other ten examples. Which of the twenty do you prefer? Use as inspiration for finding new ideas.*

I am not speaking here of ideograms such as hieroglyphics or the complicated characters used, for instance, by the Chinese. Particularly the latter really represent diagrams more or less of things and ideas, and are stylized illustrations not to be read phonetically. It is a well-known fact that Chinese of different provinces, whose spoken languages sound entirely different, can communicate one with another by means of their script. We of the Western world also have our ideograms in the shape of numerals, all of which convey the idea of a number, but are spoken very differently in various countries.

Naturally, there is no hard and fast rule for forming the letters of our alphabet in such a way that their very shape will uniquely express any particular thought or feeling. We can only strive to re-create forms which in turn will create some kind of an association of ideas or thoughts. And even then form alone is not enough. Size, layout, weight, spacing and even the degree of finish of a piece of lettering can be made to express or at least suggest — be it subtly or forcefully — something which the words or message do not. A perhaps ridiculous but nevertheless poignant example of this might be found in the comparison of two menus. The one, a many page, portfolio-sized menu, luxuriously printed on the finest paper for an exclusive and naturally very expensive restaurant; the other, a cheap, terribly crowded, one sheet, hektographed — perhaps even misspelt — pathetic little bill of fare for an unpretentious and naturally cheap little eating house.

From a comparison of the two menus alone an impression is invariably gathered that the food catalogued at such great expense must be far superior. The fact that this is not always the case has absolutely nothing to do with our subject; but the appearance of a menu *can* create an association of ideas sufficiently powerful to considerably influence one's flow of gastric juices.

And so it goes with a thousand other impressions, most of them not as tangible as the above, but understandable just the same.

Lettering, whether hand-written, drawn or typeset, will always create some kind of an impression even before the words are read. True purity of style, with flawless execution, will suggest refinement. Extreme functionalism, with its strict avoidance of every non-essential, can express many things from neat business-like conciseness to cleanliness. Floridness in ornament may suggest neither of these but nevertheless impart an air of richness — or,

quite the contrary, cheapness — according to personal taste. Purposeful irregularity in alignment can express gracefulness, rhythm and the charm of naturalness; while vigorous contrasts in weight and "color" * will scream for attention. Large very easily read type, with plenty of line-spacing and wide margins, can suggest lavish luxury; while the same type, "set solid," as the typesetters say — that is, without any extra line-spacing and a minimum of margin width — will very often be used for the text of children's books and thus seem childish; and so on ad infinitum.

Every problem of lettering has its solution, and the following chapter, Criticism and Self-criticism, has been written to help you find it.

* Typographically, the term "color" is used to denote the general tone of grayness or blackness of any piece of lettering — or type matter — in relationship to its white background. To visualize this most strikingly, look with half-closed eyes at Figures 5 and 6, as well as 42 and 43, until the words are blurred. The meaning of the word "color" will immediately become apparent.

# Criticism and Self-Criticism

LONG BEFORE I ever decided to write this book, I happened to be in a position where I had to criticize almost daily a fair number of pieces of hand-lettering. Being mostly for advertising purposes and done by more or less well-trained artists, all this lettering had to conform to certain standards of execution, legibility, attention-getting value, etc., before I could accept it. Note that I do not mention beauty, and to be quite frank I seldom had occasion to admire any examples of truly *beautiful* hand-lettering, that is, for advertising. Except perhaps on package designs and certain occasional advertisements of a very elegant genre. Everything else was done with some special reason at the back of the commercial artist's mind, be it to attract the reader's attention by sheer weight or size, to contrast harmoniously or discordantly with some illustration, to form a decorative part of the whole layout or to scream out some selling message regardless of whether or not it offended any esthetic feelings the reader might have.

In most of the things we do, we find that after a little repetition something called routine creeps into our method, and in a great number of respects it is a factor worth cultivating. Naturally it should not be overdone, but where it tends to be a time- and labor-saving helper it will also be found to leave one's mind more free to tackle less everyday problems as they arise. Criticism of almost any kind can be greatly simplified by routine, especially when the criticism has to be exercised at many points, as in lettering. A most beautifully written word can be entirely unsuitable for its purpose if a number of other qualities have been overlooked. To know what these qualities are is important not only to the critic, but more so to the artist who should be in a position to criticize his own work. Self-criticism is the shortest cut to success.

But criticism has to start somewhere, and generally does with the somewhat wry statement, "There's something wrong with it, but I don't know what!" or words to that effect.

Now in judging a piece of hand-lettering there are so many qualifying factors to be considered that the layman or the beginning student can be forgiven for easily overlooking one or more of them. The job he is criticizing may appear to him to be just right, while the one quality which he has overlooked may be pre-

cisely the one which, without his realizing it, impairs an otherwise excellent piece of work.

This is where routine should set in, and in order to help my invisible readers and students I prepared a list of all the qualities a good piece of lettering should have, in an attempt to organize them into a sequence of importance, and, of course, so that none should be forgotten.

It was an alarming list and included such terms as beauty, readability, appropriateness, style and many others, representing qualities which I then discovered to be practically unclassifiable as far as sequence of importance went.

The two following examples will illustrate what I mean:

*This piece of lettering might be criticized as being extremely monotonous or considered beautifully precise*

Figure 7. A *carefully done example of* drawn *Italic lettering.*

*This style could be termed crabbed and eccentric, or found to possess "character". Its legibility is undeniable.*

Figure 8. A *quickly* written *example of another style of Italic lettering.*

15

The appropriateness of either one or the other for any given purpose is absolutely relative to the purpose and at this point the whole question becomes more or less a matter of personal taste. Taken merely as pieces of lettering in themselves, both are good, but when used incorrectly in connection with any kind of illustration or ornament their negative qualities show up immediately. In these examples both the text and the lettering were made to harmonize with one another; in other words, the style of lettering is definitely appropriate to the message. But take the next two examples, Figures 9 and 10; these demonstrate how incongruous any style can be if used without taste.

Figure 9. *The lettering is incongruous with the message, yet the style could be adapted to fit the purpose.*

Good taste is the most unclassifiable quality of all and yet it is one of the first things to be thought of before starting any piece of lettering. True, these last two examples are exaggerated to the extreme, but it is only the fact that *we can read the messages in English* that makes us realize that the styles used — the way they have been — are entirely out of place.

On the other hand, to say that there is only one correct style in which to interpret any given message is of course a gross overstatement. There are many ways of expressing with hand-letter-

ing something suggestive of the idea conveyed in the text, and it is one of our main objects here to help the student discover them.

But "style" alone — as used to differentiate between the five basic styles, Roman, Italic, Gothic, Script and Block (see Figure 18, page 29) — is not something which can be criticized in itself. Its FORM however can; and, as will be seen, the term FORM will be used to cover a multitude of qualities. For instance, in criticizing the FORM of the lettering examples in Figures 9 and 10, one can immediately see that they are unsatisfactory for the *purposes in question,* but this does not mean that the styles are incorrect. Script could well have been adapted to express the horror con-

Figure 10. *Gothic lettering ignoring the atmosphere of the message.*

tained in the text of Figure 9 while the Gothic characters in Figure 10 could well be modified to suggest the daintiness of Valenciennes lace.

Finding that all the numerous qualities of good lettering seemed impossible to fit into a hard and fast sequence in which any one characteristic permanently remained more important than another, I tried to discover a more general method which would be easier to apply when criticizing. Certain qualities, such as beauty, could be applied not only to FORM, but also to LAYOUT and EXECUTION; but beautiful EXECUTION by no means guaranteed beautiful FORM. (A well-dressed woman need not be beautiful, while a beautiful woman doesn't have to be well-dressed to be attractive.)

A group of sharply defined catagories with as little overlapping

17

as possible seemed indicated and finally the Formula ° exempli-
fied by the illustration on the opposite page emerged.

The layman and student may need some explanation of the full
value and limits of the terms used. Here is a brief definition of
each of them to make the Formula usable right from the start.
Naturally, after a complete perusal of the book further knowledge
will complement these short notes.

SIZE: At first glance it might appear ridiculous to consider the
size of any given piece of lettering as being its first and most im-
portant factor, but a moment's reflection will prove otherwise.
SIZE, as used here, is meant to apply to the relationship between
the lettering and the surface upon which it appears. A number of
other influences, such as the space surrounding the surface and
the distance at which the lettering is to be read, will also have to
be taken into account as these often have the most remarkable ef-
fects on SIZE. And it is understood, without any doubt, that the
lettering artist's very first consideration when starting any job is
— the SIZE.

FORM: In the first place, the term FORM covers the style of let-
tering used. As most messages can be interpreted in more than one
of the five styles illustrated on page 29, a little careful judgment
will have to be exercised before too quickly declining (when criti-
cizing) or choosing (when executing) any one style. There are
often reasons, and they are not always just esthetic ones, why, to
take one example, Script is better than Roman or vice versa.

FORM also refers to the shape of the individual letters, their
grouping into words and the use of two or more styles for different
words in the same inscription.

Criticizing FORM in the light of the above just naturally takes
care of appropriateness. See Figures 9 and 10.

WEIGHT: In terms of black letters on a white background, the
thickest and blackest are to be understood as heavy, while thin
letters are of light weight. The thick strokes of most standard pro-
portioned letters can be thickened to what one might call "med-

° It is natural that these six words, when drawn to fit the same length of
line, assume different heights, but it is a peculiar coincidence—in the English
language at least — that these heights quite automatically give each one of
the six factors the grade of importance it deserves.

18

Figure 11. *THE FORMULA. Memorize these six terms.*

# LETTERING IS TOO BIG AND MUCH TOO HEAVY FOR QUICK LEGIBILITY

Figure 12. *Too much emphasis is no emphasis!*

ium weight" without changing the proportions (height to width) to any appreciable extent. The Figures 42 and 43 on page 86 give an example of two extremes of weight in Roman capital letters.

LAYOUT: By LAYOUT is meant the arrangement of a piece of lettering on a given surface or within certain boundaries. SIZE, FORM and WEIGHT are things to be thought about before putting your pencil to paper, but LAYOUT means getting down to work. The LAYOUT is the general composition arranged with a view to obtaining the most pleasing or striking result, and takes into account the possibilities of the contrasts between the black letters on the white surface. A great deal more will be said about LAYOUT, but for the time being the simpler definition will suffice, although perhaps it should be said at this point that LAYOUT often considerably influences the readability of a piece of lettering.

SPACING: The term is clear enough, but it should be remembered that there are three different kinds of SPACING to be considered:

> Letter-Spacing (spaces between letters)
> Word-Spacing (spaces between words)
> Line-Spacing (spaces between lines)

Each of these can add to or detract from the readability. The LAYOUT should automatically prepare the way for correct spacing and naturally the SIZE will take care of margins, which are, in a way, part of the spacing.

EXECUTION: Meant here is the degree of finish — polish, one might call it — given to the final work. The FORM of a letter, as well as the purpose of the job, generally prescribes the amount of finish it requires: as for instance heavy Block letters on a short-lived occasional showcard would never require the exquisite finish of delicately engraved letters on a visiting card or an elegant letterhead. Retouching with white should be resorted to only to remove small irregularities, but never to give a letter its own natural FORM. If a letter is badly formed in the first place, no matter how carefully it is finished it will always remain a bad one.

Although the term "legibility" does not appear in the Formula, this characteristic is nevertheless always taken care of automatically by the other six. In some exceptional cases — for instance, where lettering is used solely for decorative purposes — legibility

21

is by no means an important factor. In fact the term "legibility," in itself, cannot be confined to any definite place within the sequence of the Formula.

When criticizing any given piece of lettering ask yourself the following questions:

1. Is the SIZE of the lettering right?
2. Is the FORM of the lettering right?
3. Is the WEIGHT of the lettering right?
4. Is the LAYOUT of the lettering right?
5. Is the SPACING of the lettering right?
6. Is the EXECUTION of the lettering right?

If the answer is always "yes," you may rest assured that the job in question is excellent, but a single "no" will immediately draw your attention to the flaws or weaknesses.

Strewed among the pages of this book are several exercises (and also more ambitious studies) done by some of my good friends and students. Some of these are obviously the work of beginners, but I am grateful for their permission to use these as what we have jokingly called "horrible examples." By drawing the attention to some of the less obvious flaws and errors, *which have not been made intentionally,* we, my collaborators and I, have felt that telling the new student in this way what *not to do,* as well as what to do, would be helping him to avoid like faults.

But, as there is nothing like the ability to do one's own criticizing, suppose you begin to do so by taking any particular piece of lettering you may admire or dislike and criticizing it. Should you use any of the examples in this book, cover up any accompanying notes and check with them afterwards. Advanced students would do well to choose examples not contained in this book, and particularly some of their own work.

Examine the chosen piece of lettering and ask yourself whether it would not look better if it were smaller or larger. Consider, of course, the object of the words you are criticizing, and the distance at which they are supposed to be read. After all, you may be looking out of the window at the inscription over the portal of a building across the road.

The chances are that if you do not immediately decide that the SIZE of the lettering appears just right to you, you will find it a little too large! Certainly you will seldom find it too small. Now

try to visualize the same piece of work slightly smaller or larger, as the case may be, and you will be astonished at how quickly you can arrive at a reasonably sound judgment.

The next question, that of FORM, may not be answered so expertly by the average beginner, but if he is at all interested in lettering, he will already possess a certain amount of good taste (or just plain discrimination) which will probably enable him to judge, at first glance, whether the style (Roman, Italic, Gothic, Script or Block) is the best suited to the particular job. A glance back to Figures 7, 8, 9 and 10 will show what is meant.

While judging the appropriateness of the style, certain other factors such as clarity, simple beauty of natural forms, and rhythm come into play. These as a rule are felt rather than perceived, and any doubts entering one's mind at this point will be removed as the criticism continues.

The criticism of FORM will, of course, have to consider the shape of each individual letter, not so much as a single unit, but as a part of each word and the letter's relationship to its neighbors.

For instance, this word

**PARKING**

Figure 13a

is perfectly legible and a good example of a simple, slightly decorative style of Block lettering. Its "decorativeness" would be more apparent in an inscription of several words and lines.

But in spite of its legibility it could not be called entirely satisfactory for a roadside sign, which presumably should be read very quickly. The labored effort to make all letters parallel, and even the horizontal middle strokes all at the same level, has robbed the word of this advantage.

The next example

**PARKING**

Figure 13b

23

THE ART OF HAND-LETTERING

with its diagonals and middle strokes drawn where one feels they should be, will make it clear that these forms, while having no pretense to decorativeness, let alone beauty, are definitely more appropriate for their purpose.

A peculiar overlapping, unfortunately unavoidable, of the terms FORM and WEIGHT occurs when the FORM of exceptionally heavy letters is under consideration. WEIGHT influences FORM to a surprising degree, and one can often find really ugly forms of individual heavy letters which, however, in a complete word seem perfectly in place, and, as likely as not, could never have been formed in any better way. Many examples of this will be demonstrated in the chapters that follow.

The criticism of WEIGHT must begin with two considerations, those of

*Effect* and *Intention*

*Effect* is very often not the result of intention although one should strive to make it so. On the other hand *Intention* should, through the critic's eye, be quite obvious.

To make this clearer here are a few examples of some criticisms of *Effect:*

> The lettering is too heavy (or light) in WEIGHT to harmonize with, let us say, the illustration, the architecture, the surroundings, etc., etc.

> The lettering is too heavy (or light) in WEIGHT to give a pleasing contrast with the illustration, architecture, etc., etc.

> Being purely decorative, the lettering is too heavy (or too light) in WEIGHT as the case may be.

In the matter of *Intention*, however, one might use the following typical criticisms:

> The lettering is not heavy enough in WEIGHT to give importance to the message or attract attention.

> The lettering is too heavy in WEIGHT to express some desired characteristic — for instance, daintiness, elegance, speedy lightness, easy rhythm, etc., etc.

> The lettering is too heavy, or too light in WEIGHT to be functional — i.e., perfectly and quickly readable.

# CRITICISM AND SELF-CRITICISM

LAYOUT can as a rule be criticized rather quickly. Judgment in this case depends to a great extent on personal good taste and, of course, a peculiar sense of equilibrium. One person will prefer an over-orderly arrangement of the lettering within a rigid rectangle — a so-called block — while another will like a free and informal distribution which fits into or contrasts with the shape of the background, especially in the case of irregularly shaped spaces. One should not, however, be too hasty in making a decision when criticizing LAYOUT. It is safer to ask one's self, "Could the LAYOUT have been improved by rearranging this, that or the other?" There is seldom an absolutely unique solution for any problem of disposition; in fact more often than not the meaning of the words themselves has a strong influence on their arrangement.

In the same way, as groups of letters are grasped and read as words, so are groups of words read in a certain logical grouping. This grouping can of course be broken up for purely decorative reasons but a moment's consideration will tell whether the job under criticism is intended to be purely functional, decorative or perhaps a combination of both. *That* is for the critic to decide, but even more so for the lettering artist the moment he picks up his pencil to start work.

Rhythm and balance should be more or less taken care of under FORM and WEIGHT, but LAYOUT must always be made responsible for the immediate impression the job makes on the reader. The slant of Italic letters can, for instance, play havoc with balance, but a careful LAYOUT can do much to minimize and even completely disguise such optical illusions.

SPACING, as mentioned before, has to take into account three kinds of SPACING. But there are other important moments outside of this routine examination.

Collisions between the ascenders and descenders * of small letters sometimes cause unsightly conglomerations. These should be avoided by adequate line-spacing or, better still, rearrangement of the words. Long vertical "rivers" — a typographical term — caused by word spaces coinciding one under another in several lines of lettering are as disturbing as a run in a silk stocking. The

---

* Ascenders are the parts of small letters protruding above the "body" of the letter as in b, d, f, h, k, etc., while descenders are the "tails" projecting downwards as in g, p, q and y.

obvious remedy is rearrangement, but a slight change of letter-spacing near the middle of the offending "river" can often save a lot of work. To be able to do this kind of wangling necessitates a certain amount of knowledge of what can be done to certain accommodating letters whose width may be altered without too greatly changing their family resemblance. There are several of these elastic letters and more will be said about them in various parts of this book.

The above also applies to a disturbing streak of more or less vertical black which may appear when letters whose straight ascenders and descenders happen to coincide in the same way. If rearrangement or different spacing is quite impossible the best remedy is to cut off parts of the ascenders and descenders to provide for more "air." It is, by the way, better to reduce the length of the descenders than to take off too much from the ascenders.

And, finally, EXECUTION should, wherever possible, be judged from the original work. Nowadays the majority of all reproductions are made photographically and originals are as a rule executed considerably larger than they will finally appear. This photographic reduction tends to diminish small irregularities in EXECUTION and makes the letters appear more precise. It must, however, always be remembered that hand-lettering is *hand*-lettering, and that it is not the degree of finish which is decisive in judging whether the whole job is good or bad. Perfection is worth striving for and particularly so when it comes to lettering which is to be read at short distance and with a certain amount of leisure. This applies especially where the lettering is the sole source of interest to the reader either from a purely functional or a decorative standpoint. If, however, this is not the case, the most meticulous finish will never make up for any flaws in the other characteristics in the Formula.

Hand-lettering is preferred by clients for many purposes and reasons because they know, or at least feel, that metal type with its certain inflexibility not very often can give that "character" which is needed to emphasize or dramatize a message, or, for instance, go well with a specific illustration.

In the case of lettering to be used in its original EXECUTION, such as illuminated manuscripts, addresses, diplomas, etc., all the way down to rapidly made showcards, the final purpose, or perhaps destination, of the work will be the safest clue to the degree

of finish necessary. In the majority of these cases, retouching which can be seen is out of the question. In fact, where plume- or brush-written letters are used, small technical imperfections, if purely incidental, can often enhance and emphasize the beauty and character of the lettering.

Here the perfection of FORM achieved solely by the forming tool should be all the polish needed.

# The Five Basic Styles

So MUCH HAS BEEN done to complicate the classification of the styles of lettering, and so many conflicting terms already have been used, that a simpler system seems indicated.

Some terms used by type foundries are undoubtedly exactly what foundries, typesetters and allied professions need, while signwriters (whose art has many desirable qualities) also seem to have a professional terminology of their own. To say nothing of what some of the leading dictionaries occasionally have to say. The adjectives "light face," "bold," "condensed," etc., are as a rule appropriate, but "modern," "old-style," "classic," "formal," etc., are vague to an extreme. That is, as far as we are concerned.

It is when some call a style of lettering that looks like this

Figure 14
# ABCDE

"Gothic," while others call this

Figure 15
# 𝔄𝔅ℭ𝔇𝔈

"Gothic," too, *but also* "Black Letter," "Old English" and even "Text," that one begins to become confused. In appearance, the first example has as much right to be called "Black Letter" as the second, while the term "Text" is meaningless — unless thoroughly qualified — for either example.

Continuing in our search, we find that

Figure 16
# ABCDE

is also called *"sans-serif"* (without serif). A good, perfectly under-

standable term — once you know what a serif is (see Figure 28) — if it were not for the fact that the following

Figure 17 **A B C D E**

in spite of being without serifs, is called "Roman," never sans-serif!

## THE FIVE STYLES COMPARED

These are only a few of many such misnomers, so I shall use throughout this book a simple, consistent and logical visual classification of the styles — namely, these five as lettered. Each style will be studied, discussed and explained in its own chapters.

Roman

*Italic*

Gothic

*Script*

**Block**

Figure 18. *Learn these five styles, the basis of all lettering.*

29

When the beginner-student of figure drawing finds that he has to learn the names of dozens of bones, muscles, etc., he may sometimes wonder why and perhaps even think that this knowledge is so much waste of time and superfluous. Later, however, when confronted with a problem of anatomy which he must solve without the help of a model, he will discover that knowing these names turns out to be an extraordinary help in enabling him to remember things he ought never to forget. The action of muscles under the skin, the coordinated movement of muscle groups, the limits of movement of certain joints — knowing all these things is just as important as "copying" what can be seen on a more or less stiffly frozen model or a plaster cast. Perhaps more so.

A piece of hand-lettering can be as dead and dreary as a careful drawing of a plaster cast or as fresh and lively as a two-minute action study. The former needs little more than a certain ability to see things exactly and the patience to copy them with equal precision. The latter needs an advance knowledge of anatomy, proportion, rhythm, balance, etc., etc., plus that certain something required to put all this material together with a minimum of visible effort. But the effort, both mental and physical, will nevertheless be there in every single line, although the two-minute time limit will practically never suffice for a study of every detail. The artist *knows* all these details beforehand and gives them little or no thought, thus allowing himself maximum freedom to concentrate on what he is trying to express, be it movement, poise, grace or whatever he is looking for.

To know how to do five distinct styles of lettering already provides us with five possibilities of doing a piece of work, each differing entirely from the others. This knowledge, if it is a *working* knowledge acquired through study and practice, gives the lettering artist the necessary freedom to think of other more important things than mere readability.

Compare the five following examples and you will notice that not one of them expresses any characteristic which might definitely be considered masculine or feminine, energetic or dainty, simple or sophisticated, to mention only a few. Yet each style can be adapted to adorn a tombstone, a box of face powder, a whisky label or an ad for agricultural machinery.

At the end of the second paragraph back, I used the expression "mere readability," but it was not meant to imply that readability

# THIS STYLE
## CAN BE ADAPTED
## FOR SUGGESTING
## VARIOUS MOODS
## OF EXPRESSION

Figure 19. *Typical Roman majuscules.*

is a secondary quality of lettering. On the contrary, it should be a major consideration in practically every job. To which general rule there are, of course, the usual exceptions.

But the main reason for showing in Figure 18 the five styles "at ease" — that is, doing nothing in particular but being just plain readable — is to impress upon the student the wide range of media at his disposal for any lettering problem. Naturally, some styles will immediately appear to be unsuitable for certain jobs and one's decision will probably be instinctively correct and thus narrow down the choice. On the other hand, these five styles can also be multiplied by two, by remembering that each style has its majuscules and minuscules, that is to say, capitals and small letters.* Even Gothic and Script can, under certain circumstances, be done entirely in capitals and give beautifully decorative, if somewhat less readable, results. In exceptional cases like this, the factors readability or decorativeness will influence the final choice.

In the last analysis, however, it will be found that, in having exercised due care in choosing the right one of the ten possibilities mentioned above, you will have automatically solved that peculiar problem of appropriateness.

* The terms "upper case" and "lower case" used to designate capitals and small letters are purely typographical expressions. Their use is not justifiable when referring to hand-lettering.

*This style can be adapted for sugges- ting various moods of expression*

Figure 20. *Typical Italic lettering.*

**This·style·can·be adapted·for·sugges- ting·various·moods of·expression.**

Figure 21. *Typical Gothic lettering.*

*This style can be adapted for suggesting various moods of expression*

Figure 22. *Typical Script lettering.*

## This style can be adapted for suggesting various moods of expression

Figure 23. *Typical Block lettering.*

# ROMAN

# The Roman Alphabet

ALTHOUGH IT IS the fifth, this chapter is really the beginning of this book. For without a thorough working knowledge of the Roman alphabet the student of lettering will hardly be able to appreciate half the beauties of a good piece of hand-lettering, and will probably find it extremely difficult to design new forms *of any value*. Merely changing the form of a letter — without knowing why the original letter had its own distinctive form and without any respect for certain fundamentals — is not designing and never will be. True, sometimes quite pleasing results do happen by chance, but these will never give the same satisfaction as a job executed with forethought and conscious appreciation of form.

The Roman alphabet is the ancestor of all the styles of lettering dealt with in this book, and, in spite of some of their extraordinary differences in form it is remarkable that anyone who can read this book will find them all perfectly readable.

Evolution is a peculiar phenomenon. The Roman alphabet was originally composed entirely of majuscule letters; but evolution has so completely changed the form of the greater half of these letters that it would probably be quite impossible, or at least very difficult, for an Ancient Roman to read our so-called Roman minuscules, to say nothing of our handwriting. For instance, the words

24 COLOSSEVM ARGVMENTVM

would have meant something to him, but the scribbled words

25 *Colosseum argumentum*

would most definitely have appeared to him to be in some strange language and utterly illegible. The Roman numbers, as you know, were also nothing but letters of the alphabet, and our present-day Arabic numerals, although they have been made to look very Roman, would have puzzled him still more.

The evolution from majuscules to minuscules has been a very complicated one. In fact our present-day forms are illogical to the extreme, and the type face you are now reading is really an un-

believable mixture of plume-writing, stone mason's art and Gutenberg's reputed inventiveness, to say nothing of the medieval scribe's haste to keep up with the steadily increasing orders for copies of manuscript books long before Herr Gutenberg had his good idea.

But let us begin to discuss the Roman alphabet. Nothing is to be gained, in this book at least, by inquiring into the ancestry of these twenty-three simple but at times very beautiful symbols (the **J, U** and **W** being comparatively recent additions). They are the first known symbols which every one of us can today read and understand, and it need not interest us to know now whether they came from the Greek — which they did! — or were developed from hieroglyphics — which is also more or less true!

The best known and, let us say for us laymen, most readable examples of ancient Roman lettering are in plume-written manuscripts. The materials used do not interest us, but a knowledge of the writing instrument with which these letters were produced is of vital importance to enable us to understand more about form and proportion. This instrument was nothing but a reed or sometimes a quill cut to shape to form a broad-pointed pen.

This manuscript writing looked more or less like this

# ABCDEFGHIKLMNOPQRSTVXYZ

and it should be noticed that the horizontal strokes, and particularly the up-strokes of **A,M,N,V,X** and **Y**, are thinner due to the influence of the pen. The diagonal line of the **Z** was probably a down-stroke, but the angle at which the pen was held made it thinner than the vertical ones. So from now on you will know when you see letters like this

# AMMNVX

that the person who did them knew very little about the fundamental forms of the Roman majuscules.

This lettering was generally written comparatively quickly, which accounts for a certain uniformity in the strokes. It is as if the scribe unconsciously mechanized his hand movements to produce the quickest strokes possible with a minimum of exertion.

Most of the strokes were straight down, and it is understandable that the curves in the letters **C,D,G,O,Q** and **S** tended to become that way too, which explains why these letters in the above example are not as round and pleasing in form as they might be. But it is to be presumed that there were some scribes who took a little more pride in turning out a neat job and that these artisans sometimes had shorter manuscripts to copy with which they might take a little more time and care.

There is a peculiar pleasure in working with a tool which almost works by itself, and what is more natural than to let that tool have its own way if the result is more pleasing to the eye? A curved line, such as the half of an **O** or the main stroke of an **S**, has a lovely form if a little unhurried care is taken in making it, particularly with a broad pen-point or plume.

Gradually the round letters became wider and certain proportions of width to height developed. The monotony of all letters having apparently the same width was broken, and it was found that irregularity in the proportions not only looked interesting from an esthetic standpoint, but that this certain irregularity made for easier reading! It is the very irregularity of our "Roman" *minuscules* which makes it so much easier for us to read them than a page printed entirely in majuscules.

Rome became more and more sophisticated and endeavored to immortalize its grandeur. The stone masons stepped in and had plenty of work to do. Naturally a piece of lettering here and there to extol the virtues of some general, or even a good ex-spouse, was suitable for immortalizing purposes and the stone masons began to hew lettering into almost every slab of marble they could lay their hands on.

And these stone masons did a finer job of lettering than any of the scribes, probably because they had much more time.

Which accounts for the serif.

Now to cut a plume-written letter into marble is in itself not a very difficult task. You just have to make a deeper and wider V-shaped incision for the thick strokes and a shallower and narrower one for the thin ones. The light and shadow do the rest.

But light and shadow also play havoc with the optical length of incised straight lines, especially when they run in four different directions and when the ends are not clearly emphasized by a sharp, clear cut. The plume-written letters did not particularly

lend themselves to cutting in stone for the following reasons:

The beginnings and endings of vertical strokes were not at right angles to the strokes themselves.

Those of the downward diagonals, as in **A** and **M**, were more satisfactory.

The thin upward diagonals were the most indefinite of all.

The following illustration of incised letters, based on *plume*-written letters, will make this clearer:

Figure 26. *Incised stone letters, no serifs.*

Note the beginnings and endings of the vertical strokes and it will be seen that it was almost impossible to obtain even an optical illusion of perfect alignment. But the stone masons knew how to fix that and did so by finishing the ends of most strokes with a clean *horizontal* cut right on the guide lines at top and bottom.

The job now looked like this, and the alignment appeared much better:

Figure 27. *Incised stone letters, alignment improved.*

Now a triangular cut of this kind happens to be quite difficult to make if the three lines which are to meet in the incision are to be straight and exact, like this:

And cleaning up little irregularities can easily result in making the stroke *longer*.

So in order to do this *without lengthening* the stroke, the masons cut away a little more from the *side* cuts without touching the short triangular cut.

The result

was so satisfying that this trimming became more and more pronounced until the final result looked like this:

The whole word now appeared like this:

Figure 28. *Incised stone letters, serifs added.*

The serif was born, and it has remained with us ever since.

What considerations caused the stone masons not to put serifs on *all* angles, as, for instance, the middle angle of **M**, the second of **N**, etc., must be left to conjecture. Perhaps they possessed enough good taste not to wish to deprive the symbols of *all* their plume-written character.

However, one does find many examples where a serif has been added to the top point of the **A** (Figure 44) and where both top points of the **M** and the first one of the **N** are serifless (Figure 52). Such deviations are entirely permissible, can look very elegant and are often quite useful. But serifs on downward pointing angles are never done. (Further notes concerning serifs will be found on pages 58 to 83 where each individual letter is discussed.)

In the Formula which I presented on page 19, SIZE — which is the primary factor — is merely considered in its relationship between the lettering and the surface upon which it is to appear. SIZE influences FORM to an extent far greater than would appear obvious at first hand, and one could start a long discussion concerning the necessity of elongating letters at the top of a high monument so that they would appear normally proportioned when seen from the ground. The Roman stone masons really did this, by the way, but as we are concerned only with more or less normal lettering problems, let us not go too far.

But the normal proportions of any lettering style must be considered as our first problem. Let me reassure you, however. Memorizing the ideal proportions of the letters of an alphabet is much simpler than memorizing the ideal proportions of the human anatomy in figure drawing.

In anatomical drawing the head is usually taken as the standard of measurement and eight heads is considered a normal — in fact, rather ideal — height for an adult standing figure. It is imperative that the figure artist always remembers and thinks of this proportion in relation to all parts of the body when drawing a normal figure, but he is also at liberty to purposely change it slightly to obtain special artistic or other effects. In fashion drawing, for instance, one often finds female figures with ten head units and slimness without skinniness, and, in heroic sculpture, male figures of massive width without superfluous fat.

The lettering artist has less to worry about. He can manage with two simple standards of measurement: the height of the letter and the thickness of the vertical stroke. The stroke thickness comes under the heading WEIGHT; it greatly influences FORM and will be discussed later under these headings.

The classic proportions of the Roman alphabet of majuscules can very easily be memorized from the drawing in Figure 29. I have endeavored to show them in as simple and clear a manner as possible, for quick reference.

The first two lines show the letters which fit roughly into a square, the second pair gives the letters whose width is approximately ¾ of their height, and so on. On the last line, **K** and **P** are roughly ⅝, and the crossed **W** is slightly wider than its height.

It must be remembered that these proportions are only approximate and are merely given as a guide for quick reference. They are to prevent such errors as are to be found in the accompanying examples on page 44 (Figure 30).

The first example is made of letters copied from the Classic Proportion Chart, page 43, and shows how good proportions are necessary to make a well-balanced job. The three other examples show what happens when all letters are of the same width throughout, which are 1/1, ¾ and ½ respectively; they are just impossible.

The classic proportions given in the chart are for letters with vertical strokes having a thickness about ⅛ of the letter height. A letter **I**, 1 inch high, would be about ⅛ inch thick, entirely disregarding the serif, of course. The thin strokes of **A** and **E**, for instance, should be noticeably thinner, at most 1/16 or even less.

In almost every style of lettering, the stroke thickness can be varied from extreme thickness to extreme thinness. This question

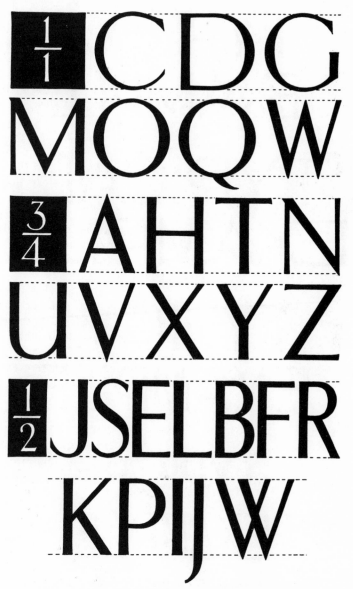

Figure 29. *PROPORTION CHART, Roman majuscules.*

# TYPICAL EXAMPLE

# TYPICAL EXAMPLE

# TYPICAL EXAMPLE

# TYPICAL EXAMPLE

Figure 30. *Correct and incorrect proportions compared.*

of WEIGHT will be dealt with later, but while discussing proportion please remember this lettered message:

# WHEN REDUCING THE WIDTH, THE PRO PORTIONS SHOULD STILL HARMONIZE

Figure 31

# & THE SAME APPLIES TO INCREASING

Figure 32

These are not extreme examples of exaggerated proportions but they will serve as an illustration.

For the purposes of practical teaching, however, let us for the present stay with the classic Roman majuscules, their normal pro-

45

portions and weight, and proceed to our next consideration. This concerns the problem of

LAYOUT AND SPACING OF ROMAN CAPITALS

which "copy" let us take as material for a trial piece of lettering.

We have here six words for one of which we can conveniently substitute the ampersand — & — and this fact already gives us six layout possibilities, viz., one to six lines of lettering.

Let us, to begin with, enjoy the freedom of unlimited space, by which I mean that we are not bound to any particular shape of area, or size.

Write the words fairly quickly with a suitable plume *without the help of guide lines,* to begin with in two lines:

# LAYOUT AND SPACING OF ROMAN CAPITALS

Figure 33a

The layout is good. Why? because the word-spaces in the two lines do not coincide one with another and because the line-spacing seems just right.

Now let us try three lines, changing the spacing arbitrarily:

# LAYOUT & SPACING OF ROMAN CAPITALS

Figure 33b

Not bad, but we can try another possibility:

46

# LAYOUT
# AND SPACING
# OF ROMAN CAPITALS

Figure 33c

Passable, and perhaps a little better than (b), but the whole thing does seem a little crowded. Perhaps the line-spacing in (a) is better after all. We can try that again later.

Now for four lines:

# LAYOUT AND
# SPACING OF
# ROMAN
# CAPITALS

Figure 33d

Not so good! So let's experiment with an ampersand and a little spreading to form a block:

# LAYOUT &
# SPACING
# OF ROMAN
# CAPITALS

Figure 33e

We're getting somewhere, although the word **SPACING** does

47

seem a little anemic. Let's forget the block and do some straight-forward centering:

## LAYOUT AND SPACING OF ROMAN CAPITALS

Figure 33f

Much better, although the coinciding of the spaces after **AND** and **OF** is not good. Together they make a hole in the layout and although this cannot always be avoided an effort should be made to do so.

In five or six lines, centering is the most obvious solution, but it is nevertheless interesting to notice how very different these two layouts look:

## LAYOUT & SPACING OF ROMAN CAPITALS

Figure 33g

# LAYOUT
# AND
# SPACING
# OF
# ROMAN
Figure 33h    # CAPITALS

But both are good and probably the only reason for deciding between (g) and (h) would be the shape of the total space at one's disposal.

Many more sketches could be made in this manner, but for this particular problem these eight will suffice and we shall choose (f) as it lends itself rather well for demonstrating correct SPACING. We may yet get rid of that unpleasant hole.

One might be tempted to employ an ampersand, but as this is so obviously a room-saving symbol it should be used only when there is ample justification.

For the beginner, it is advisable at this stage to make one or

# LAYOUT
# AND SPACING
# OF ROMAN
Figure 33i    # CAPITALS

two more efforts to get the layout more to his liking. So here are two final attempts. In the first, with less line-spacing, crowding again disturbs us and the hole is even more apparent.

With wider line-spacing and a little juggling in the third line

# LAYOUT
# AND SPACING
# OF ROMAN
# CAPITALS

Figure 33j

we find that reading becomes easier and that the hole no longer disturbs. Moving the word **LAYOUT** a little to the left is a simple matter and will not change the layout, which is now ready for use.

This layout should now be sketched in the desired size in thin, easily erasable pencil, *but still without the help of guide lines.* If you really *must* draw guide lines before you sketch your layout, don't blame me if you soon have to rub them out and make new ones. Guide lines are only for guiding and should not be drawn until you really know where to put them.

Your letters should be nothing more than thin outlines, mere skeletons to show the place they will occupy. Remember the proportions of each letter and put the letters fairly close together to form the words.

At this stage, line-spacing and letter-spacing are our next concerns. If and when your skeleton layout looks right, here is a very simple and practical method of putting in your guide lines:

Lay a slip of paper on your layout so that the straight, vertical right edge cuts across two or more lines of lettering. Now make three pencil marks on this right edge to mark off the height of a letter and the line-space beneath it. See Figure 34.

Check these two measurements with the other three lines of lettering and make any small adjustment you may think necessary. With this paper measure, mark off all your guide lines on the

Figure 34

job itself and draw them in pencil with the T square. Always very lightly so that they can be erased easily.

This is approximately how your job should look at this stage:

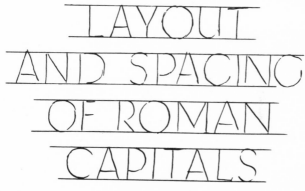

Figure 33k

Now comes the somewhat ticklish problem of letter-spacing, but a little practice should soon make you adept. That is, if you remember this one very simple rule:

# MAKE SPACES LOOK OF EQUAL WEIGHT

Figure 35

51

By this it should be understood that "space" does not mean "distance." This illustrated rule does not contain every possible combination of two letters and there are some, such as **AA, CA, LA, RA, KA, TY** and **VY** which need special handling on occasion.

The rule itself can be extended, by adding that *the greatest distance should be between two thick vertical strokes, as in* **MIL**, *and the smallest between two round letters, as in* **DO.**

Making your pencil drawing ready for finishing depends more or less on the technique you intend to use. Here are the most usual methods:

> Pen Drawing, freehand.
> Pen Drawing, using a ruler and, if necessary, compasses.
> Brush Drawing, freehand of course.
> Plume Writing, which requires experience, but which
> should need no further preliminary drawing.

The beginner's needs are greatest, so I suggest making a more or less carefully done pencil drawing which can be finished in ink or tempera in either of the above techniques.

It is always a good custom to draw your longest line of lettering first, or, if lines are to be of equal length, the one with the most letters in it. In our present case, it is a lucky coincidence that the words **AND SPACING** give us practically no problems of letterspacing. The letters **PAC** fit well into each other and we can use a moderately tight letter-space, which generally looks good with normal Roman capitals.

Proceed with the other lines and you will encounter your first problems with **LA** and **CA**. And at this point it is good to remember that we are doing *hand*-lettering which is as flexible as set type is rigid. It is the optical illusion of a well-balanced piece of lettering that counts, rather than the mechanical exactness of the proportions and execution.

Your finished pencil drawing should look somewhat like this:

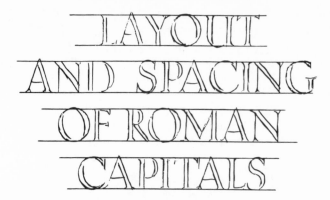

Figure 33l. *Finished pencil drawing.*

It is here that you can notice how the problems of **LA** and **CA** have been solved. The horizontal stroke of **L** has been considerably shortened and the **A** moved away from the **Y** as much as is optically possible to balance the still rather large amount of white space between the first two letters. The space between **C** and **A** has been lessened by extending the upper part of the **C** and enlarging the serif, and considerably shortening the lower part. Note also that the horizontal stroke of the **T** in **CAPITALS** is a little longer on the right-hand side, toward the **A**.

# LAYOUT
# AND SPACING
# OF ROMAN
# CAPITALS

Figure 33m. *Finished work based on previous sketches.*

A difficulty for the beginner is the ability to judge his letter-spacing in the pencil stage. The thin gray pencil lines often look correct, but the contrasting solid black and white of the finished work emphasize the errors. Until you are sure of yourself, it is often a great help to fill in the double lines of the thick strokes with pencil shading.

Complete your piece of lettering in whichever way you wish; then compare it with the accompanying finished job. And then, best of all, criticize it yourself with the help of the Formula on page 19.

# CHAPTER SIX

# *Analysis of Roman Majuscules*

THE FOLLOWING PAGES, 58 through 83, illustrate and discuss individually and in detail every letter of the Roman majuscule alphabet. Remarks concerning letters which are similar to others have been repeated to give you the information you need where you expect to find it. So, if you read, "see also . . .," this is merely a help to memorizing.

The letters shown are of classic proportions similar to those mentioned on page 43, Figure 29, and are well-formed, straightforward Roman capitals made with a deliberate avoidance of any special artistic or personal touch. They are intended as a reliable standard and can be used as a model to copy, in much the same way as a figure artist would use plaster casts.

The black area gives the height between the guide lines, and each letter (with the exception of **I** and **J**) is shown in an exact square with a further thin white horizontal line to mark the true center.

This black square has the peculiar tendency to minimize the "optical illusions." It is at first glance hardly apparent that the height of the **C** is considerably more than that of the **D**. In black letters on white — the technical term is "positive" lettering — this would, in letters of this size, be very noticeable and perhaps a little confusing.

While endeavoring to make this book as complete and convenient as possible, conciseness has also been my aim. It has therefore been impossible to include every variation of each letter (even only of Roman capitals) under each example. Even if space permitted, such a cataloguing of single letters would be dangerous to the beginner. Only in combination with other letters, as in words, are certain variants justifiable, so I believe that the pages of examples which follow the complete alphabet will be of far greater value. These examples particularly demonstrate how WEIGHT and SPACING can very considerably influence FORM.

First a few words in general concerning *all* the following Roman majuscules. The thick straight strokes have all been made slightly thinner at the middle. This is hardly noticeable, but the following example will show how much more elegant the upper word looks:

# HILT
# HILT

Figure 36. *The upper example is to be preferred.*

Also the thin strokes, as the next example shows, should be thickened very slightly towards the serif and the serifs extended gracefully in a continuous line, not as a separate triangle:

Figure 37. *The upper example is to be preferred.*

Similarly, curves should gradually and evenly thicken or taper, especially when emanating from straight lines. The inside of curves should never be straight except in very heavy-weight forms:

# BDOS
# BDOS

Figure 38. *The lower line shows common mistakes.*

## TYPICAL MAJUSCULES AS MODELS

In presenting the following analysis of the Basic Roman Majuscules, let me repeat that these have been drawn as plain, straightforward, but well-formed letters without pretense to any artistic individuality or character.

Do not use them with the idea of slavishly copying them, but rather as important reminders of fundamentals. When using them as models, little can be gained by copying them singly. It is much better to form words of several letters and thus learn about their flexibility in practical use.

## PROPORTION

Width, without serif, is ¾ of height.

## OPTICAL ILLUSIONS

The top point should always protrude above the guide line. Otherwise the **A** will appear to be too small. See also **N, V** and **W**.

The horizontal line should be placed well below the true center, so that the two spaces thus formed are about equal in area. An occasional exception may be made to harmonize with neighboring letters.

## NOTE

The top point can also be finished off with a serif, but only going to the left. This is sometimes convenient in certain spacing problems, such as **LA.** This serif would naturally not extend above the guide line.

See Figures 44 and 45 for variations.

## PROPORTION

Width of upper half, without serif, is ½ of height.

## OPTICAL ILLUSIONS

The point where the two curves meet at the main stem should be a little above the true center. This automatically makes the bottom curve a little wider than the top one, as also in **S**. Never exaggerate this proportion unduly; the result will always be ugly.

## NOTE

The serifs extend only to the left, as also in **D,E,F,L,P** and **R**. Thickest part of curves should be slightly above the center of each curve. Compare with the plume-written form. It is important that the curves thicken and taper off evenly—i.e., the bulge should not be too sudden.

## PROPORTION

Width is almost the same as the height.

## OPTICAL ILLUSIONS

In all round letters, like **G,J,O,Q,S** and **U**, where the curve would otherwise touch the guide lines at a tangent, the curve should protrude over or under the guide lines as the case may be. This for alignment's sake; if not considered, the letters will appear to be too small.

## NOTE

The thickest part of the **C** is somewhat below the true center line, a reminder of its old plume-written origin. The upper serif should be comparatively large, certainly much heavier than on the **G**, while the bottom one is generally merely the thin line beginning to become thick again, cleanly cut off. This clean cut is a typical stone mason's job.

## PROPORTION

Width, without serifs, is almost the same as the height.

## OPTICAL ILLUSIONS

The thickest part of the curve is always slightly thicker than the straight stem. Compare with **C**, and you will see that the curve, being connected with the horizontal lines at top and bottom, does not need to protrude over the guide lines. The horizontal strokes take care of the alignment, and it is always advisable to make these horizontals sufficiently long from the stem so that they do. In other words, do not start off with your curve too suddenly.

## NOTE

The thickest part of the curve is slightly above the true center line, as in **O,Q,B,P** and **R**. The serifs do not merge into the horizontal lines but extend only to the left.

## PROPORTION

Width, without serifs, is ½ of height.

## OPTICAL ILLUSIONS

The middle horizontal stroke should be made above the true center as in **B,F,H,R,** but never unduly exaggerated. There are exceptions, of course, and this middle stroke can sometimes be put even below the true center. This depends, however, on the neighboring letters and sometimes on the size of the minuscules following an initial **E**. This middle stroke is also often shortened, sometimes quite considerably if a very open letter is desired, but generally the above proportion gives the best results.

## NOTE

The bottom horizontal stroke can often be lengthened a little to the right to help fill a gap, for instance as in **ET**.

## PROPORTION

Width, without serifs, is ½ of height.

## OPTICAL ILLUSIONS

The second horizontal stroke should be made above the true center as in **B,E,H,R,** but never unduly exaggerated. There are exceptions, similar to those which apply to **E** and **P**. This second stroke, however, should never be shortened any more than necessary.

63

THE ART OF HAND-LETTERING

## PROPORTION

Width, without serifs, almost same as height.

## OPTICAL ILLUSIONS

The **G** will appear too small if the curve does not protrude above and below the guide lines as in **C,J,O,Q** and **S**.

## NOTE

As in **C, O** and **Q**, the thickest part of the **G** is in the curved stroke, below the true center. The top serif should be kept small (as against **C**) and the emphasis put on the upright stroke as this is the characteristic of the **G**. Never make it too high, however, certainly never above the true center. It can, though, be considerably shortened if a very open letter is desired. The little spur at the bottom of the straight stroke may be omitted. The straight stroke is sometimes extended down as in **U**, and in ornamental forms to even considerably below the guide line.

## PROPORTION

Width, without serifs, ¾ of height, for *general* purposes. The proportion of **H,** like **N,** is flexible; it can be widened or narrowed as need demands.

## OPTICAL ILLUSIONS

The horizontal stroke should be above the true center as in **B,E,F** and **R.** Do not exaggerate unduly.

## PROPORTION

**I** is just **I,** but **J** should be about ½ as wide as it is high. When **J** is extended below the guide line it becomes narrower.

## OPTICAL ILLUSIONS

If used as above, the **J** should protrude very slightly below the guide line for alignment's sake. It can be extended below the line, however (following **A,** for instance), for better spacing, or as an ornamental initial. Both forms can be made to end with a serif or a "knob." This knob is a privilege of the **J,** and in a truly classical Roman alphabet (to which the **J** does not belong). It can be used on no other letter.

See Figure 45 for three variations of form.

## PROPORTION

Without serifs, the width of **K** should be about ⅝ of its height. ½ is generally too narrow and ¾ too wide.

## OPTICAL ILLUSIONS

The peculiarities of this letter can hardly be termed optical illusions, but careful note should be made of its construction. The thin *upward* stroke should begin well below the true center and, disregarding the serif, should not reach the ⅝ width limit. The third stroke, however, should start above the center and extend to the full width. In other words, the top part of **K** is narrower than the bottom, as in **B**. The angle of both slanting strokes should be about the same.

## PROPORTION

Without serifs, the width of L is generally ½ of its height.

## NOTE

The thin stroke of the L can be lengthened or shortened considerably to fit with the next letter in a word. This is very useful in some difficult spacing problems, such as **LA** and **LT.**

## PROPORTION

Width, without serifs, almost same as height. Width is greatly influenced by weight and by neighboring letters. In general it is safer to keep on the wide side.

## OPTICAL ILLUSIONS

The middle point where the 2nd and 3rd strokes join is exactly between the two uprights and can be made to touch the bottom guide line. (See Figure 45.) It should, however, not go below as in N,V and W. On no account should it be raised higher than shown above. When sloping 1st and 4th strokes are used, M is generally wider than high, and letter-spacing needs careful attention.

## NOTE

The upright strokes should really appear to support the others, and not merely the serifs. The top serifs should only point outwards, otherwise the letter will look like a V with extra supports. See Figure 45 for three interesting variations of M and endeavor to justify their form.

## PROPORTION

Width, without serifs, ¾ of height. This proportion is exceedingly flexible and **N**, like **H**, can be considerably widened or narrowed to take care of spacing problems.

## OPTICAL ILLUSIONS

The bottom point should protrude below the guide line. This corner would otherwise appear to be too short as in **V** and **W**. Never put a serif on this angle.

## NOTE

The serif on the thick stroke extends only to the left as in **M**. The left *upstroke* should appear to be solidly supporting the weight of the whole thick stroke and not merely the serif.

The two background spaces should appear to be fairly equal in area. In heavy weights, this generally necessitates chopping off the bottom point for alignment's sake.

70

## PROPORTION

Theoretically a perfect circle.

## OPTICAL ILLUSIONS

To prevent the letter appearing too small, the curves at top and bottom should protrude over and under the guide lines.

## NOTE

In the above classical form, the outside of the **O** can be a perfect circle. When, however, the letter is drawn symmetrically – i.e., without the slight optical slant – the curves at top and bottom should be slightly flattened so that the thick portions, left and right, appear longer.

In some alphabets, the **O**, together with **C,D,G** and **Q,** is narrower. In such cases the letters are drawn symmetrically straight.

## PROPORTION

Width, without serif, about ⅝ of height.

## OPTICAL ILLUSIONS

Thickest part of curved stroke is above its center as in all other round letters. The bottom end of the curve is often straightened out like a **D,** but the slight upward curve as shown is more graceful.

## NOTE

Never make a **P** like an unfinished **B** or **R**. The "loop" should be distinctly larger, being the characteristic feature of this letter.

## PROPORTION

Width, without tail, theoretically a perfect circle as **O**.

## OPTICAL ILLUSIONS

The curves at top and bottom should protrude above and below the guide lines as in **O**.

## NOTE

In the classical form the **Q** can be a perfect circle. The tail, with its many possibilities for decorative treatment, is its chief feature. Whatever style of tail is decided upon, the following rule will be useful to remember. Never start a thick tail from a thick portion of the **O**, or, in the case of allowing the tail to start inside the letter, never let the thick part of the tail cross the thick part of the main curve.

## PROPORTION

Width, without serifs and with normal tail, ½ of height.

## OPTICAL ILLUSIONS

The "loop" joins into the stem slightly above the true center as in
**B**. The tail should emerge from the thin part of the loop (as in **Q**)
and is very often allowed to extend below the bottom guide line.
This should be taken advantage of when words are very tightly
spaced, especially when a straight letter like **I** or **E** follows. As in
**Q**, the tail lends itself to a great number of variations, which, how-
ever, are influenced by Size, Weight and Spacing.

## PROPORTION

Width of upper half, ½ of height.

## OPTICAL ILLUSIONS

Curves at top and bottom protrude over and under guide lines, to prevent S appearing too small. As usual, the optical center is above the true center so that the upper half is smaller than the lower.

In certain styles of Roman letters this is sometimes reversed, making the top look bigger than the bottom, but when this is done it should never look as though the S has been turned upside down. Proper treatment of the serifs will take care of this.

## PROPORTION

Width, ¾ of height, but this can be varied to suit neighboring letters as in the case of **L**.

## NOTE

The serifs on the thin stroke can be varied in a number of ways, most of which can be found in the pages of examples following this alphabet.

## PROPORTION

Width without serifs, ¾ of height.

## OPTICAL ILLUSIONS

Although the final serif, which goes only to the right, is within the guide line, the curve at the bottom must, as usual, protrude below.

## NOTE

The above form with two thick strokes will be found more practical (and as a rule more pleasing) than the form with one thick and one thin stroke, although the latter is very useful where "color" is affected. See Figure 41.

## PROPORTION

Width, without serifs, is ¾ of height.

## OPTICAL ILLUSIONS

The bottom point should extend below the guide line, as in **N** and **W,** to prevent the **V** from looking too small.

## NOTE

To save space, the serifs are often joined with neighboring letters.

## PROPORTION

Usually about the same width as height. The above crossed form has been made to fit the square, but generally the two **V**'s are so arranged that they cross near the optical center, making the **W** slightly wider. See Proportion Chart, Figure 29.

## OPTICAL ILLUSIONS

The bottom points should extend below the guide lines as is usual in **N** and **V**.

## NOTE

There are several variations of **W**. See Proportion Chart and the various examples following this alphabet. The simple version — without the crossing shown above — is sometimes made with a serif where the 2nd and 3rd strokes join. This is a survival from the time when a **W** was formed by placing two **V**'s together, like this **VV**. It is seldom used today.

## PROPORTION

Width, without serifs, ¾ of height.

## OPTICAL ILLUSIONS

The thin *upward* stroke crosses the other very slightly above the true center, thus making the upper space a trifle smaller than the lower.

## NOTE

As in **V** and **W**, the serifs are often made to join neighboring letters.

## PROPORTION

Width, without serifs, ¾ of height.

## OPTICAL ILLUSIONS

The point where the three strokes join should be right on the true center line. Compare with **X** to see how this makes the triangular background space a little larger. This point of junction may be dropped a little to improve balance with neighboring letters.

## PROPORTION

Width, about ¾ of height.

## NOTE

As a rule both top and bottom strokes are of equal length. They can, however, be lengthened or shortened individually to fit into neighboring letters as occasion demands.

## PROPORTION

Width of above example, about ¾ of height. As this symbol, called
an ampersand, always stands alone, however, its proportions are
flexible and can always be varied to suit the allotted space.

## NOTE

This symbol, which is an abbreviated combination of the letters
**ET,** the Roman word for **AND,** has dozens of beautiful variations.
There are many in this book, but for the artist wishing to use one
I would suggest his trying to design one expressly for his particu-
lar job. This is fascinating practice, especially for styles of letter-
ing other than Roman.

# Variations from Typical Roman Majuscules

VARIATIONS OF ROMAN majuscules are innumerable and if one were only to combine two of each of the many characteristics such as light weight and narrow proportions, or normal weight and wide proportions, the elaboration or even exclusion of serifs, and other "personal touches," one would have enough alphabets to fill this book.

But as there are several other basic styles of lettering to be considered, we must content ourselves with a brief showing of some typical examples of the Roman — enough, I hope, to serve as inspiration. Many little problems of FORM, LAYOUT, SPACING — yes, and wangling — are handled, and the text will draw your attention to many an inconspicuous but useful trick.

All styles of lettering do not lend themselves to every particular subject, but on the other hand there are also subjects which do not lend themselves to every style of lettering. It sometimes happens — and this is surprisingly often the case — that even certain words do not lend themselves to a satisfactory rendering in a certain style of lettering without some kind of adjustment.

Take for instance the word

# SOLITARY

Figure 39. *The O is too prominent.*

which, for the sake of argument, is to be shown as a single word, and which has here been drawn following the correct proportions of Roman majuscules. Obviously the circular O seems too conspicuous and in a case like this it would be better to make a narrower one, like this:

# SOLITARY

Figure 40. *The O has been adjusted.*

Below are two interesting instances of changing the letters to fit the word. In the word **UNITED** the letters **U** and **E** have been lightened to more or less balance the white spaces caused by the **T** and **D**. The thin second stroke of the **U** next to the thin one of the **N,** and the short middle stroke of the **E,** have given the word even color. With half-closed eyes you can appreciate this better.

# UNITED
# UNIQUE

Figure 41. *Comparisons for "color."*

In **UNIQUE** everything has been done to darken the word. Both **U**'s have the thick second stroke, the **Q**'s tail is drawn well into the letter to lessen the white space, and the **E**'s middle stroke of full length completes the illusion.

Apart from the color of these two words, note how each one is more or less a design in itself.

The question of color can of course be solved in other ways, and the following two examples speak for themselves. But this thinning and thickening disclose a number of other important and interesting facts.

In spite of being of the same height as the others, the heavier letters appear to be distinctly larger. They are, at the same time, much less readable; although inappreciable in so short a text, the effort necessary to grasp and read each word is greater. This would be still more noticeable in longer words, and is worth remembering when quick readability counts.

In the open version, only two letters have been changed from "standard": the upright stroke of the **G** and the middle stroke of the **E** have been shortened. Note also the "open" **W** and **M.**

85

# LIGHT WEIGHT OPEN FORMS

Figure 42. *Open version of Roman majuscules.*

In the closed version — which is by no means the heaviest of heavy — the truth that WEIGHT influences FORM is strikingly apparent. All letters have become wider than standard and every effort has been made to reduce blank spaces by enlarging serifs

# HEAVY WEIGHT CLOSED FORMS

Figure 43. *Closed version of Roman majuscules.*

on thin strokes. Compare treatment of **W, E, G, F, R, M** and **S**. A still wider version is shown on page 93, Figure 55.

The following example of a style particularly suitable for free brush rendering merits attention for the various ways in which room-saving devices have been employed. The often occurring problems of letter-spacing in the combinations **CA, OO, TT, RA** and **CT** have been well solved, and the line-spacing is good. The use of a top serif on the **A**'s is interesting.

# AMERICAN BOOKS ARE ATTRACTIVE

Figure 44. *Free brush rendering with space-saving hints.*

Speaking of A's here are a number of them without top serifs.

# TAJ MAHAL

# TAJ MAHAL

# TAJ MAHAL

Figure 45. *Letter-spacing studies, and some variations of* **A, J** *and* **M.**

87

And here, Figure 45, we have an interesting instance of how FORM can influence SIZE, at least optically. Taking the **T** as measurement we find that the height of all three lines is the same, but that *in spite* of its WEIGHT the second appears to be less in height than the first and third. This is caused by the very pronounced serifs, which you will notice are all joined together in the second word, along with a quite perceptible widening of the **A**'s.

This example was made to draw special attention to a few variations of the **J** and **M**, some different ways of letter-spacing and various treatments of serifs.

### ORNAMENTATION

Before concluding this section with a few inspirational ideas in the way of FORM and LAYOUT, I would like to say a word or two concerning the ornamentation of Roman majuscules.

The less the better.

Ornate embellishment of Roman majuscules is almost always

Figure 46. *Decoration flowing from* **N**, **Q** *and* **R**.

out of place and if an initial is sometimes "illuminated" (that is, adorned with more or less elaborate decoration either in colors or black and white) at the beginning of a chapter or page, for instance, it should be done in such a way as not to distort the classic form of the letter itself.

Decoration flowing from the letters is only possible in the case of a few characters. They are **A, G, J, K,** as well as **N, Q** and **R** in the previous example. And this again is only possible — and should only be resorted to — when some appropriateness with the message justifies it.

<div align="center">COMPARATIVE EXAMPLES</div>

The following studies, through page 94, demonstrate something of the variety possible when rendering even a single theme. Compare them thoughtfully, criticize them in every way, **and** think what you would have done to improve them.

Figure 47. *Compare this with the examples which follow.*

ALWAYS
ENDEAVOR
TO FIND SOME
INTERESTING
VARIATION

Figure 48. *Would slightly wider line-spacing have improved this layout?*

ALWAYS ENDEAVOR
TO FIND SOME INTER
ESTING VARIATION

Figure 49. *The seemingly inconsistent treatment of the serifs is purposeful. Heavier serifs on the N's, M's, A's, V's, etc., would have affected the airiness of this layout.*

90

# ALWAYS EN DEAVOR TO FIND SOME INTERESTING VARIATION

Figure 50. *A monumental treatment with considerable freedom. Although not quickly readable, its layout has an appealing quality.*

# ALWAYS ENDEAVOR TO FIND SOME INTER- ESTING VARIATION

Figure 51. *Obviously only a sketch. A lot could be done to improve letter-spacing. Find out where.*

91

ALWAYS
ENDEAVOR TO
FIND SOME
INTERESTING
VARIATION

Figure 52. *The irregularity of alignment and individual treatment of many letters give this example character.*

ALWAYS
ENDEAVOR
TO FIND SOME
INTERESTING
VARIATION

Figure 53. *A noteworthy example of excellent spacing. Would this have been possible in a much heavier weight?*

# ALWAYS ENDEAVOR TO FIND SOME INTERESTING VARIATION

Figure 54. *Pleasing regularity in color, but tighter letter-spacing would have improved readability.*

# ALWAYS ENDEAVOR TO FIND SOME INTERESTING VARIATION

Figure 55. *This style is handy where weight is needed, and readable in almost any size.*

# THE SPEED AT WHICH A PIECE OF LETTERING IS TO BE READ IS A MAJOR CONSIDERATION WHEN CHOOSING THE STYLE OF LETTERING TO BE USED

Figure 56. *An example of quiet dignity, very suitable for the message it carries.*

Quick readability should not always be considered the most important aim; a purposeful retardation of the reading-speed can be a way to compel the reader to concentrate on the message

Figure 57. *The effort which it took you to read this probably emphasized its meaning.*

# The "Roman" Minuscules

PALEOGRAPHICALLY SPEAKING, there's no such thing. The minuscules were developed from cursive lettering (see pages 133, 134) which departed from the Roman majuscule alphabet to such an extent that, as I have already mentioned, no Roman would have recognized more than a few of the symbols the new ones were supposed to represent. The re-departure from cursive, with its connected letters, was caused by a number of things, the most important of which was the development of the angular German Gothic style of manuscript lettering, which, while being exceptionally neat and exact, did not lend itself to joining — as you will discover in the chapter on Gothic — or to Gutenberg's need for separate letters in his typesetting shop.

Scores of illustrative examples would be necessary to describe this evolution and probably scores more to show how the forms of the minuscules became "romanized" again. Furthermore, so much would have to be said to explain the influence of one national style upon another, and how these styles migrated backwards and forwards, that a very long and dry chapter would result. In the later chapters on Italic lettering, an attempt has been made to make this evolution a little more clear, but as this book is not for paleographers, we must confine ourselves to our present needs and facilities, not forgetting that perhaps some of our best work of today will influence that of some distant future.

Repeating the procedure used to explain the FORM of the Roman majuscules, we first find that the minuscules also definitely owe their shape and their characteristic thick and thin strokes to plume-writing.

abcdefghijklmn
opqrstuvwxzy

Figure 58. *Typical plume-written alphabet.*

Remnants or survivals of cursive writing are still to be seen in

the upward tilt of the endings of several of these letters, such as
a, d, h, i, k, l, m, n, t and u.

These endings — connections would be the more correct term —
are to be found in our present-day Roman minuscules only in the
letters a and t. All the others seem to have definitely made up their
minds to become separate letters and stop where they end. Excep-
tions do occur in some *type faces* but they are personal touches of
the designer and cannot be discussed here.

The serifs on our present-day minuscules owe their form indi-
rectly to the stone mason, of course, but more directly to the ef-
forts of designers trying to make their minuscules harmonize with
the majuscules, at least as far as the finishing details go. The seem-
ing lack of any organized consistency in the direction and one- or
two-sidedness of these serifs betrays many influences. On the one
hand, a leaning towards the hooks with which scribes started off
their downward strokes in cursive writing, and, on the other, a
purely arbitrary desire to finish off the ends of the strokes in a
symmetrical manner. The question of alignment was also a main
consideration; but obviously the necessity of making a difference
between I and l made itself felt, too. And if we go on like this we
shall yet become paleographers. Within the scope of this book,
however, it must suffice to give good examples of Roman minus-
cules showing the correct placing and direction of the serifs, to-
gether with a few possible variations, without too much regard as
to how they got there.

But before we get to this, the question of proportion should be
settled. Disregarding the letters with "ascenders" and "descen-
ders," it will be found that three-fifths of the height of the ma-
juscules is just about the right height for the minuscules — that is,
for a normal, straightforward, easily readable mixture of capitals
and small letters. With this height as our standard of measure-
ment, the simple canon of proportions which follows immediately
becomes clear.

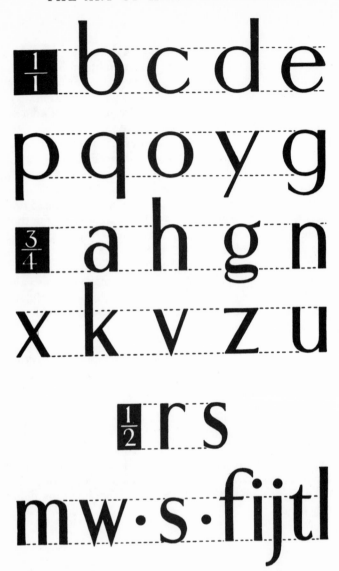

Figure 59. *PROPORTION CHART*, *Roman minuscules*.

The somewhat wider s (in the bottom line) often harmonizes better in certain letter combinations.

The wider type of g (in the second line) is easier to make and often quite useful, but it looks better with a wider type of **a.** The two following renderings demonstrate both varieties of all three letters:

# gas gas

Figure 60

The stroke thickness should almost always be slightly less than that used for the capitals (the l is 1/9). The height of the ascenders is generally more or less the same as that of the capitals.

Let me repeat that the above-mentioned proportions are to be regarded as for a normal alphabet of minuscules to be used with the normal or "classical" alphabet of Roman majuscules illustrated in our Proportion Chart, Figure 29, page 43.

# THE ART OF HAND-LETTERING

## TYPICAL MINUSCULES AS MODELS

In the following pages — 101 through 112 — two different styles of Roman minuscules are shown as "models." The first (left) letter of each pair naturally belongs to the same alphabet — the "plume" form — and the second to the "drawn" form. (See page 118.) The two styles should not be mixed. Both alphabets, however, can be used in combination with the majuscules shown on pages 58 to 83 and harmonize perfectly.

The same method of presentation has been used. The horizontal middle band (black) should be 3/5 of the height of the capitals. The upper and lower bands (also black) should be 2/5 of the height of the capitals; the upper band takes care of the ascenders and the lower band of the descenders. (These bands for the minuscules have been somewhat reduced here compared with the majuscules, pages 58 through 83, because of page limitations.)

This division by the guide lines into seven equal parts will be found to provide a very practical norm for everyday purposes. The fact that the descenders take up only about ¾ of their allotted space prevents collisions between ascenders, descenders and capitals on adjacent lines of lettering. Apart from this purely mechanical reason, however, it is from an esthetic standpoint better to make the ascenders longer than the descenders. From the standpoint of readability, too, the ascenders contribute far more to easy readability than the descenders. Cover up the lower half of any line of lettering and see for yourself. Then try the upper half. Considering this, it seems logical to give the upper half its due.

In our notes under each letter, the plume form at the left will naturally be discussed before the drawn form. (Both forms were drawn in making the originals, and the two terms "plume" and "drawn" are used merely to accustom the student to recognize the influence of the tool originally responsible for the letter's basic form.)

As the student will by now recognize where optical illusions occur, this information will not be repeated except when absolutely necessary. The proportions of width to height are also not given, the drawn squares being sufficient reminder as to which letters should be kept on the narrow side. Many of these proportions are elastic, depending as a rule on neighboring letters in word formations.

100

**PLUME:** The thin connection of the loop at the top is generally done upwards. The end serif is occasionally straight as in **d**.

**DRAWN:** The loop is connected downwards and the ending hook is essential as in **t**. Note difference in knobs.

**PLUME:** The spur terminating the stem is typical but can be less pronounced, even eliminated.

**DRAWN:** The bottom serif is perfectly correct, but a spur or entire elimination is preferable, making curve flow out of stem.

101

**PLUME:** The knob gradually tapers from top, and main stroke is thicker at bottom than in drawn form, slightly filling the empty space.

**DRAWN:** Symmetrical in design. The upstroke ending can be evenly thin as in second **e.**

**PLUME:** Note thickening where loop meets stem at top. Bottom serif is generally straight as shown above.

**DRAWN:** Symmetrical.

Note end serif goes only to right. Both ends of loop are thin where they join main stem.

PLUME: Middle stroke, in keeping with the tool, is often slanting, but can be horizontal as in drawn form.

DRAWN: Symmetrical. Middle stroke is sometimes thickened slightly and also lowered to true center.

PLUME: The long f is unusual but often very decorative in certain word formations.

Cross stroke in both forms can be lowered to suit next letter.

Bottom serifs straight and on right and left for both styles.

103

PLUME: Top of curve thickens towards the stem which starts *without* serif as in q.

DRAWN: Straight serif only to right.

This open form is unusual but very useful in either very open or very heavy styles.

PLUME: The tool's influence is strikingly apparent.

The small o is typical and the main stroke of the tail covers the guide line.

DRAWN: Symmetrical o. Note upward swing of "dot," which, however, can also "droop" as in plume form.

104

**PLUME:** The curve is thicker at the top than in the drawn form, as also in **m** and **n.**

In both styles all end serifs are on right and left.

Never make dots on **i**'s and **j**'s too small. They should be *optically* as thick as the stems. And, of course, never omit them.

105

Thin upstroke should start well below true center line. Note identical treatment of three serifs: all are made on both right and left sides.

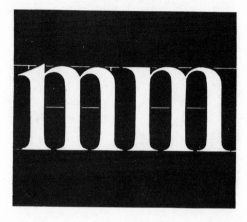

**PLUME:** Curves thicker at top as in **h** and **n**.

Note that **m** is wider than the square, but is not made up of an **n** with another stroke added.

The inside spaces are considerably narrower than in **n**.

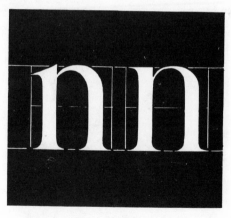

Same as **m**.

See **m**, and note that all bottom serifs are always on right and left.

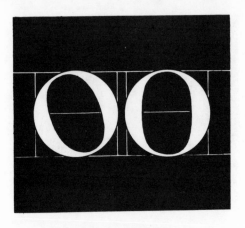

The plume and drawn forms
speak for themselves.

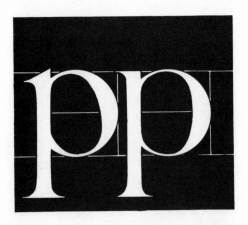

PLUME: Note thickening of
curve at bottom near stem.

DRAWN: Symmetrical, with
thin strokes at top and bottom.

Identical bottom serifs.

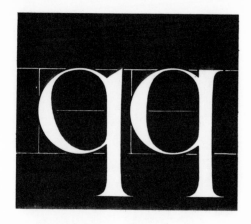

PLUME and DRAWN: Same treatment as for open g. Bottom serifs identical and the same as **p**.

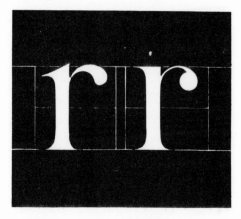

PLUME: Note thicker "tail" with gradual widening towards the knob.

DRAWN: Thin tail with "sudden" knob.

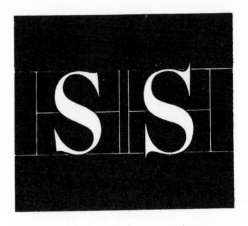

Both forms are basically alike except for the serifs, which, however, should always be definitely pronounced.

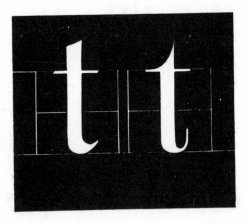

See **a** for comparison of end strokes, remembering that **a** and **t** are always finished off in this way.

The top ends, however, are interchangeable and both correct.

**PLUME:** The curve thickens gradually at the bottom and is definitely thicker at this point than in the drawn form.

Note *particularly* the direction of serifs in both forms.

See note on page 112.

As to v, w, x, y and z, except where manuscript writing is to be used and left the way it comes out of the plume, as in Figure 72, there is no characteristic difference in the treatment of the serifs of these five letters. The y's tail, however, should be adapted to the plume or drawn style, whichever is used.

# *Layout and Spacing of Roman Minuscules*

IT HAS BEEN NECESSARY to vary slightly our teaching sequence in order that you become thoroughly acquainted with the forms of Roman minuscules before considering the problems of their layout and spacing, but we can now proceed to these problems, using the same method and the above text. The use of some capitals will make the exercise far more interesting — and harder.

Once again, let us enjoy the freedom of unlimited space and begin by making some rough plume-written sketches for the general LAYOUT and WEIGHT — *without guide lines* as you will probably remember:

## Layout and Spacing of Roman Minuscules

Figure 61a

Here the words look all right, but the line-spacing is obviously too tight. The y over the **R**, and the g colliding with the l are things to be avoided. But that is why we are making sketches to discover such avoidable flaws.

Let's see how three lines work:

## Layout & Spacing of Roman Minuscules

Figure 61b

# Layout
# and Spacing of
# Roman Minuscules

In each of these trials the line-spacing is still a little close. It seems that the tight letter-spacing makes one want to be economical with space too. Or perhaps we haven't got used to handling ascenders and descenders yet.

Let's try four lines, this time with plenty of line-spacing. Oh, and don't forget, or perhaps you've noticed it already; **Minuscules** is a pretty long word:

Figure 61d

# Layout and
# Spacing
# of Roman
# Minuscules

Dodging the collision of the S with the y was simple, and, if one wished to, something could be done with the y's tail to fill that gap; but we are not yet ready for such elaborations.

Figure 61e

# Layout and
# Spacing of
# Roman
# Minuscules

This time it is the third line which is giving trouble. Centering will not help much, and it seems that four lines is not the ideal solution, which, seeing that we have ten letters in each of three lines (spaces between letters are counted), seems a great pity. But there is still another possibility!

Figure 61f

**Layout and Spacing of Roman Minuscules**

This is the best to this point and particularly good as far as the descenders are concerned. But let us see what five and six lines look like:

**Layout and Spacing of Roman Minuscules**

Figure 61g

**Layout and Spacing of Roman Minuscules**

Figure 61h

I personally feel that (h) is the best of the lot, but tastes differ, thank heavens! I happen to be partial to lots of white space, but considering that *your* clients may not always see eye to eye with me and will often prefer a definitely more economical use of expensive white space, I suggest that we proceed with a finished drawing of (b).

So the next step is the skeleton layout *right on the good paper itself* in thin, easily erasable pencil lines, still without guide lines. This is to make you sure of yourself. In time you will probably no longer need to make the rough plume-written sketches and be able to visualize your laid-out piece of lettering before you even pick up your pencil.

Putting in the guide lines, if you intend your descenders to encroach on the space reserved for the next line's ascenders — as you do in this case — is no problem. Simply ignore the fourth line for the descenders and mark your paper measure like this:

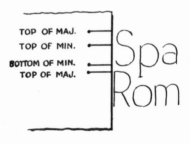

Figure 62

A similar paper measure, when space is ample, would be made like this:

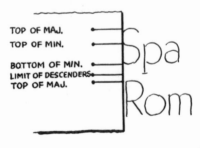

Figure 63

116

With the guide lines drawn in, your finished layout will, or ought to, look like this:

Figure 61i. *The line-spacing has been slightly widened, and the second and third lines centered.*

Note that I have letter-spaced **Min** a little more open than the rest of the letters. This is not a particular knack; once you are sure of your proportions and know the simple rule of letter-spacing on page 51, Figure 35, you, too, will make such allowances quite automatically.

Fairly tight letter-spacing is generally best for Roman minuscules; the very words you are now reading in type are spaced that way. One of the best rules I know is to make a unit of each word. Wide letter-spacing generally takes more time to read — almost necessitating spelling — while a tightly spaced word seen as a unit is recognized and read in a flash. Our own daily handwriting is the best proof of this.

We can dispense with an illustration showing the above layout worked out in pencil, but for comparison's sake I believe the two following "finished drawings" will be interesting and instructive. In the first, "plume" form minuscules have been used; in the second the "drawn" form.

# Layout & Spacing of Roman Minuscules

Figure 61j

# Layout & Spacing of Roman Minuscules

Figure 61k

The use of one or the other style is a matter of taste.

Compare the work you have done and take our old standby, the Formula, to hand to be your own critic. (See Figure 11, page 19.)

CHAPTER TEN

## Variations of Roman Minuscules

THE VARIATIONS of Roman minuscules on the following pages by
no means exhaust the possibilities of creating many others.

They are particularly interesting to study, each from the indi-
vidual viewpoint of FORM, WEIGHT, LAYOUT, SPACING, etc. The
captions will draw your attention to things worth noting, but you
will learn more by trying to criticize each piece yourself.

# Always endeavor to find some interesting variation

Figure 64. *Although this was drawn, some of the plume-written char-
acteristics remain.*

# Always endeavor to find some interesting variation.

Figure 65. *Would you consider this more readable than Figure 55?*

# Always endeavor to find some interesting variation

Figure 66. *Good weight and spacing, but a little careful retouching would have improved it.*

# always endeavor to find some interesting variation

Figure 67. *A ruler and compass job with an interesting layout. A little more line-spacing would have increased readability, but was this intended?*

# Always endeavor to find some interesting variation

Figure 68. *This has sparkle and eye-catching value but, here again, line-spacing appears too tight.*

# Always endeavor to find some interesting variation

Figure 69. *Such exaggerations in form are often good in ad headlines, but don't overdo them.*

121

# Always endeavor to find some interesting variation.

Figure 70. *Good for free brushwork. Letter-spacing is excellent and the layout makes reading still easier.*

# Always endeavor to find some interesting variation

Figure 71. *Not too conducive to reading. The forms are good, but the line-spacing has drawn the lines together into a uniform gray mass. Compare with Figure 75.*

# ROMAN MINUSCULES

Always endeavor to find some interest-ing variation

Figure 72. *A quickly written plume version. Try something like this yourself, varying the layout.*

# ALWAYS endeavor to find some interesting variation

Figure 73. *A variation of Figure 65. All three spacings are good. This style can take considerable reduction and is suitable for reversing, white on black.*

123

# Always endeavor to find some interesting variation.

Figure 74. *Tight letter-spacing and wide word- and line-spacing combine to give perfect readability and an air of refinement.*

# The dignified beauty of Roman minuscules calls for little embellishment. Save the flourishes for Italics and Script.

Figure 75. *Note how easy it is to read this message. It is well worth remembering, too.*

# *"Romanized" Arabic Numerals*

"ROMANIZED" ARABIC NUMERALS need little mention. They are
very simple to adapt to any Roman alphabet you might happen to
use. The accompanying illustration shows two basic sets which
are good examples of "drawn" numbers based on "plume" forms.
Before attempting to draw "new" forms, make yourself some
plume-written sketches and let the tool inspire you.

1 2 3 4 5

6 7 8 9 0

1 2 3 4 5

7 8 9 6 0

Figure 76

# Italic

# Evolution of Italic Lettering

PERHAPS THE MOST comprehensive way of explaining what Italic letters are, is to begin by saying what they are *not*.

In the first place they are *not* Roman letters merely done at a slant like this: *ROMAN*. And secondly, they are not, in the true sense of the word, *cursive*. What is there cursive — that is, running or flowing — in a word that looks like this: *ITALIC?*

True, the term "cursive," as defined in a leading dictionary, seems a little more justified when applied to

## *italic minuscules.*

There is a slight feeling of running or flowing; but the principal characteristic of cursive writing, namely that the letters are *joined together*, is lacking entirely.

Furthermore, to return to our first argument, merely slanting the words

# straight Roman minuscules

would give us

# *slanting Roman minuscules*

which are neither cursive nor Italic.

What, then, are the true characteristics of Italic letters? Italic is a style of letter written or drawn at a slant, having as a basis for the form of its majuscules pure Roman capitals complete with serifs, while the minuscules are the very charming consequence of some quite intricate crossbreeding which resulted in the French terms *bâtard* and the Spanish *bastardilla* being used as names for this style.

What really happened is a very long story but, roughly, the evolution of italic minuscules was this.

128

With the spread of learning in Europe centuries ago came the necessity for more books. Original manuscripts had to be copied by hand and the scribes who made these copies were often hard-pressed for time.

Now to make each of the letters

Figure 77a

one needs to make four strokes of the plume. But when in a great hurry one can simplify these symbols by making them rounder and with only two strokes, like this:

MEW or even
like this:
Figure 77b

ΠΕW
Figure 77c

Similar economies were made with some of the three-stroke letters. Starting off with

ABFGHNR

Figure 77d

it was found that these too could be simplified for speed without departing too radically from their original recognizability. These letters when written quickly and in two strokes looked more or less like this

ΔbFGhΠR

Figure 77e

and our alphabet of "quickhand" was now somewhat like this:

129

# AbCDEFGhIJKL MNOPQRSTUW

Figure 77f

But a tendency to still further round some letters for speed's sake resulted in a pleasant uniformity, but — an increased illegibility. Some letters like **C** and **G, D** and **O, E** and **F, H** and **N, I** and **L** could be mistaken for one another if written too quickly or carelessly.

# CC DO EF hn IL

Figure 77g

So certain characteristics of these letters were exaggerated by the simple expedient of elongation

# CG do Ef hn IL

Figure 77h

and our alphabet now looked more like this:

# abcdefghijkl mnopqrstuw

Figure 77i

With the exception of the **S**, each letter was now formed with two simple strokes and not one of the symbols could readily be mistaken for another.°

° Compare the above letter **R** in Figure 77i with our minuscule **r** of to-day and you can picture for yourself how the final tail eventually atrophied. And here is another peculiar phenomenon about this same letter. The

130

I admit having skipped some steps in the evolution, but repeat that the object of this book is not to make expert paleographers out of its readers, and that this short and rough sketch is merely to arouse the student's interest towards a better knowledge and understanding of FORM and how it came to be influenced by seemingly irrelevant factors.

We are indebted to the Renascence for a return to the classic appreciation of beautiful forms, or, if your prefer it the other way around, the appreciation of the beautiful classic forms. And it is not at all surprising that the Italian scribes of the time appeared to be perfectly satisfied with leaving the Roman majuscules, *when used as capital letters*, exactly as they were. Embellishments were used, but these generally consisted of flourishes which were part of the letter itself, seemingly added to harmonize with the minuscules, which, owing to their quicker writability and readability had definitely come to stay.

But the simplified forms of "quickhand" were far too crude to be worthy companions of such dignified capitals, and the wave of refinement in all other arts influenced these letters as well. The characteristic ascending and descending strokes which had done so much to make reading easier were no longer treated as mere "accents," but were given order, harmonizing proportions and definite functions: and all this within a frame of renascent classical beauty. In order to satisfy the refined taste of the day, these new forms just had to be made to look as though the ancient Romans had designed and executed them.

And the serif, which the scribes had in their writings used rather arbitrarily, was now used with careful discrimination and put wherever it was thought necessary, first for uniformity and beauty, and secondly for alignment's sake.

Now a plume-written serif (unless very carefully done — that is, with the plume turned at an angle unnatural for its easiest manipulation thus calling for "drawing" rather than writing) is not a true aid to perfect alignment. The following will suffice as an example:

French *R* (see chapter on Script) apparently developed from the *second* half of the above simplified **R**. Cover up the straight stroke and you can easily imagine the *h* developing from the remainder.

# plume-written
# plume "drawn"

Figure 78

The "drawn" form took much longer to execute and it is seldom found except in shorter manuscripts where the time taken for its execution was of no great importance.

But, when neatly done, the written form, in spite of its slight irregularity, looked good, even with "formal" Roman capitals, especially when these were also written and not drawn, as was generally the case.

Now, if one studies the plume-written letters carefully, one will find that there is a tendency to neglect the end serifs. Most of the letters start off well with a carefully drawn "spur" (which is a sort of easily made serif, necessitating, however, two extra strokes), but they generally end in a much simpler fashion. Just a plain, not so uninteresting little upward hook.

And it is to this little hook that we are indebted to a very considerable degree for our cursive writing, that is, our ordinary handwriting as we practice it even today.

Not only was this bottom hook very easy to make (in fact, the plume made it practically by itself), but it also looked good — it had a certain dashing quality about it — and, surprisingly enough, it solved a little technical problem that had probably annoyed most scribes. It was a problem, let us call it a drawback, which even hand-letterers of today encounter, namely, a certain difficulty in starting a new stroke. The relatively thick black ink, not unlike our own today's India ink, did not run freely from the plume at the beginning of a stroke, and the plume generally had, and still has, to be coaxed with a little twisting or pressure to let go of its load of ink. Once started, however, the stroke flowed smoothly until the plume was lifted from the paper or parchment. Obviously, if a way could be found to keep the point of the plume on the job, a great saving of time — and annoyance — would result. The little end hooks with their upward trend were the solution to

the problem. At least they supplied, if drawn up high enough, a wet spot at which the following letter in a word could be started without so much twisting or pressing of the plume. What came out by following this technique looked more or less like this:

*plume-written*

Figure 79

Some words could now be written without even lifting the pen at all, and, in any case, a saving of some effort had been accomplished.

The further development came quite naturally and, in the course of time, the scribes did eventually manage to write each of their words in one single uninterrupted stroke.

*plume-written*

Figure 80

Once again for speed's sake, which also accounts for their slant, the letters became rounder still, and some of them even lost a stroke or two in the process.

This was true cursive at last! Within this "modern" development, the majuscules naturally changed their forms as well. They will be discussed more fully at the right time, under Script.

And, I hear you ask, "Where are the Italics?"

Cursive handwriting was "invented" long before Italics and the curious development which led to these very practical letters being *separated again* seems paradoxical to the extreme.

They were separated to cover the needs of that newfangled invention which was to save still more time, the letterpress. Obviously it was, if not impossible, then at least highly impractical to carve every known word to form a little printing block in itself, as would have been necessary if the cursive style of writing had been strictly followed as to design. It must be remembered that the first printed books were obviously made to look like hand-written books; perhaps less with the intention of palming off a

133

"machine-made" substitute than with the desire to make the sub-
stitute as readable and acceptable as a hand-made original. It
could hardly be expected from the first letter-engravers that they
should, or even could, anticipate entirely new "streamlined" forms
designed expressly to do justice to the new technique of book
printing and, above all, type-setting.

In passing, it is interesting to dwell upon the thought that
Gutenberg, the inventor and successful exploiter of movable type,
quite naturally used the manuscript letter forms to which he and
presumably his German customers were most accustomed. The
style of these letters was Gothic, in which practically every let-
ter was written separately, that is, without any attempt to join
the letters in forming words! Had the Germans at that time been
used to writing a perfect cursive style in preference to their neat
but slow Gothic, it would be intriguing to speculate whether our
printed books of today would look quite the same as they do. I am
inclined to doubt it.

Printing, after becoming well established in Germany, now
spread out over Europe, but although it was generally German
printers who went along as technicians, the fashion in the styles of
manuscript lettering, which differed enormously in the various
countries, greatly influenced the typographic picture.

The heavy Gothic style of letter was evidently not liked by, or
perhaps was merely not legible enough to, the Italian, French,
Dutch, Spanish and English bookworms, and so new "national"
type faces had to be designed to please these clients. Naturally,
the most popular local book hands were used as a basis for these
designs and the types cut by several of the new printing establish-
ments were really nothing but carefully carved copies of con-
temporary manuscript letters.

Aldus Manutius, a Venetian printer around 1500, is said to have
designed a type face following some of the more beautiful cursive
hands of the day. The necessary separation of individual letters
brought about some changes in form, the most notable being, of
course, this very separation. The final upward end-hooks could
not be made to connect with the next letter in every combination
of letters; but instead of being discarded entirely (which most of
our functionally-minded modern designers would undoubtedly
have done), they were allowed to remain and form a more or less
ornamental appendix in keeping with the general form of each

individual letter and also with a certain family resemblance within the whole alphabet.

In spite of the various necessary digressions, I trust that I have not confused my reader or led him too far astray from the present subject: *italic minuscules.*

The pattern of this book, namely the discussion in each basic style of majuscules before their minuscules, has been more or less prescribed by our chapters on Roman letters. This pattern is for utility's sake and will be generally adhered to.

But considering the rather astonishing fact that Italic majuscules were invented *after* the minuscules, the necessity for the present deviation will, I hope, be understood. It is of interest to note at this point that the custom for quite some time was to use Roman capitals with Italic minuscules.

Let us at last return to our program and begin the discussion of Italic majuscules.

# *Italic Majuscules*

Obviously the form of Italic capital letters evolved, in the first place, through the attempt to make the Roman capitals acquire some family resemblance to the Italic minuscules.

Slanting them was the first step — a change which immediately brought about not only an alteration in Form, but a remarkable readjustment of the proportions. A glance at Figure 81 will instantly make it clear that we are confronted with a problem of optical illusion.

The word *AIRDROMES* was selected as it contains all the basic strokes necessary to complete an alphabet. The weight chosen is a medium one to give sufficient contrast between the thick and thin strokes.

At a quick glance one is inclined to think that the individual letters in the first line, when compared with those of the normal Roman alphabet, are all considerably narrower in proportion. The difference in the majority of the letters, however, is so slight as to be insignificant; but in the wide letters, **D, O** and **M** (and naturally **C, G** and **Q**), the width is really considerably decreased. These wide letters, measured across, are now only slightly more than ¾.

One cannot draw a slanting circle. The perfectly round plume-written **O** of the Roman alphabet only *appears* to be slanting to the left and it is quite feasible that this optical illusion caused some scribes to draw their letters to correct this asymmetry. Try drawing a circular **O** with the thicknesses of the strokes reversed to obtain that Italic slope to the right — in other words, a left-handedly written **O**. Then add an Italic *M*, and agree with me that the result

$$OM$$

looks extremely awkward. More about the most difficult Italic letter, the *O,* later.

The chief reason, however, for the narrowing of the wide letters is connected with another remarkable optical illusion. Examine Figure 81 again and you will notice that the slope of the "vertical" strokes tends to make the letters appear taller. The more inclined

# *AIRDROMES*
# *AIRDROMES*
# *AIRDROMES*
# *AIRDROMES*
# *AIRDROMES*
# *AIRDROMES*
# *AIRDROMES*

Figure 81. *The effect of slant on Italic majuscules.*

the slant, the taller the letters appear to be. Of course the strokes really *are* longer but the height between the guide lines is exactly the same. This optical narrowing of the wider letters had to be carried through, physically so to say, in order to obtain a reasonably satisfying family resemblance.

When drawing this page of *AIRDROMES* no particular attention was paid to mathematical exactness, except that the inclina-

137

tion of the sloping guide lines (for the verticals) was increased in ratio. Each line of letters was drawn with optically the same amount of letter-spacing. The rather surprising result that the more slanting letters make longer lines was quite unintentional, particularly in view of the fact that the letters *have not gained in width*. This gives us an important rule worth remembering:

> Italics, while gaining *optically* in height, *optically* lose in width, but *actually* need greater length of line to provide for spacing.

From the foregoing, it might logically be concluded that a canon of standard proportions for Italics is an impossibility. It *is* an impossibility, especially if it is desired to establish an ideal standard. Esthetic values and personal taste cannot be made to fit into a single rigid formula.

Realizing, however, the beginner's need for a tangible norm, I have prepared one on the same order as the one for Roman capitals, Figure 29, page 43. To be perfect it would have to be far more complicated, which would make it undesirable as a learning-aid. Its aim is to help the beginner to remember a certain basic relationship of proportion between the individual letters, one to another. Study this norm on the facing page.

Note that the grouping into three widths, wide, medium and narrow, remains practically unchanged, but that the widths of the first two groups have become narrower than Roman. Note also that **K** and **P** (⅝ letters in Roman) have now joined the narrow group, which is identical with the Roman, namely ½ of height.

Generally speaking, Italic letters create the impression of being much narrower than Roman, but it must always be remembered that this is due to the aforementioned optical illusion caused by the slant of the verticals. *Never exaggerate this slimness unduly without thinking beforehand what the slant will do to the form.*

This is particularly well demonstrated in Figure 81. Compare the individual letters in their vertical rows and notice, in spite of identical proportions and height, the amazing change in FORM. The adjective "amazing" may seem to you a little far-fetched, but take a piece of tracing paper and draw only the outlines of the seven **O**'s as they stand. This will convince you.

The forms of Italic capitals are not easy to master, but I believe that the following mechanical explanation will be very useful to

**3/4** C D G

O M Q 75°

**5/8** A H T N

U V X Y Z

**1/2** J K P B R L

E S · I J W W

Figure 82. PROPORTION CHART, *Italic majuscules. This is merely an aid for beginners to memorize the relationship between wide and narrow letters. See opposite page.*

students whose feeling for FORM needs a little help.

Imagine the three simplest letters, **T, H** and **E**, made of stiff black cardboard strips, pivoted together where the strokes join. These letters are then pivoted onto two white horizontal strips to represent the guide lines. Like this:

Figure 83a

Now push the bottom guide line to the left and you will have Italics, like this,

Figure 83b

which of course is very simple.

When it comes to letters with "diagonal" strokes, however, my more mechanically-minded readers will immediately smile and say, "It won't work."

They are right, because the following contraption

Figure 84a

would never budge.

140

But we can certainly make good use of the theory. By using the pivot holes in the guide lines and putting in the others where they would theoretically stand — if the thing worked — we would get our angle points just the same. Like this:

Figure 84b

Joining these points is a simple matter, and the result is correct.

Figure 84c

Of course you will have noticed that the diagonal strokes have become longer or shorter, as the case may be, but this is something you need never worry about. If the pivots are in the right place, the length of stroke adjusts itself automatically and will always look right.

Now for the curved letters. They are not quite so simple but the theory remains the same. Three letters will suffice, and although the diagram looks complicated the principle is the same simple one and worth studying:

Figure 85a

141

Pushed into Italic formation we get this:

Figure 85b

And to complete the theory let us make a finished drawing using as a guide the pivot centers in the last illustration.

Figure 85c

I have gone to some length to demonstrate this "practical" theory because I have found that most beginners make the same mistakes when doing Italic capitals.

Here are samples of the most usual errors:

*VARYING*
*SLANTS*

Figure 86a. *Try to discover the mistakes in the slope of various letters and compare with Figure 86b.*

The only correct letters in Figure 86a are **I, N, L, N** and **T,** in spite of the fact that all letters are more or less well-formed. The **V** leans too much to the right, as do the **G** and both **S**'s, the second

142

more than the first. Both **A**'s, and the loop of the **R**, do not slant enough and one might even say, compared with the angle formed by the **I**, they are sloping to the left. Which leaves the **Y**, whose lower half is correct, but whose upper half seems to fall to the right. By referring back to Figure 84c you will see how these errors happened.

In Italics, the form of all letters is governed primarily by the slope of the verticals, and it might be advisable and certainly more easily understandable if we were to take the liberty of calling this line of direction the "sloping vertical." Let us do that to make further discussions clearer.

Naturally all vertical strokes have to be parallel, but the plumb-line centers of such letters as **A, C, G, M, O, Q, S, V, W, X, Y** and **Z** have to be, too — parallel to the "sloping vertical."

I admit that the second example (Figure 86b) might be regarded as stiffly and too formally exact. But the student may rest assured that I am not advocating mechanical precision as an ideal. Far from it. Hand-lettering should be allowed every degree of artistic freedom — but only after its basic principles have been mastered with discipline and respect, as well as with understanding and feeling.

*VARYING SLANTS*

Figure 86b. *The various mistakes in Figure 86a have been corrected. Compare with your own criticism.*

The next most usual errors are to be found in the round letters; the six following contain them all:

*DDOOSS*

Figure 87

Although pretty obvious, all the errors may not stand out sufficiently to be detected by the uninitiated, so here is the list:

1st **D.** The curved stroke starts too near the straight one. A perfect **D** needs a short stretch of straight horizontal.

2nd **D.** The horizontals are too long, or, the curve starts too late and ends too early. The straight line inside the curve gives the stroke an optical bulge in the wrong direction.

1st **O.** A bad case of a too "sloping vertical," but also an example of too well-meant symmetry. The right side is a tracing of the left, and in an alphabet of narrow Roman capitals, this letter, with its axis set upright, would be perfect.

2nd **O.** The "sloping vertical" is correct, but once again both sides are symmetrical to the axis, a bad practice in Italics as a comparison with the illustration below will show.

1st **S.** Main stroke starts too early and ends too late and is furthermore too straight. Compare with the **S** below.

2nd **S.** Main stroke is too short — in its thicker part — to harmonize with any neighboring letter. The thin curves at top and bottom lack the certain flatness so useful for alignment. Compare with the **S** below.

In examining the accompanying figure

*DOS*

Figure 85d

144

— which is a good example of drawn letters — note that a fine white line has been left on the curves of the **D** and **O**. One might call them the "bones" of the curves. They are really remnants of the pencil guide lines which were used to fix the "sloping vertical." Notice how they help to optically balance the two sides of the **O**, and that their beginnings and endings coincide horizontally. It is a great help to really draw these lines in ink when making a finished drawing of Italic majuscules, but care should be taken that the curved lines which are inked later should entirely cover these "bones" and not leave any part showing as in the 2nd **D** of Figure 87.

So far we have dealt only with drawn Italic majuscules, as I have found that this method of execution is generally preferred both by beginning students and the great majority of clients. But the art of wielding the plume should not be neglected.

In the four following examples, the same procedure was followed throughout:

1. A thin skeleton layout was made in pencil, using half a page of this book as space.

2. The horizontal guide lines were drawn.

3. The "sloping vertical" guide lines were pencilled in, using the adjustable T square.

4. After choosing a plume of the right width, the lettering was written without any further preliminaries, and left the way it "came out of the plume."

## *USE YOUR PLUME TO LEARN FORM*

Figure 88a. *A plume-written sketch. See Figure 88b, page 148, for a more finished rendering.*

# ENDEAVOR TO WRITE QUICKLY

Figure 89a. *By doing as this example directs, your hand will gain dexterity. See Figure 89b, page 148.*

# TURN THE BOARD SO THAT YOUR "SLOPING VERTICAL" IS CONVEN-IENT TO YOUR "HAND"

Figure 90a. *Another quickly written sketch. For a more careful finish, see Figure 90b, page 149.*

# EXPERIMENT WITH VARIOUS THICKNESSES & SLOPES

Figure 91a. *A plume-written sketch. Compare with Figure 91b, page 149.*

It will be seen that these examples, in spite of having a slightly wobbly line here and there, are already quite acceptable when criticized with the aid of the Formula. A little careful retouching and they could almost be used as finished drawings thus taking care of EXECUTION as well. I generally use quite cheap cartridge paper for quick sketches of this kind, which accounts for the roughness of some of the strokes.

But the FORM is there and that is what matters. Allowing the plume to do its own forming, finding the right angle at which to hold one's plume and endeavoring to write more quickly after the first few painful experiments — these three simple rules and lots of practice will soon convince you how easy it is.

Now for another way of doing it. With the four examples as a basis for layout, we can use other techniques to make carefully drawn "finishes." All four were treated in different manners and the results speak for themselves. It is worth while comparing the original roughs with the finished jobs, as these second versions were done by a student of mine, with a quite short experience in hand-lettering. Sketches and finishes follow the same order.

147

*U*SE YOUR
PLUME TO
LEARN FORM

Figure 88b. *One of many possible variations done after 88a.*

*ENDEAVOR
TO WRITE
QUICKLY*

Figure 89b. *Although not appropriate to the message, this carefully drawn finish is an interesting study. See rough, Figure 89a, page 146.*

# TURN THE BOARD SO THAT YOUR "SLOPING VERTICAL" IS CONVEN- IENT TO YOUR "HAND"

Figure 90b. *Note, when you compare this with the rough, Figure 90a, that the thickening here of the thin strokes has added color.*

# EXPERIMENT WITH VARIOUS THICKNESSES & SLOPES

Figure 91b. *A pen-drawn finish using Figure 91a, page 147, as layout. Note treatment of serifs.*

# *ITALIC CAPITALS ARE NOT TO BE RECOMMENDED FOR LONG TEXTS*

Figure 92. *Another precept worth remembering.*

For shorter pieces of lettering of not more than two or three brief lines, the so-called "swash" capitals, with their exaggerated curved strokes, can be used with delightful results. Naturally,

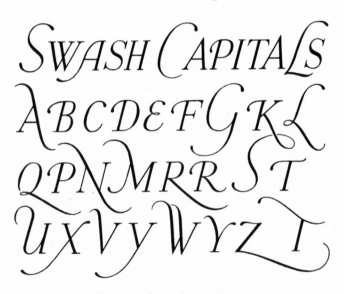

Figure 93. *Suggestions for Italic swash capitals.*

careful discretion should be observed not to overdo this style of ornamentation, and it is advisable to make a few "rough" sketches of various layouts before being satisfied with one's first effort. There's always a better way. It is seldom good to incorporate a flourish wherever one is possible, and often enough it turns out to be impossible to add one where you can use it to best advantage, be it to balance an arrangement or to add to its symmetry. The simplest way to lay out a job of this kind is to draw your words in skeleton outline, using simple Italic forms and proportions, leaving plenty of space all around and then finally adding your flourishes where they appear best.

As an interesting test of your skill, try writing the words

*THE GREATEST*
*WOMEN IN HISTORY*

as simply or as intricately flourished as you think will look good. You will be astonished at the dozens of sketches you can turn out, and perhaps find it quite difficult to make a choice. And don't forget the possibility of doing it in 1, 2, 3, 4 or 5 lines, as well as the so much simpler and yet more masterly way with a suitable plume.

Laying out a piece of lettering solely in Italic majuscules needs a little more judgment and consideration of the space at your disposal. It will be found that the "sloping vertical" may cause you some trouble, its tendency being to become straighter or more slanting as you proceed to sketch in your skeleton layout; you may also find that your lines are too short or too long; and, finally, you may have difficulty in centering your lines or, if you are making a "block" of lettering, in getting the lines to begin and end optically vertically under one another.

Quick sketching will always enable you to get the best results, and, for the first trials, merely endeavor to get all your letters in, remembering that:

Italics, while gaining *optically* in height, *optically* lose in width, but *actually* need greater length of line to provide for spacing.

So, to be on the safe side, do not let your "sloping vertical" slope too much until you are pretty sure that the length of line will work out satisfactorily, and, above all, allow yourself more line-spacing than you would for Roman majuscules. The "sloping vertical"

151

guide lines (which are the *third* step ° ) will take care of the parallelism, but when making a block it is advisable to pencil in your left and right margins. Otherwise the slope of the first line will have the tendency to make you start your second a little too much to the left.

Now draw your horizontal guide lines after making a paper measure as described on page 51, Figure 34, adjust your T square to the slope you want and draw "sloping vertical" guide lines to cover the area of lettering. Make them as faint as you can, spaced about the width of an **O.** You can space them closer together or wider apart if you prefer; but I have found this width the quickest to make and the most serviceable. In any case it is a great help in getting letters in the same width category more or less equal. (Leave your adjusted T square fixed.)

Your drawing should now look something like this:

Figure 94

° The practice of drawing the "sloping vertical" guide lines before starting the layout tends to be very confusing and certainly detracts from a general visualization of the whole.

And there is nothing else to be done but to finish the job in which-
ever technique you prefer.

But let me describe a method which I generally apply when
rushed for time on a job which must be reasonably well done but
not too expensive. To save space, and to give a larger illustration
showing more detail, I have picked out the word *CAPITALS* as
the example.

Your skeleton layout is ready as in Figure 94 above.

Figure 95a

Draw in the letters carefully in pencil, making sure that the
letter-spacing is right.

Figure 95b

Now turn your drawing board so that the final vertical stroke
of the last letter (in this case the **L**) is horizontal to your line of
vision and at the top, apply the T square (which is still adjusted)
at the top of the board (which is now at your left hand) and ink
in all the parallel verticals. Also, while you are at it, put in the
"bones" of the curves and the thin lines of the vertical serifs on
the **T**'s, **E**'s, **C**'s, **S**'s, etc., which might happen to cross your path.
Use a thin, flexible or hard pen-point, whichever you prefer,
and draw the thick strokes with two parallel lines, leaving them

Figure 95c

153

to be filled in later. These "outlined" heavy strokes will serve as a very handy guide to get the right thickness of the curves when you come to them.

With the shorter handier ruler, ink in all thick strokes of the diagonals of the A's, N's, M's, W's, etc., and then turn your board again at a convenient angle to do the thin ones. (Figure 95c.)

Figure 95d

Ink the curves, freehand of course, checking the thickness of the thickest part with the neighboring vertical, and completely hiding the "bone."

Adjust your T square back to a right angle to ink in all horizontals as in T, E, F, H, A, L, etc., and, at the same time, all the horizontal serifs. Complete your outlined job now by putting in the little curves on all the serifs, and the job is ready for filling-in. (At this point it is advisable to erase all your pencil lines. You may have to wait several hours before erasing over thick filled-in strokes.)

The result will be, I repeat, a reasonably well done, neat and clean job, perhaps a little too exact to have any artistic pretensions but nevertheless quite usable for everyday purposes.

In spite of already having stated that Italic capitals are not to be recommended for long texts, I should like to remind the reader that the highly decorative value of Italic majuscules should definitely be taken into account for certain types of work where beauty is the first consideration and where quick readability may be sacrificed to this end.

## FURTHER COMPARISONS OF ITALIC MAJUSCULES

The following examples will, I hope, serve as inspiration. A careful study of the eight specimens is rewarding. A most interesting way of doing this is to compare the details of the same letter in each example. This comparison will particularly impress upon you the significance of the term "bastard." Some of these examples show many curious and some seemingly illogical combinations and yet it will be seen that the serif is apparently indispensable. As a general rule it is. The absence of serifs in some alphabets of Italics robs them of all their charm and grace.

But the mixture of elements exemplified by several of these examples is the most fascinating characteristic of Italic majuscules. The very fact of their being single letters as opposed to Script, from which they have inherited their slant, flourishes and cursiveness, gives them a versatility of their own. They can be letter-spaced more easily, and an occasional flourish here or there can help to fill a gap, balance a word or embellish a whole inscription. This embellishment can go very far, can even be overdone. Therefore as a general rule it is advisable to keep flourishes on the simple side and save the more florid ornamentation for Script. As in most decoration, good taste will tell you the extent to which you can go. Even a single Italic initial with nothing but its own "natural" flourishes will often greatly enhance and "personalize" many a piece of otherwise uninteresting lettering.

# AIRDROMES

**AIRDROMES**

AIRDROMES

**AIRDROMES**

AIRDROMES

AIRDROMES

AIRDROMES

AIRDROMES

Figure 96. *Some useful variations of Italic majuscules.*

ALWAYS
ENDEAVOR
TO FIND SOME
INTERESTING
VARIATION

Figure 97. *Simple decorative treatment of serifs on thin strokes.*

ALWAYS
ENDEAVOR
TO FIND
SOME
INTERESTING
VARIATION

Figure 98. *Wider letters make the tight line-spacing possible.*

157

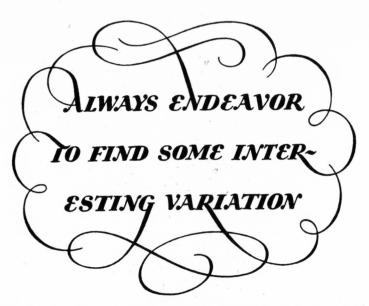

**Figure 99.** *A few swash capitals lend their tails to form a simple decorative border. Note that only one flourish has been added.*

ALWAYS EN-
DEAVOR TO
FIND SOME
INTERESTING
VARIATION

**Figure 100.** *Widened letter-spacing is sometimes in place, especially when fanciful letter forms are used.*

158

*Always Endeavor To Find Some Interesting Variation*

Figure 101. *Pleasant readability, the result of careful layout and word-spacing. Would a heavier weight have looked better?*

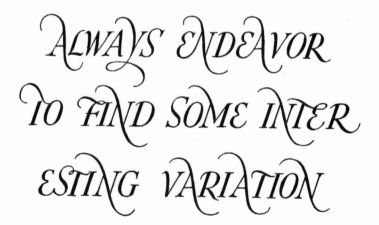

Figure 102. *Playful treatment with swash capitals. This would look better in a single line, for instance on the rim of a bowl or plate.*

*Always Endeavor to Find Some Interesting Variation*

Figure 103. *A simple but well-balanced layout. All the spacing is excellent and the treatment of many letters is worth studying.*

Figure 104. *An obviously carefully drawn study. The forms of the initial* **A** *and the* **G** *show the influence of the plume.*

# *Italic Minuscules*

AGAIN THE STUDY AND RENDERING of Italic minuscules becomes our main concern. A glance at the three examples on these two pages will immediately make clear that this style of lettering has an extremely wide versatility of its own, even without taking into account the decorative possibilities of swash capitals.

These three styles of Italic minuscules may be considered as basic. Innumerable variations can be discovered, where sometimes it might appear that the breeds have been mixed, but an analysis of the rendering will immediately disclose which basic style has been used. Remember that the true Italic minuscules were based on cursive hands, that is, Script; and that Roman minuscules merely drawn at a slant are not Italics.

*Compare and memorize the various big differences, as well as certain similarities in these three examples of "standard" italics.*
*vw & jqky*

Figure 105a

*Compare and memorize the various big differences, as well as certain similarities in these three examples of "standard" italics.*

*& jkyq*

Figure 105b

*Compare and memorize the various big differences, as well as certain similarities in these three examples of "standard" italics.*

*g & jqkyy*

Figure 105c

Here is a concise analysis of the three different styles. The three headings were drawn to give them a more finished appearance and to emphasize the certain similarity with regards to weight, layout, etc. If the first two had been written, as they could have been, the influence of the tool would be more apparent, but there would be such a great difference in character that almost every observer would be inclined to choose one style and ignore the other two. A quick opinion is often good and necessary; but in this case a carefully weighed decision (if one has to be made) is of greater value to the student. A wider plume, a more flexible pen and a much heavier weight in the third example would bring about such drastic changes in the final results that most similarities would vanish.

### IMPORTANT NOTE

Whichever basic style is used, the greatest care should be exercised in getting the bends right — that is, the curves where the thick strokes taper off into the thin ones.

These *must* be uniform throughout any piece of lettering. (See Figures 105a, b, c.)

## The influence of the tool and its angle

Figure 106a

The basic stroke here is made with a plume held at an angle convenient for quick writing. This stroke, as in the t, comes out like this:

Its thickest part is right in the bend. *This is most important.* (See note at bottom of 1st column.) All other strokes (including the curved ones) and also the starting hooks on **b, d, h, i, n, r,** etc., follow this same pattern. For the crossing of the t and f, the angle of the plume is slightly changed. The board is best held fairly straight. No pressure is exerted on the plume so that it does its own shaping.

164

*The
influence
of the
tool and
its angle*

Figure 106b

*The
influence
of the
tool and
its angle*

Figure 106c

Here the basic stroke is pen written. A soft flexible crow-quill nib, *used with pressure,* renders the t stroke like this:

This lettering is obviously drawn and is supposed to be. All the serifs are horizontal and within the guide lines.

Here the down-stroke should be as even as possible, tapering off quickly, but not suddenly, before the upward end-hook. The tapering can be more gradual on the descenders, as in g, f, j, etc. The round strokes are made by starting off thin, increasing the pressure towards the middle and relinquishing towards the end, thus tapering off more slowly. Turn the board to facilitate the easier execution of the long straight strokes. *Remember that the bends taper off rather quickly* (See note, page 164.)

These serifs (except for t) are drawn only at the *beginning* of straight strokes and should extend only to the left; which automatically leaves a and q without them. On the descenders of p and q and the second stroke of u are ending serifs. On the first two letters they extend to right and left. The inner line on the curved stroke is almost straight with a tiny curve added at the bends to prevent a sharp angle from forming. In exceptional cases this angle is sometimes left to give a very sharp-cut engraved effect. (See Figure 107a-c.)

**165**

Now, for final comparison, let us once more examine the following four letters which contain both straight and curved strokes as well as serifs:

*d d d d*

Figure 107a

Thickening them will considerably emphasize their characteristics:

*d d d d*

Figure 107b

Widening will again produce another effect:

*d d d d*

Figure 107c

The weight of Italic minuscules can vary just as much as in any other style of lettering, but as a rule it is safer to keep these elegant letters on the thinner side. The beauties of form in the various examples at the end of this chapter would be minimized by thickening the thick strokes. On the other hand, overslender thick strokes having little contrast with the thin ones tend to give Italics a weak and anemic appearance. In cases where very thin Italics seem to be the only solution, I suggest using very pronounced serifs.

The laying-out of Italics, whether all majuscules, all minuscules or mixed, should in general follow the routines described on pages 46 to 53 for Roman capitals, and on pages 113 to 118 for Roman minuscules. Summarizing these to essentials we have:

166

# ITALIC MINUSCULES

1. Make layout in skeleton outline (faintly of course) to find SIZE in relation to area.

2. Add flourishes, also sketchily, where appropriate and in keeping with style chosen.

3. Make adjustments to avoid disturbing collisions of ascenders and descenders.

4. Draw horizontal guide lines with the help of a paper line-gauge (see pages 51 and 116).

5. *Now* put in (very faintly) your "sloping verticals" with the help of your adjustable T square.

6. Proceed with a careful, detailed pencil drawing.

7. Finish in whatever technique you prefer, remembering the uniformity of the bends (see note on page 164).

*Always endeavor
to find some
interesting
variation*

Figure 108. *A drawn example. The letter forms, however, are unmistakably plume-written. Note uniformity of bends.*

*Always
endeavor
to find some
interesting
variation*

Figure 109. *A charming example of pleasantly round, very readable, Italic minuscules. This tight line-spacing, however, can cause collisions between ascenders and descenders.*

*always endeavor to find some interesting variation*

Figure 110. *Although somewhat stiff, the compactness of the layout and the crisp sharpness of the lettering have a certain appeal.*

**Always endeavor to find some interesting variation.**

Figure 111. *This was based on a quick plume-written sketch. Compare it in color with Figure 119, page 173.*

169

*Always endeavor to find some inter-esting variation*

Figure 112. A rather uninteresting effort in plain, straightforward Italic minuscules. The line-spacing had to be wide to avoid collisions in descenders and ascenders.

*Always endeavor to find some interesting variation*

Figure 113. The influence of the pen is strikingly apparent. This was based on a small pen-written sketch, with some irregularities exaggerated for effect.

*Always endeavor to find some interesting variation*

Figure 114. *The plume's influence again. The sketch was written, and the finish drawn. Criticize the layout for practice.*

*Always endeavor to find some interesting variation*

Figure 115. *Although not pure Italic throughout, the general effect remains harmonious.*

*Always endeavor to find some interesting variation*

Figure 116. *A quick, plume-written sketch, with something Gothic in the tightness of its spacing.*

*Always endeavor to find some interest- ing variation*

Figure 117. *Note the openness of many letters which, together with generous letter-, word-, and line-spacing, give this pen-drawn example its free and easy airiness.*

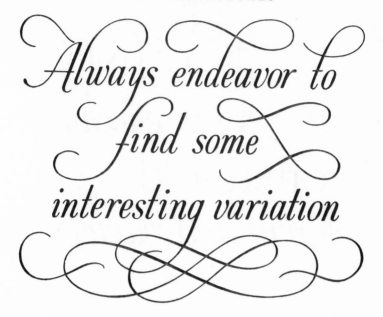

Figure 118. *Drawn Italic lettering, making use of Script flourishes as suitable decoration.*

# ALWAYS
# endeavor to find some interesting variation

Figure 119. *Straightforward, but unimaginative, heavy Italic minuscules useful for many purposes.*

173

# ITALICIZING
# *while giving emphasis*
# often adds
# *charm and variety*

Figure 120

# *Italicizing* while giving emphasis, *often adds* charm and variety

Figure 121. *This and Figure 120 are shown as reminders that Italics can successfully be used in combination with Roman minuscules.*

Gothic

# *Gothic*

Aʟᴛʜᴏᴜɢʜ ɢᴏᴛʜɪᴄ characters have a Germanic origin, as national an origin as Greek, Hebrew, Russian and many of the Slav languages, it is remarkable that the majority of the letters used are, in their structure, very similar to Roman. On the other hand, some of the letters, both majuscule and minuscule, and especially some of the combinations of two and even three of the latter, are practically illegible to a person accustomed to reading only Roman characters. So it is conceivable that an English or Spanish speaking student might encounter great difficulties in reading, for the first time, a page typeset in Gothic, yet he might find it very simple to read the same page if it were typeset in Roman.

A great deal could be said about some of these "illegible" characters and their relative necessity in the German language, but as they are never used for any other than purely German texts they need not be discussed here.

The Gothic styles of lettering — and there are many! — have a number of most desirable qualities among which are: beauty, decorativeness, preciseness, color, expressiveness, etc.; therefore, a textbook on lettering would not deserve the name if they were excluded. The appropriateness of Gothic is obviously a matter of taste. Its venerable dignity, however, is beyond all question and there are often cases where no other style of lettering could be more appropriate.

Except in cases where legibility is of no importance, Gothic majuscules should not be used exclusively to form words. The following word, for instance, while being undoubtedly very nice to look at, is

Figure 122

It is safer to revert to Roman capitals, if capitals must be used, as they can often be adapted to harmonize with Gothic characters.

# GOTHIC

Gothic characters, both majuscule and minuscule, are all based on plume-formed strokes. The plume forms the strokes almost mechanically while the hand sets the style.

## GOTHIC MAJUSCULES

Let us examine how the tool and the hand cooperate in creating two distinct styles. The German usage of capitalizing all nouns has had a remarkable influence in this respect. Most styles of Gothic minuscules have a definite angularity, or one might also call it uniform straightness. Naturally a whole page or any large mass of such lettering will look anything from beautifully precise to boringly monotonous according to individual taste and mood. Such individual tastes or preferences among the old scribes may have brought up two schools of thought in the handling of the many capital letters which, through their frequency, were often strewn all over the page: One could either carry the exact precision to the limit by designing majuscules to blend in with the minuscules, or design them to contrast in such a way as to enliven the page and thus relieve the monotony.

Both methods were used with equally satisfactory results. On the one hand, angular straight-limbed majuscules appeared, while, on the other, rounder shapes were developed. In both cases the same plume which formed the minuscules was used. The greater contrast achieved in the latter instance, however, seems to have brought about another curious development. Rounder shapes are apt to run much wider and these wider letters would create big white holes in an otherwise uniformly "gray" page. So the scribes, unless they filled these spaces with other colored decoration, embellished their capitals with additional strokes to give them the necessary weight or color. This accounts for the sometimes strange complicatedness of many of the letters.

For double comparison, the following two alphabets should be examined not only as a whole, but letter by letter:

# ABCDEF
# GHIJKM
# LNOPQR
# STUVW+
# XYZZ

Figure 123

This "straight" alphabet, with its variation on the opposite page, can be used as a basis for innumerable further variations. The distribution and number of capitals in any given text will, as a rule,

Figure 124

be the safest guide in deciding which to use.

The possibilities of elaborating on the "round" Gothic majuscules shown next is immediately apparent.

ABCDEF
GHIJKM
LNOPQ·
RSTUV
WXY3

Figure 125

The mixture of straight and round strokes lends itself to still more varieties, in which even the straight strokes can often be made into single or double curves.

The seeming complicatedness of Gothic majuscules shouldn't

Figure 126

deter the student from trying to do them. They are not as com-plicated as they seem, and once you have acquired the *simple* knack of wielding the plume you will be surprised at the ease with which they *form themselves*.

# ABCDEF

# GHIJKM

# LNOPQS

# RTUVW ?

# XYZ

Figure 127

The five alphabets of majuscules shown have all been drawn (to give them a greater degree of finish), but the most casual glance will convince you that the basic forms are plume- *written*. A most rewarding and satisfying exercise for every student will be to re-write these alphabets with a suitable plume. His object should be not to slavishly try to copy them but to follow the direction of the

184

basic strokes, leaving his plume to do the forming.

The results will naturally never look like the originals but there is the encouraging possibility that some of them will look even better. The width of the plume, the angle at which it is held, and the different ways of rendering the curved strokes will all have a very distinct bearing on the finished letter. Even the speed at which the letters are done will influence their form.

## GOTHIC MINUSCULES

The true character of any piece of Gothic lettering, however, will be found in its minuscules. In fact, when laying out any kind of job in Gothic, I nearly always make it a point to decide upon the style to be used for the main message and often completely finish, in ink, this part of the lettering before tackling the initials and decoration. The treatment of the first initial, as well as any other capitals which may occur within the text, can be decided upon with greater ease and freedom if the text already stands as an accomplished fact. It goes without saying that a certain amount of preliminary arrangement is necessary to leave the space to be assigned to such capitals, but a very faintly sketched-in outline or silhouette of such letters is all that is needed. They can always be elaborated later.

There are then two basic courses to follow: Either the initials should be blended into the whole picture or they can be made to contrast very strongly with the rest of the text.

The results of the latter course can be strikingly beautiful if the distribution of such initials immediately forms a pattern interesting *at the first glance*. In contrast, and as an extreme example of bad layout, it is seldom wise to place a number of decorated or even heavily rendered initials too close to one another, especially directly under one another vertically as might happen if the first letter of each line were a capital.

I prefer, as a general rule, to make the majuscules in keeping with the style used for the minuscules. Not only does this give a piece of work a feeling of unity in design, often stressing some outstanding quality of the minuscules, but it also avoids an unpleasant feeling of haphazardness. This will often be found in cheap examples of commercially made diplomas, certificates, presentation documents and the like, where the initials almost seem to have been cut out of somewhere and pasted in place with-

out the slightest regard for their suitability, let alone harmony with the smaller letters which follow.

Although I have found it necessary to give a few complete basic alphabets of Gothic majuscules, so that the student may quickly visualize the fundamental forms and strokes, I do not intend to give such copy-book versions of the minuscules. A careful study of what can be done with a plume will probably prove far more valuable to the student wishing to find his own style.

You cannot help men permanently by doing for them what they could and should do for themselves  Lincoln

Figure 128

In the first place, the basic structure of Gothic minuscules remains the same as it does in Roman, Script, Italic, etc. A few letters can be varied such as

# ɑɑ, ɣɣ, ᴢ ᴣ

but an **o** or an **m** will always retain the same basic structure whether the strokes are made straight or curved. Just how to vary these basic strokes to give an alphabet a different character is the object of our next study.

Unless the plume is held at an unnatural and generally uncomfortable angle, it will be found that the straight down-strokes will always be narrower than the plume itself. It is quite important to remember this in order to be able to appreciate and remember the necessity of turning the hand in some styles of Gothic.

Gothic minuscules (with the usual exceptions: **f, i, j, l, m** and **w**) all have about the same width within any normal alphabet. Compared with Roman minuscules, this uniformity immediately becomes apparent.

# apparent variation

# no apparent variation

The advantages and disadvantages of this uniform width are worth noting. For layout purposes it would seem that characters of equal width should simplify their arrangement with regard to spacing and, as far as letter-spacing goes, this is true. There is no necessity to worry about giving more air between straight characters and less between round ones. The distances will always be the same and a well-spaced word unit will be the result. The difficulty arises when the layout calls for lines of equal length. (See Figure 128.) Gothic minuscules then show up their inflexibility. For example, in the above Roman line, "apparent variation," much could be done to change its length. By narrowing the two **p**'s, **e, o** and even the two **r**'s, this line could be squeezed together con-

siderably without harming its basic style. It could also be length-
ened by using slightly wider a's and t's; and slightly wider letter-
spacing to arrive at a still longer line would not be disturbing
within a larger block of several lines.

Whatever modifications were made to this Roman line, they
could be done without changing the color of the page at that
particular spot. Gothic minuscules, however, are peculiarly sensi-
tive to such changes in color and the only way to lengthen the
Gothic line, "no apparent variation," would be to resort to both
widening *all* the letters in themselves *and all* the letter-spacing in
the whole line. Shortening the line would naturally call for nar-
rowing both the letters and the letter-spacing. Yet even this meth-
od of widening or narrowing, can be done only to a very limited
degree. The stroke-thickness — which should not be changed
within a given piece of lettering — together with the spaces with-
in and between the letters, give the line its color. Too great a con-
trast between a line of narrow letters and a line of wide letters is
immediately apparent and can often ruin an otherwise perfect job.
Important to remember, too, is the fact that word-spacing in
Gothic is always kept much narrower than in Roman. The usual
density or blackness of this lettering calls for it, as wide word-
spacing would give very disturbing white gaps.

Therefore, the safest thing to do if a line of Gothic minuscules
cannot easily be adjusted to fit a certain length is to leave its length
the way it is and rearrange the layout accordingly or, of course,
divide the word between syllables.

The practice of using line-fillers is not to be recommended. In
my opinion they almost invariably look like subterfuges which,
with a little more forethought during the preliminary laying-out,
might have been avoided. I do not mean by this that line-fillers are
entirely taboo: their decorative use can enhance a diploma or
similar page, but their perfect distribution is then extremely im-
portant and should be thought of beforehand to avoid any dis-
turbing masses of superfluous decoration down the right-hand
side of the page. The same can be said of too many hyphens down
the right-hand edge of a block of lettering, such as occur when
many words are syllabicated. They can have a very unpleasant
effect, just as they often do on a page of type.

The possibilities of varying the FORM of Gothic minuscules are
many. With the exception of the very heavy renderings (where

the weight influences the form), it will be seen that practically all Gothic minuscules tend to be narrower than their height. This is mainly because there are no truly round letters in any Gothic alphabet. No matter how curved the two basic lines of a small o may be, you will always find a definite straightness at the beginning of the first and at the end of the second stroke. The tendency of the hand seems to be to make at least a part of every letter run parallel with all the rest of the strokes, in a straight downward motion. (See Figure 129, a to g.) There is definitely nothing *cursive* about this style of lettering.

But even with these limitations — that is, equal letter-widths and lack of roundness — a great deal more can be done to vary the character of these minuscules than in any other style of lettering.

The most obvious variations of any style are of course the making of the letters wider or narrower, thicker or thinner, and rounder or straighter. In Gothic, however, the plume can be made to do all kinds of additional tricks to still further add character and variety.

In no other style of letter is the word "structure" as meaningful as in Gothic. The moment you start to form a Gothic letter with a plume you will feel that you are constructing it rather than writing it. Every stroke is purposeful and seems to have a definite finality of its own. And it is one of the most important characteristics of Gothic, that the short strokes with which most of the long vertical main strokes are started and finished are the ones which give any particular alphabet its individuality and character. They are part of its structure.

It would be misleading to call these short strokes serifs, because they are not truly designed to finish off the main strokes as in Roman or Italic, which styles would still retain their character without serifs.

As far as I know there seems to be no particular name for these strokes, so, rather than coin new words, let us use the two short words *leads* and *ends* and leave them italicized wherever they mean these particular strokes. By this designation, the *leads* lead into the main strokes at the top while the *ends* terminate them at the bottom. Thus an e has no *lead* and a prolongated *end*, while the r has a short *lead*, and an *end* which can be either short or long. As you read further this will immediately become clearer.

With our terminology settled, let us now examine the accom-

panying examples, Figure 129, a to g. The words "stroke endings" were chosen as containing the best letters to illustrate the most usual varieties of *leads* and *ends*. They have been rather mechanically drawn to demonstrate that the vertical main strokes in all seven examples are exactly the same as regards thickness and spacing. *For practice, a wide plume should be used.*

**stroke endings**

Figure 129a

The letter **i** shows that the *lead*, main stroke and *end* have all been done together — that is, without lifting the plume after each stroke. In other words, the zig-zag line is uninterrupted. All the letters in this line have been done in this way; wherever a *lead* or *end* is used it is really a unity with the main stroke.

**stroke endings**

Figure 129b

The *lead* and *end* of the **i** show plainly that exactly the same strokes have been used as before, but that an interruption has occurred. The *lead* was stopped, the main stroke was restarted a little to the left, and the *end* also placed to the left. Three distinct strokes were used, resulting in the little spurs which now protrude from the main stroke. Some letters have hardly changed, but it is important to note at this point that the first *leads* of **r, n, m** and **p** should not protrude to the right so far as to complicate the joining-up with the next *lead*. (Note the apparent difference in height of these letters as compared with Figure 129a.)

**stroke endings**

Figure 129c

A simplified, almost cursive variation of **a**. The *leads* and *ends* are now all curved, thus changing the zig-zag line of the **i** into a single waved line. This rendering is carried out throughout all letters, even to making a single main stroke for the **s** instead of two. This is an ideal alphabet for quickly laying-out any job with Gothic minuscules.

# stroke endings

Figure 129d

The *leads* are curved inwardly and shaped like the small second stroke of the **r** (or the dot on the **i**) and the main stroke is once again started slightly to the left, giving a sharper more elegant looking spur. Ordinarily, with the *leads* curved this way one would reverse the direction of the *ends* as in the lower *end* of the **s** or the **g**, but for variety's sake I have shown this other rendering.

# stroke endings

Figure 129e

The *leads* and *ends* are almost horizontal strokes, protruding at times where space permits, but continuing without interruption from the main strokes to form the long *ends* of such open letters as **t, r, e** and **c**. This extension of the *ends* is used almost invariably to fill in the white space which would result if a short *end* were used.

# stroke endings

Figure 129f

The double curve which these *leads* and *ends* make is not only interesting but a beautiful example of the forms a plume can be

191

persuaded to create. Needless to say, a little practice is necessary to keep them uniform. They can, as shown, be embellished with fine serifs.

**stroke endings**

Figure 129g

This is obviously a drawn example, although with a little patience and a narrower plume (necessitating double strokes to achieve the full thickness of the main strokes) the above result *can* be written.

The above seven examples by no means fully exhaust the possibilities of varying *leads* and *ends*. They will serve as a guide, however, and I hope they will inspire many of my readers to experiment further for themselves.

One of the most interesting characteristics of Gothic minuscules is the treatment of the ascenders and descenders. *As a general rule,* they should be shorter in relation to the height of the body of the letter than in Roman minuscules. In other words, the

Figure 130

ascender of a Roman **b** is generally 2/3 as long as the height of the **o** which forms its body. In Gothic, where the letters are more slender, ½ the height is sufficient. In fact, even less will often be enough, as the second line in the previous example illustrates.

The first line shows all ascenders, and, of the two renderings of each letter, the most used and preferable version is given first. The split ascenders lend themselves admirably to further elaboration but, unless special reasons demand it, the use of the split **d** and **t** is not to be recommended.

In the second line, the long **f** is optional while the long **h** is used very often and with remarkably pleasing results. This descending of the last stroke can also be used with good effect on **n** and **m,** but should not be unduly exaggerated.

The third line speaks for itself, but due note should be taken that in Gothic, as in all other styles, the descenders can be made considerably shorter than the ascenders. Another detail worth remembering is that in the **p** the final *end* always crosses the main stroke. The long **z** is optional and should be used where it might improve the design of a word, as, for example, in

## Lizard Lizard

Figure 131

In the previous chapters much has been said concerning Layout, so that there is little need to repeat the main principles here. Gothic, however, owing to its pure plume-written character, needs a little more individual consideration, or, one might say, consideration for its individuality.

## Letterspacing in Gothic should be tight, never open

Figure 132a

The above "reminder," which was written in about two minutes without the help of any pencil line and left unretouched, is the key to the whole problem of WEIGHT, LAYOUT and SPACING.

The very "structure" of Gothic which I mentioned before demands a certain rigidity of structure in its layout. This does not mean that all layouts have to be fitted into perfectly squared-off rectangular blocks; but it does mean that letters should be made to form more or less solid words — little word-designs in themselves — and that these word-blocks have to be put together to form a unity of design one with another.*

To put this more clearly: words with tight letter-spacing should not be placed too far apart, or, stated differently, they should not be too widely word-spaced. The same applies to line-spacing. Several lines of dense lettering too widely line-spaced will give an unpleasant effect of black and white horizontal stripes. Of course this may occasionally be desirable, but only very special reasons would make such an exception acceptable. The very fact that ascenders and descenders are relatively short seems to confirm this general rule for line-spacing.

Making a layout with Gothic minuscules and going by these rules for letter-spacing, word-spacing and line-spacing, will generally result in a piece of lettering of considerable blackness (see Figure 132a). This is the true spirit of Gothic, in comparison, for example, with the light airiness of formal Script. Yet such dense blackness of color is not always desirable and the question of WEIGHT will therefore have to be our next consideration. This is very easily solved, merely by using a narrower plume for making the layout.†

If your first layout looks good but seems too heavy for its particular purpose, place a piece of not too transparent tracing paper over it and trace the whole thing with a narrower plume. The following sketch was traced from Figure 132a. The result will

---

* It is interesting to note that, in German, italicizing to emphasize certain words or phrases is not done. Such portions of any text are letter-spaced, sometimes rather considerably, and are often quite difficult to read. But the end justifies the means; the reader has to slow down and the emphasis sinks in. The typographical picture, however, generally suffers.

† You can of course use the same plume and make your layout larger, but there are some disadvantages to this method. It is a mistake to think that lettering can be photographically enlarged or reduced at will to any considerable extent and still retain its original effect.

seldom be completely satisfactory, because of the new letter-spacing and the larger white spaces within the letters themselves. The tracing, however, will serve excellently to give a general impression of the new color. If this new weight is satisfactory, make a new layout without tracing the tracing but using it only as a visual guide for arrangement.

**Letterspacing in Gothic should be tight, never open**

Figure 132b

Thickening lettering can be done in the same way only if the difference is to be very slight. WEIGHT influences FORM and it is often surprising how different a line will look if done over, using only a slightly wider plume (to say nothing of the longer line).

And, last but by no means least, is the remarkable difference in weight which can be achieved by simply turning the hand slight-ly to obtain the full width of the plume for the main stroke.

**Thin and thick strokes – with the same plume**

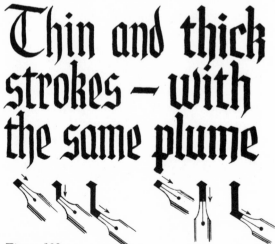

Figure 133

195

The above quick sketch was done about 6 inches (15cm.) wide with a ⅛ inch plume and photographically reduced. Such large letters are somewhat difficult to handle at first but for the sake of practice there is nothing like a wide plume to give one the feeling of structure and a lasting knowledge of the forms which can be expected from the tool. The sketch also illustrates how imperative it is that all the vertical main strokes be done with the plume held at the same angle throughout a single piece of lettering.

Naturally, this constant turning of the plume greatly slows down the writing speed; but the concentration required to remember when to turn, how to treat the *leads* and *ends*, and how to make them join properly with the main strokes, combined with this methodical slowness, gives surprisingly satisfying results.

Before turning to some final tips on the easiest methods of EXECUTION of Gothic, let us consider the possibility of departing from the strictly vertical to a sloping style. Although unusual and very seldom used, sloping Gothic letters can be made to fill a gap in the versatility of this style of lettering, namely for italicizing words needing some kind of emphasis.

To illustrate this I had intended to draw or write a few sample words. While searching for an appropriate text for these, it occurred to me to give you the opportunity of watching over my shoulder to see how I put out a quick, but fairly well-finished, job. The procedure is a semi-mechanical one, putting more emphasis on exactness and nicety of workmanship than on a freer, more artistic rendering with all its unintentional and very often delightful irregularities.

After deciding on the text, the first step (Figure 134a) was to make a rough pencil skeleton layout to determine how to arrange the words. (The pencil lines were later traced in ink to facilitate reproduction in the printing of this book.)

The letters and word-spaces (one letter for each) were then counted and the results marked on the right. This was to see which lines were likely to be the longest, and where to divide words if it proved necessary or advisable.

The longest line, the third, with its twenty-five characters, looked as though it could be compressed a little, and as this seemed to be the only thing wrong, my next step (Figure 134b) was taken by making a preliminary plume-written layout.

To *emphasize* words *18*
In Gothic lettering, the *23*
use of *sloping minuscules* *25*
can be recommended. *18*

Figure 134a

To *emphasize* words
in Gothic lettering, the
use of *sloping minuscules*
can be recommended.

Figure 134b

The pencil layout had seemed a little too widely line-spaced so in this second step an effort was made to correct this mistake. The sketch, which was written directly on plain paper without any preliminary pencil indications, took about ten minutes. But now the line-spacing seemed just a little too tight and the third line was still a bit too long. As both these minor faults could easily be fixed later, I decided not to make a third sketch but start the final job.

My next step (Figure 134c) was to make a paper measure for the guide lines to take care of the letter-height and line-spacing. So by now drawing the guide lines on my second sketch

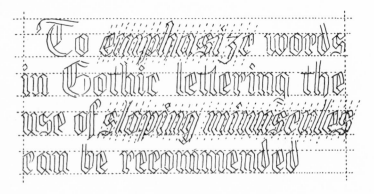

Figure 134c

I found that the line-spacing was exactly ½ of the letter-height — in other words a proportion of 1 to 2. Then, to widen the line-spacing, I decided on a proportion of 2 to 3, which gives a line-space of 2/3 of the letter-height instead of ½ as before.

With the paper measure, the pencil guide lines were soon drawn and the next step (Figure 134d) was to pencil the third line of lettering. In spite of considerable compressing, however, this line persisted in finally sticking out over the right-hand pencil margin. A few trials to stretch out the second line to make it as long as the third convinced me that the letter- and word-spacing would have to be so extended that the color of the line would suffer. I finally gave up and let that third line have its own way.

The pencil drawing now looked like this:

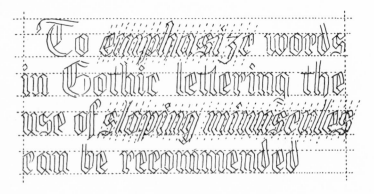

Figure 134d

198

You will notice that I put in some faint guide lines to take care of the sloping verticals.

To ink the verticals, as well as the sloping verticals, was the next step (Figure 134e); and here the great value of my second sketch proved itself. A careful examination and comparison of the thicknesses of these two main strokes brought to light how much thinner the sloping ones were. (I should explain at this point that the sketch done as Figure 134b was written throughout with the same plume held at the same angle all the time.)

All the straight and sloping verticals were now inked, using two plumes, a wide one for the straight and a slightly narrower one for the sloping. Naturally the adjustable T square came in handy, and of course at this stage slight adjustments in letter-spacing were taken care of where necessary. Note that it was also possible to squeeze the es a little to the left.

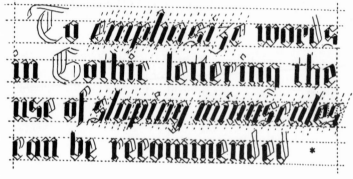

Figure 134e

And now for the *leads* and *ends*. As mentioned before, it is these that give an alphabet its individual character, and in this particular job I postponed my choice until the last moment and, as you will see, I picked rather complicated looking ones; double curves with serifs.

In mechanical renderings of this kind, I find it simpler and quicker to draw the *leads* and *ends* with a fine drawing pen. This method enables one to achieve better joining with the main strokes — which would sometimes be difficult with a wide plume — and also gives one an opportunity to make little necessary variations here and there.

199

It is advisable for the beginner, at this point, to practice a few very carefully written *leads* and *ends* to acquaint himself thoroughly with their forms, noting particularly where they are thickest and thinnest, the angle of the serifs and similar details.

With this part of the job done (in the drawing below the pencil guide lines were eliminated for clarity's sake),

To emphasize words in Gothic lettering, the use of *sloping minuscules* can be recommended.

Figure 134f

our last concern is the treatment of the initials.

As no decoration was intended for these, a few straightforward plume-written trial letters sufficed to find the family resemblance. Note that both the **T** and the **G** were widened considerably in order to stretch out the first and second lines. The final complete job looked like this:

To emphasize words in Gothic lettering, the use of *sloping minuscules* can be recommended.

Figure 134g

It was now ready for reproduction.

I have demonstrated this mechanical method for two specific reasons. In the first place, it is the simplest way for a beginner to turn out a professional-looking job, taking into consideration that he will probably have to make a rather finished pencil drawing of the whole job before proceeding in ink. Secondly, for reproduction the execution will always have to be up to a certain standard of careful finish. This finish is practically impossible to achieve in pure manuscript form — that is, hand-written — except after much practice and a great deal of experience.

Skill in wielding the plume is an accomplished art. It is the only correct method for making diplomas, testimonials, addresses and similar documents which are to be presented or displayed in their original form. Visible erasures and corrections are out of the question, and even the slightest trace of retouching must be avoided. In work of this kind, however, the artist has a great deal more license in regard to letter- and word-spacing. For instance, uneven length of lines of lettering is not considered a flaw; it is the skilled workmanship plus a well-balanced layout that counts.

I strongly recommend that everyone who wishes to master Gothic lettering try writing some of his favorite mottoes, quotations, or even short poems, etc., in styles he considers appropriate. The fact of writing a worth-while and meaningful text is a greater incentive to better workmanship than all the practicing of alphabets in the world. (See Figure 128.)

On the following pages is shown a selection of simple, as well as more ambitious, studies featuring Gothic minuscules. The captions will draw your attention to certain things, but try out your own ability as a critic. You may find something I overlooked.

Figure 135. *Examine and compare this with Figures 137, 139 and 141. Letter-spacing in the above should have been closer; everything seems too spread out.*

Figure 136. *The black lettering is excellent, but the headline seems to lack weight. How would you improve this?*

Always endeavor to find some interesting variation

Figure 137. *A line-filler in the first line, or a somewhat larger* **Always,** *would have made a more satisfactory layout.*

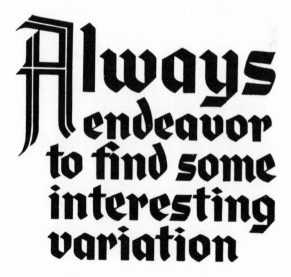

Always endeavor to find some interesting variation

Figure 138. *A very good layout in true Gothic spirit. This was drawn, of course, but try writing it with a suitable plume.*

# Always endeavor to find some interesting variation

Figure 139. *Here again letter-spacing is too open, although the general effect is quite pleasing. Compare with Figure 141.*

# Always endeavor to find some interesting variation

Figure 140. *Note the* characterful *massiveness of each letter. All strokes are slightly thicker at the top.*

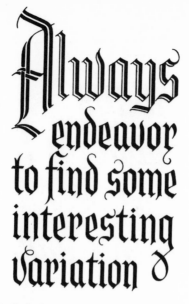

Figure 141. *A nicely balanced layout of even color. The occasional thin decorations go well with the serifs.*

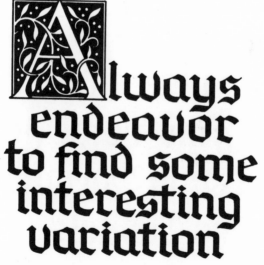

Figure 142. *This surprisingly colorful example is a result of correct stroke thickness with large white spaces within the letters. Compare with Figure 140.*

# Always endeavor to find some interesting variation

Figure 143. *An unretouched hand-written sketch. A style like this is ideal for poetry.*

# Always Endeavor To Find Some Interesting Variation Using Capitals

Figure 144. *The use of so many capitals may add sparkle, but detracts from readability.*

# Always endeavor to find Some interesting Variation

Figure 145. *A style of this nature, with its many curved strokes, needs plenty of air.*

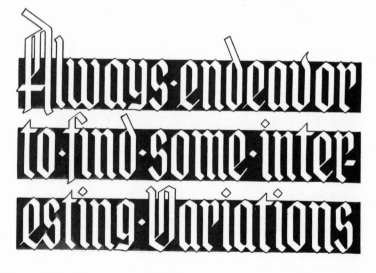

Figure 146. *Very severe, yet highly decorative, treatment. Note how descenders have been kept within the bands.*

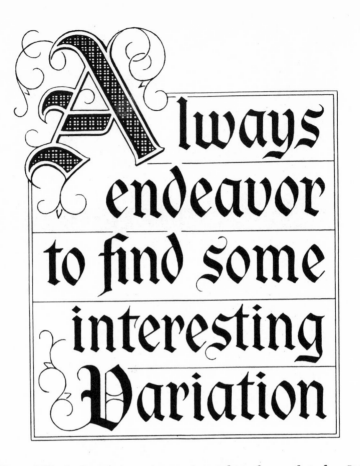

Figure 147. *An interesting mixture of straight and curved strokes. It is another example worth copying with a suitable plume.*

Figure 148. *Gothic with flourishes! Yes, and this possibility is worth remembering whenever a very ornate result is desired.*

*Script*

CHAPTER SIXTEEN

# Script

WHEN ONE CONSIDERS the hundreds of different forms in which Script letters can be made, it is not surprising that the practice of graphology came into existence. Someone evidently discovered that the handwritten characters had character of their own and presumed that these might, if analyzed with understanding, betray or at least give a hint as to the character traits of the person who had written them. While not wishing to take sides in this debatable issue, I feel that there is nevertheless a percentage of truth in the theory. By this I do not mean that a person whose handwriting is repellent should necessarily be that way himself, or that a beautiful example of expert penmanship would be sufficient to make me feel attracted towards its author.

The fact remains, however, that, irrespective of its author, handwriting definitely has a character of its own. It can run the gamut from neat, naïve simplicity combined with pleasant legibility, to disgracefully sloppy oversophistication combined with extremely disagreeable illegibility. This latter is sometimes supposed to be ultra chic, but is in my opinion an eyesore betraying, to say the least, a lack of consideration for the reader on the part of its perpetrator.

What is it that makes handwriting legible or illegible? Form, nothing but form. So let us begin our study of Script, with FORM.

FORM, as we have seen, is tremendously influenced by the tools used, but basically the skeleton of a letter must show through so that it can be recognized as just that letter. You cannot "invent" new letters with utter disregard of their basic structure. True, the Roman majuscule **A** has evolved into *A* where the resemblance is still visible; but we have also arrived at *a* ! This could send us back delving into history for the reasons for this change, but as enough has been said about such changes in the chapters on Italics, let us simply be satisfied that this third shape does exist and that most of us have learned to write it as schoolchildren.

## A TYPICAL SCRIPT MAJUSCULE ALPHABET

Our own handwriting can and probably will be our first source of inspiration for readable shapes, but some kind of a norm will be of value to the student. So here is an alphabet of *formal* Script

212

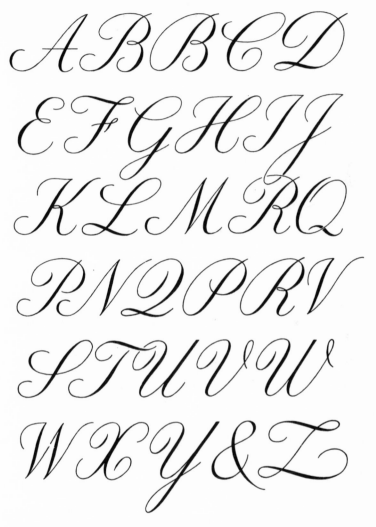

Figure 149. *Formal Script majuscules based on old copy-book forms.*

majuscules based on *handwritten* originals of French and Italian origin. Some of these letters are at least a couple of hundred years old while others have been modified to meet modern demands for readability and yet still keep a family resemblance within this

213

alphabet. Some letters are shown in a number of renderings, but all are interchangeable for reasons of design or to allow for a better tie-up with the following minuscules.

In studying this alphabet for its individual characteristics, the first thing you will probably notice is a particular rhythm of the thick and thin strokes. This is caused by the tool used, a flexible, sharp pointed *pen*. (Remember we are now dealing with penmanship.) These letters were very carefully and *leisurely written,* and all effort was put into making the tool do the forming. In other words, and to emphasize my point by contrast, no effort was made to find the quickest way of writing these letters, but at the same time no time was wasted on superfluous flourishes. This alphabet, which is strictly formal, has also been boiled down to the simplest of essential strokes. It can be used as a basis for practically any job calling for formal Script, and most of the letters lend themselves admirably as foundations from which to "grow" the most ornate flourishes and ornamentations.

The flexible, more or less soft, pen is the tool and it is advisable at this point to notice why and where the thick and thin strokes occur and how they happen. The $\mathcal{M}$ is a very good example. It is simply written — as most of these letters should be — without raising the pen from the paper, and the natural hand-pressure on the downstrokes (even on the lead-in to the first upstroke) gives the desired thickness, while the natural lack of pressure on the upstroke gives the thin stroke. This naturalness of pressure is a most important thing to remember, and on the evenness with which it is applied will always depend the success of any piece of formal Script. It is still more important when writing the minuscules.

The exact slope of these letters is somewhat arbitrary. It depends chiefly upon the slope of the minuscules, however, and should be prescribed — with the help of sloping vertical guide lines — fairly accurately. Formal Script slants considerably more than Italic and here is a quick way of finding your "sloping vertical":

Somewhere on the first horizontal line on your paper, mark off three equal parts of, say, about an inch. You don't need an inch rule; a piece of paper will do. Now from your first point draw a faint perpendicular line down and mark off four parts with the same measure. The two end marks, when joined together, will give you your "sloping vertical" like this:

Figure 150

Once you have this line, use your adjustable T square to rule as many sloping guide lines — parallel to this one — as you need to cover your lettering area and you are ready to start work. Naturally you do this *after* you have sketched in your general layout, or just before you begin to do your final pencil drawing. The long straight strokes of **G, U, W** and **Y** will fall exactly on, or at least parallel to, these guide lines.

But to return to FORM. The alphabet on page 213, Figure 149, merely demonstrates how the strokes happen. The first strokes (upstrokes) of **A, M** and **N** are a reminder of the Roman majuscules, and the slight thickening at the lead-in has been purposely shown to stress the direction of the stroke. This slight thickening is not shown in the letters **B, F, I, K, R, P, S** and **T,** because this time the curve is upwards, being the ending of a downstroke. For reasons of balance and color, these short upstrokes are often thickened towards their centers, but this has not been shown in this alphabet for explanatory reasons.

Note that all strokes start off thin, begin to thicken when the natural downward hand-pressure starts, and taper off again when pressure is relaxed.

The slightly downward movement from left to right in the "horizontal" strokes of **F, L, Q, T** and **Z** also makes them become thick strokes, while those with an upward tendency as in **C, G, H, I, J, K, L, R, P, S,** etc., are thin. Only in two letters, **D** and **O,** does the horizontal line at the top run from right to left — that is, backwards. In pure *written* Script this part of the letter can never be anything else but thin. The pen just wouldn't allow it, in fact it would splutter in protest.

## AN UNORTHODOX SCRIPT TREATMENT

Sometimes among more ornamental initials one may find that the artist has changed around the stroke thicknesses — that is, put thin strokes where thick ones should be and vice versa. The result

215

is never very satisfying. As a rule the whole letter looks structurally unsound; it is certainly unbalanced and does not harmonize with the small letters following it. The accompanying example demonstrates this more graphically:

*Distribution of Thick and Thin Strokes Illogical*

Figure 151

These Script majuscule initials were copied more or less freely from "modern" alphabets. The result, on the whole, can hardly be called an example of bad lettering, and the average layman would probably find nothing wrong with it except, perhaps, the two different kinds of **T.** Basically, however, it *is* bad lettering because it is incorrect lettering and just as bad as

AM for AM

no matter how painstakingly rendered.

I am not saying that these questionable Script capitals (as here combined with typical minuscules in Figure 151) cannot be written with a pen, but in order to do them the hand would have to be

216

held in such an unnatural position, or lifted from the paper several times, as to make writing most difficult. Furthermore, an entirely new set of minuscules would have to be found to go with them. The result would be quite difficult to read and not worth the effort.

I would like to repeat again and again that mere copying from many of the hundreds of ready-made alphabets is apt to lead the beginner astray. Only after he has studied the forms and convinced himself that they are correct should he copy or adapt them.

To show that there is seldom a rule without an exception, let us go back to our basic Script alphabet and examine its last letter, the **Z**. Just why the downstroke is thin is hard to see, but there are two very logical reasons. The first lies in the naturally alternating pressure exerted when writing with this backward and forward (zigzag) motion. The hand wants to make one thick, one thin, one thick one thin. Secondly, if made with three thick strokes, the **Z** would become very heavy and contrast upleasantly with the minuscules following. The thin downstroke in **Z** is, however, very often slightly thickened in the middle, but care should be taken to leave it thin where it crosses the thick horizontals.

Variations of these formal Script majuscules are as numerous as you can make them, bearing in mind, of course, that you are dealing with *penmanship*. "Calligraphy" is perhaps the better term as it suggests elegant writing in its most decorative sense. It most definitely is an art, because while the pen influences the form, it is the hand — and back of it the mind — which influences the tool to do its work.

## SOME TECHNICAL POINTERS

Now for a few words about wielding your pen. Suddenly we find ourselves faced with the question of SIZE. In these days of photographic enlargements we hardly have to worry about writing letters a foot high; the camera will take care of that. But we have to get our originals onto paper first and here the limitations of our tool, the soft flexible pen, at once become apparent.

About the thickest stroke you can expect from an average steel crow-quill nib, without breaking it, is 1/16 inch or 1½mm. With this thickness in mind, about the largest majuscule the average beginner can comfortably do would be about 1 inch or 25mm. high. This is quite a large letter, but inasmuch as the minuscules are

only one half this height — slightly under is still better — I can recommend this size as easy for the beginner to practice with. And practice he must.

## THE SCRIPT MINUSCULES

The minuscules being the more important message carriers in any piece of Script, I consider this the right moment to introduce them more fully to you.

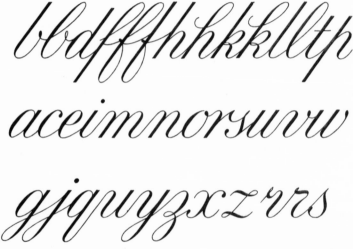

Figure 152. *Formal Script minuscules. with the most accepted variations. This can be considered a BASIC ALPHABET to study or adapt.*

This alphabet, which contains all the accepted variations of the same letter, is strictly formal and, as in the case of the majuscules, may be used as a basis for any job calling for formal Script. All the ascenders and descenders lend themselves as the beginnings of flourishes, simple or ornate.

The quickest, and, in my opinion, the only correct way of really grasping the feeling of the forms in this or any other style of Script, is to write it. Draw in pencil a number of parallel horizontal guide lines a little less than ½ inch apart and use three for each line of Script. Then, with very faint lines, put in plenty of sloping verticals and proceed without any further preparation to write, with ink, any words that may occur to you, beginning with all the capitals of the alphabet, like this:

218

*Apple, Banana, Cherry,*
*Date, Elderberry, Fruits,*

Figure 153. *How to start your exercises in formal Script.*

Do not worry if the initial cannot be made to join with the minuscule following it, but do endeavor by all means to write the rest of the word in one continuous line—i.e., without lifting the pen from the paper except, naturally, to cross your t's and dot your i's.

Formal Script, sometimes called round hand or English Script, has, as mentioned, a considerable slope and it is advisable to turn your board a little so that the sloping verticals will be more nearly perpendicular. You will thus be writing slightly uphill, but the long straight strokes of letters with ascenders and descenders will be much easier to render and the bottom and top curves will practically form themselves. That is, they will after a little practice. And it is just this practice which will give you the feeling of rhythm so necessary in rendering good Script lettering. That rhythm of thick and thin, thick and thin, plus the roundness of a flowing style.

Naturally, it is important to exert *even* pressure on the straight downstrokes and still more important to begin relaxing that pressure *before* reaching the curve toward the next letter. The round strokes bring up a similar problem of dexterity both at top and bottom, so let us examine the individual strokes throughout the whole alphabet. Remember, we are practicing to *write* them, not to draw them.

In a, c, d, g, o and q, the upstroke from the preceding letter is carried well over to the right to form the top of the letter. This stroke is then retraced and the thick downstroke begins, as soon as natural hand pressure is exerted. This pressure relaxes just as naturally when the time comes to think of the next upstroke. This thin upstroke should be drawn up as high as necessary (as in d) to prevent any breaking off of the continuous line. The following diagram shows all four steps:

219

Figure 154

There are several ways of forming an **e**, according to the letter preceding or following it. But the two important renderings — as a letter in itself — are the following:

Figure 155

The first is the more cursive, while the second is the more leisurely and acceptedly correct formal version. This formal version is written with a kink in the upstroke to assure that the joint with the preceding letter, whatever it may be, always is near the center.

The letters with ascenders, **b, f, h, k** and **l**, can be done either straight or looped. When using the looped version, the long downstroke of **b, f,** and **l** should have a definite curve. The choice of either rendering is very often governed by the word to be written. Here are typical examples:

Figure 156

These show only three ways of writing the same word. It is entirely a matter of taste which one is preferable. One should, however, try to use the same rendering throughout in any piece of lettering consisting of several words.

Descenders are less versatile. In the letters **f, g, j, p, q, y** and **z,** only the **f** can be varied — that is, in formal Script. The following example might lead one to ask, "What's the difference?"

Figure 157

But occasionally quite interesting letter combinations do crop up where making the right choice is fun. The letter **q**, which in English is invariably followed by a **u**, should in formal Script always be tied up with it. Here are three ways of doing this:

Figure 158

The second stroke of **h**, **n**, and **p**, and the third in **m**, as well as the first ones of **u**, **v** and **y**, are called pothooks. Although at first glance the thick part of the stroke appears to be straight, it is not. It should have a subtle curve, that of a reversed **s**, and both hand and pen seem automatically to join forces in rendering this simplest of all strokes.

*h n y*

Figure 159

While discussing **m**, **n**, **u**, **v**, **w** and **y**, it is useful to remember that all these letters can start off either with straight or curved first strokes, and the last four with pothooks. Note also that the former versions are more economical as far as space is concerned:

*manual manual*

*view view*

Figure 160

The remaining minuscules, **r**, **s**, **t**, **x** and **z**, need individual attention. They are no more difficult to *write* than the others, but cer-

221

tain variations must be considered when it comes to their joining up with other letters.

Figure 161     *rr*     (So-called English **r**)

In this letter, both straight and curved main strokes are permissible and both join up easily with any preceding letter. The second stroke or hook, however, often has to be lowered or raised to accommodate the next letter as the following examples show:

Figure 162     *art rh*

Figure 163     *r r r*     (So-called French **r**)

This letter has three basic forms to choose from. The first and last have a pothook as main stroke; the second, however, has an interesting main stroke which you will see from the dotted line is like part of a small **o**.

Figure 164     *S S*

In formal Script, the two forms of **s** are influenced only by the preceding letters. The connection with the following letter always starts at the bottom as indicated.

Figure 165     *t*

The cross-stroke is the only thing that changes. Some letterers prefer to put it above the guide line. For alignment's sake, I prefer it within the guide line. That is, in formal Script.

222

Figure 166                    *x*

As will be seen later when discussing *informal* Script, there are
many ways of making a Script x look good. For formal style, how-
ever, stick to the one shown, made of an inverted c to which an
ordinary c is added. This is, by the way, the only letter where you
may lift you pen from the paper.

Figure 167            *z*    *z* *z*

This is an easy one, whichever variation you prefer, and in the
following examples only a few of the many possible combinations
are given:

*furze*

Figure 168        *furze furze*

Try out the others for yourself, and thus get some more practice.
"Practice, practice, practice!," I hear some of my invisible stu-
dents saying. "Who on earth would attempt to *write* Script today
excellent enough for reproduction? Why, everybody knows that
all those masterpieces that one sees in magazines, on packages and
as title headings are *drawn*. Carefully drawn in pencil, then inked
in — even using a ruler where necessary — and, finally, still more
carefully retouched with white to assure perfect execution!"

Of course they are. Many lettering experts even use up yards of
tracing paper in the drawing, tracing, redrawing and retracing of
a piece of lettering until they are definitely satisfied with the re-
sult. This, however, is merely a method — a very good one, I admit
— of obtaining perfection in Size, Layout and Spacing. Without
a very firm knowledge of Form, however, the beginner will not be
able to solve his problems on tracing paper. To be able to *draw*
Script perfectly he must know *first* how the letters form them-

selves in *writing*. Remember, also, that lettering is not always done with black ink on smooth white paper in a size convenient for a small working table. Large projects, for instance, often cannot be turned around and upside down for more convenient handling of curves. The choice of materials also very often demands entirely different tools. You cannot write formal Script with a pen on a tempera background; you must write it with a suitable brush. But unless you have definitely mastered the FORM of Script, you will find it extremely difficult to persuade your brush to produce Script

---

*This is an example of formal script with tight letter-spacing and close spacing between lines.*

Figure 169a. *See text on page 226.*

*This is an example of formal script with tight letter-spacing and wide spacing between lines.*

Figure 169b

characters which look as if they were pen-written. I have known artists who did *all* their lettering with a brush, be it Roman, Italic, Script, Gothic or Block. It was almost invariably perfect, but only because the artists were past masters of FORM.

There is little to be said about the WEIGHT of formal Script. SIZE, pen and pressure take care of it. I would, however, like to suggest that the beginner who is particularly interested in this style of lettering, gradually allow his Script to become smaller and smaller, still exerting plenty of pressure on the downstrokes and

*This is an example of formal script with open letter-spacing and close spacing between lines.*

Figure 169c

*This is an example of formal script with open letter-spacing and wide spacing between lines.*

Figure 169d

making them as thick as the pen can stand.

The greater contrast between thick and thin strokes, and especially the shape of the turns from thick to thin, will help him memorize the forms still more, while the difference in color and letter-spacing will provide inspiration for later creative work.

Exceptionally thick downstrokes cannot be written directly and will have to be drawn in carefully before rendering in ink.

## SPACING OF SCRIPT

No amount of text is as good as a few illustrative examples explaining the "problems" of letter-spacing and line-spacing. Letter-spacing depends upon the WEIGHT of the letters used, while line-spacing is purely a matter of LAYOUT. See pages 224 and 225.

Of the four examples shown herewith, Figure 169b, with its preciseness and rather severe but not unpleasant regularity, will probably appeal to more readers than the other three. The *tight* letter-spacing, plus the *ample* word-spacing, plus the *generous* line-spacing, makes every word quickly readable at a glance. Although this cannot be said of 169a, it will sometimes be found necessary to use a combination like this. Testimonials, addresses, presentation scrolls and similar manuscripts are often written in formal Script. Lack of space then calls for economy in line-spacing. Large areas covered with tightly written Script using the straight style of ascenders (as in Figures 169a and b) can, when uniformly done, look very beautiful. Quick readability is by no means a necessity; in fact, I am inclined to favor slower reading in a manuscript whose copy is in a dignified, serious vein. It is the general decorative appearance of the job that counts.

Where much less copy is to be used — as, for instance, in private greeting cards, bookplates, invitations and similar short announcements — the round hand is often more suitable both with a view to lending an air of less formality and to taking advantage of the more generous space for possible decorative flourishes. In keeping with the message, these flourishes can range from simply enlarged ascenders and descenders to ornate or frivolous designs.

One more word about letter-joining. In examining our four examples it should be noted that, where straight ascenders are used, the first stroke of n, m, r, u, v, w and y should also be straight wherever possible. (See Figures 169a and b.) Yet this is not to be taken as a hard-and-fast rule. Some variations may be necessary

in certain words, and a quick pencil sketch will soon help you make your decision. In the round hands, however, make your joints as flowing as possible.

It will be found that the above paragraph ties in with the problem of letter-spacing. The interruption in flow caused by straight ascenders and straight first strokes (see Figures 169a and b and Figure 184 on page 248) results in less "air" between the letters. This must be taken into account by placing all other letters slightly closer together. In contrast to this, of course, the flowing joints in the round hand need more room and consequently all other letters must be more widely spaced, as in Figures 169c and d. The object of these differences in letter-spacing is to obtain only one important result: *uniformity of color*. To appreciate what color means, examine once more the four examples with half-closed eyes so that the individual letters become blurred. Immediately you will notice a difference in the all-over tone of gray thus optically achieved. Always strive for this uniformity of color when doing larger masses of Script. Care should be taken not to unduly spread or condense a word to fill out a line to fit a certain length. Such a word can easily change the color at that spot and spoil the uniformity. It is better to split a word at the end of a line or fill in a short space with a flourish or line filler, if splitting the word is impossible.

Line-spacing of formal Script should as a rule not be as close as in Figures 169a and c. These two illustrations were purposely exaggerated to stress this point. Apart from a certain air of cheapness due to overcrowdedness, their legibility has suffered. The main reason, however, for avoiding too close line-spacing should be the danger of collision between descenders and ascenders. Yet Script, being elastic, one can almost always move a word slightly to right or left to prevent disturbing entanglements. In a straight hand such collisions *must* be avoided, but in a round hand two intertwining loops are permissible provided they do not become one single loop. If any shortening has to be done, remember it is always better to shorten a descender rather than an ascender. And here is a worth-while tip while we are on the subject of close line-spacing. Whenever I have several lines of Script to write, I leave the descenders unfinished until I have written the next line. Then I go back and shorten or adjust the missing descenders wherever a collision might have resulted.

Too widely line-spaced Script hardly ever occurs. In examples I have seen, my first reaction has been, "the lettering is too small!" When using Script it is, in my opinion, an affectation to strive for super-elegance or refinement by overdoing the space between the lines. Much more can be gained by utilizing some of the space thus wasted in leaving larger margins and making shorter lines of slightly larger Script.

## FLOURISHES

Flourishes are the traditional ornament for formal Script. But like every other ornamentation they can be, and very often are, overdone. When designing and executing Script with flourishes, all the qualifying factors contained in our established Formula have to be considered: SIZE, FORM, WEIGHT, LAYOUT, SPACING and EXECUTION.

SIZE: Depending upon the job, flourishes, as a rule, need plenty of white space to look good. They have an air of lavish luxury which cannot go well with economy. They should never look crowded, and wide margins are absolutely necessary.

FORM: Pen written flourishes have a distinct FORM of their own, and should be done (or appear to have been done) with the same pen with which the letters were formed. Most of the basic forms are contained in the alphabet, Figure 149, page 213. In the examples which follow, most of the others will be found.

WEIGHT: Not only does the pen influence the FORM; it also most decidedly limits the WEIGHT. It is not good practice to allow the decoration to appear to be heavier than the lettering. Too much ornamentation tends to lose its airiness and take on a color of its own which may then be darker than the lettering itself.

LAYOUT: Careful LAYOUT is an absolute necessity. For instance, any of the six examples on the next pages could be used as the "main illustration" of a job with a great deal of text, or as a single element on an otherwise blank page. Whichever way they might be used, the LAYOUT of the word itself demands the same amount of care. In the final analysis, rhythm and balance must go hand in hand.

SPACING: Here again color is of primary importance. The thinnest hairstrokes if placed too tightly together can give too

228

much color and overpower the lettering by contrast. On the other hand, uneven spacing — judged by the old trick of half-closing your eyes — can ruin a job by making it appear blotchy in places. This phenomenon can *sometimes* be used to advantage, but only when the heavier or more *color*ful parts are purposely used to emphasize certain parts of the design. Yet these exceptions should never become the first attraction of interest.

EXECUTION: When done for presentation purposes — that is, when not for reproduction — impeccable EXECUTION is of course essential. No corrections should be visible; erasures should leave the paper as smooth as it was; and the use of white paint for retouching is entirely out of the question. For reproduction purposes, though, retouching can, and almost invariably is, resorted to. Furthermore, it is advisable to work larger than the final reproduction is to be. In no other style of lettering-ornamentation is perfection of EXECUTION so important, and every line should be carefully examined for the perfection of its curves and gradations of thick and thin.

## HOW TO UTILIZE FLOURISHES

Although this book is not intended to teach decorative design either in lettering or ornamentation, a few words on how to utilize flourishes will most likely be welcome to the beginner. The following six examples show step by step what can be done, and I hope they will prove of help in your problems.

Figure 170

The simplest way to start is to decorate just the initial. Wherever possible, the flourish should "grow" out of the letter, and in the case of a **G** a lot more can be done than in the above example; see Figure 172. Very ornately decorated initials can also be made by adding and intertwining separate flourishes. These should,

however, be in rhythm with the letter itself and look as though they belonged to it.

Figure 171

Let us go a step further by using the small g's descender as the root for a terminating flourish. Obviously a too complicated initial would not look good in this layout, while the flourish which dots the i and crosses the t gives the whole a nice feeling of balance.

Figure 172

Here we have a combination of flourishes growing from every available source without detracting from the word's readability. Two extra flourishes have been added to give the feeling of balance and unity. Note also that it is advisable to leave a margin around the word itself; in this example, the lettering is decorated but not smothered.

Although seldom done, the exclusive use of Script capitals lends itself to surprisingly beautiful decorative effects. Naturally only single words or very short messages should be treated in this way.

230

Figure 173

The rendering of the above word could well be used as a decorative heading over a block of text, or as part of a band engraved around a silver loving cup. Painted on a ceramic vase or plate, it could be used with charming results as a border without any other decoration whatsoever.

Figure 174

To get back to legibility, one can also combine Script with some of the characteristics of Italics. Here it is possible to make use of quite a number of ascending and descending tails. In the above example, simplicity has been the aim, but a lot more could be done with this simple design if an ornate result were desired. (See Figure 179, page 246.)

Figure 175

And, finally, here is an example of overdoing it. I have, however, not hesitated to show something like this, for two reasons:

Tastes differ, and some of my readers may immediately be ap-

palled at this florid ostentation and therefore never attempt to do anything like it. Yet others may appreciate its possibilities for certain types of work. If they really do, they will enjoy the fascination peculiar to the designing and rendering of this style of ornamentation and probably end up with some delightful results far superior to the above example.

In any case, this particular specimen is worth studying and analyzing for a while. The "border" is made up of a number of entirely different design elements, each of which can be picked out individually. These elements, with a little variation, can be used in themselves as decoration, even without lettering, or they can be repeated to form new patterns such as bands between lines of lettering — not necessarily Script — and, finally, each one can serve as a basis for an entirely new combination of flourishes.

Before leaving formal Script and its flourishes, one last important reminder. Always try to avoid crossing two thick strokes at their thickest points.

## INFORMAL SCRIPT

Our foregoing study has shown that doing formal Script is a matter of extremely careful and unhurried writing, in which the hand guides the tool to do the forming. The tool certainly does not influence the hand.

In informal Script, speaking in general terms, of course, almost the exact opposite is the case. Comparing point for point, we find that informal Script *appears* to be quite *carelessly* done — that is, without any pretense to formality — and that it *also appears* to have been quite quickly done. Naturally, the hand still guides the tool, but now the tool is given free rein to do its own forming. In other words, the hand does not unduly influence the tool.

Informal Script can be rendered with practically every writing tool imaginable, from a moth-eaten old brush to a piece of chalk. But the basic form of the letter, and not the shape of its strokes, still remains our fundamental concern.

I have attempted below to give the beginner an extremely elastic version of an alphabet of informal Script majuscules embodying the most familiar variations and renderings as they are legible to us today. Thousands of variations on this theme are possible, but I have endeavored to incorporate the most readable forms into one *pen-written* pattern, merely as a basic guide to letter forms.

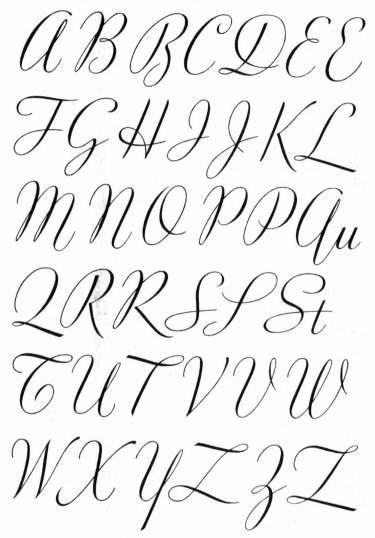

Figure 177. *A composite alphabet of the most commonly accepted variations of informal Script majuscules.*

This composite alphabet does not include many of the basic formal shapes shown on page 213, Figure 149. This fact does not

necessarily exclude them from informal rendering, however. Practically any easily readable shape of majuscule can be adapted to informal Script if you allow the tool you are using to have its way in the matter of shaping the strokes.

The same can be said of the following alphabet of informal Script minuscules, of whose basic shapes thousands of easily readable variations can be made. Yes, thousands, when you realize how different the handwritings of thousands — even millions — of individual writers are.

Figure 178. *Informal Script minuscules. For further still more informal variations, see pages 236 through 245.*

One of the most interesting things about handwriting — informal Script — is that it is taught differently in many parts of the world. This fact has led at least one distinguished American criminologist to formulate a theory that a person's handwriting may give a clue as to the locality in which he learned to write. If this theory were infallible its conclusions would naturally be extremely valuable, but a person's handwriting changes with his age and very often even with his environment. Nevertheless, in keeping with the theory, the fact remains that many people do shape some of their letters in much the same way in which they were taught to

write them as children. This can and does lead to some most extraordinary differences in the shapes of one and the same letter as done by different writers, and, curiously enough, also to some peculiar similarities between different letters. One would imagine that this could lead to utter illegibility, but somehow or other most people, especially the postal authorities, seem able to decipher almost anything in the way of writing.

## HANDWRITING EXAMPLES

We letterers are, of course, not supposed to utilize incongruous combinations, and must endeavor to make our writing and variations thereof as legible as possible to everyone. Which, however, should not prevent us from getting inspiration from the handwriting of others. Start a collection of your friends' handwriting to study the way they render certain letters. On the next few pages are some such examples with which to start your collection. I let them speak for themselves, merely stating where the author of each example learned to write. The **M** or **F** stands for male or female, while the number shows the age of the writer. The text chosen includes all the twenty-six minuscules of the alphabet.

In Italian, the letters **k, j, w, x** and **y** are hardly ever used, except for foreign words, and it is particularly interesting to note how some of these letters, especially the **w**, are formed by Italian writers. See page 236, M36 Italy; page 238, F12 Italy; and page 240, M23 Italy.

German Script, which is practically illegible to most people of other nationalities, uses a little curved hook over the **u** to distinguish it from the **n**, both being formed alike. This explains the fact that many Germans, even when writing what they call "Latin-Script," still automatically put this hook over their **u**'s. See page 239, M26 Germany, and page 242, F48 Germany. Note the peculiar German Script **x** in the latter example. Some also write a complete **t** without raising their pen from the paper; page 240, F50 Germany.

One of the letters with the most variations seems undoubtedly to be the **f**—but from here on I shall leave it to you to discover more such oddities for yourself.

*A quick brown fox jumps over the lazy dog.*

M 31—SPAIN

*A quick brown fox jumps over the lazy dog*

F 22—GERMANY

*A quick brown fox jumps over the lazy dog*

M 36—ITALY

*A quick brown fox jumps over the lazy dog*

M 57—SWEDEN

*A quick brown fox jumps over the lazy dog*

F 18—MEXICO

*The quick brown fox jumped over the lazy black dog.*

F 21—NEW YORK

*A quick brown fox jumps over the lazy dog.*

F 27—PHILIPPINES

236

A quick brown
fox jumps over
the lazy dog

M 33—ITALY

A quick brown
fox jumps over
the lazy dog.

M 54—GERMANY

A quick brown
fox jumps over
the lazy dog

M 63—TURKEY

A quick brown
fox jumps over
the lazy dog

M 8—INDIA

A quick brown
fox jumps over
the lazy dog.

M 38—DOM. REP.

A quick brown fox
jumps over the
lazy dog.

M 62—NEW YORK

A quick brown
fox jumps over
the lazy dog.

M 65—DENMARK

A quick brown
fox jumps over
the lazy dog

F 19—GERMANY

A quick brown fox jumps over
the lazy dog.

M 6—ARGENTINA

A quick brown fox jumps
over the lazy dog.

M 27—NEW YORK

A quick brown
fox jumps over
the lazy dog

F 12—ITALY

A quick brown fox jumps
over the lazy dog.

M 49—ENGLAND

A quick brown fox jumps
over the lazy dog

M 27—CUBA

A quick brown fox
jumps over the lazy dog.

F 27—SWITZERLAND

a quick brown
fox jumps over
the lazy dog

M 9—DENMARK

A quick brown
fox jumps over
the lazy dog.

M 20—BRAZIL

A quick brown fox.
jumps over the lazy
dog.

F 20—AUSTRALIA

A quick brown
fox jumps over
the lazy dog.

F 19—MEXICO

A quick brown
fox jumps over
the lazy dog

M 26—GERMANY

The quick brown fox jumps
over the lazy dog.

M 61—IOWA

a quick brown fox jumps over the
lazy dog.

M 36—SCOTLAND

A quick brown
fox jumps over
the lazy dog.

F 21—MEXICO

A quick brown
fox jump over
the lazy dog.

M 55—NEW YORK

239

A quick brown fox jumps
over the lazy dog.

M 27—SWITZERLAND

A quick Brown
fox jumps over
the lazy dog.

M 23—ITALY

A quick brown fox
jumps over the lazy dog

F 50—GERMANY

A quick brown fox
jumps over the
lazy dog.

M 54—ENGLAND

A quick brown
fox jumps over
the lazy dog.

M 28—GERMANY

A quick brown fox
Jumps over the lazy dog.

M 28—CUBA

240

A quick brown fox jumps
over the lazy dog

F 46—SPAIN

A quick brown fox
jumps over the lazy
dog.

F 23—NEW ZEALAND

A quick brown
fox jumps over
the lazy dog

M 56—HOLLAND

A quick brown
fox jumps over
the lazy dog

F 7—INDIA

A quick brown fox
jumps over the lazy dog

M 33—GEORGIA

A quick brown
fox jumps over
the lazy dog.

F 25—NEW JERSEY

241

A quick brown
fox jumps over
the lazy dog.

F 48—GERMANY

A quick brown
fox jumps over
the lazy dog

F 27—NEW YORK

A quick brown fox
jumps over the lazy
dog.

F 61—ENGLAND

A quick brown fox
jumps over the lazy dog.

M 37—CUBA

A quick brown
fox jumps over
the lazy dog

M 51—ITALY

a quick brown
fox jumps over
the lazy dog.

F 11—CANADA

A quick brown fox
jumps over the lazy dog

M 72—GERMANY

A quick brown fox
jumps over the lazy
dog.

F 23—(MAORI GIRL) NEW ZEALAND

A quick brown fox
jumps over the lazy dog.

F 28—SWITZERLAND

A quick brown fox
jumps over the lazy dog.

F 48—FRANCE

A quick brown
fox jumps over
the lazy dog.

F 13—SWEDEN

A quick brown fox jumps
over the lazy dog

F 24—SWITZERLAND

A quick brown
fox jumps over
the lazy dog

M 32—MEXICO

243

A quick brown fox jumped over the lazy dog

M 27—TRINIDAD, B. W. I.

A quick brown fox jumps over the lazy dog.

M 44—ONTARIO, CANADA

A quick brown fox jumps over the lazy dog

F 23—PANAMA

A quick brown fox jumps over the lazy dog.

M 32—QUEBEC, CANADA

A quick brown fox jumped over the lazy dog

M 29—JAMAICA, B. W. I.

A quick brown fox jumps over the lazy dog.

F 29—BRAZIL

The quick brown fox jumps over the lazy black dog.

F 10—NEW YORK

A quick brown fox jumps over the lazy dog

M 30—PUERTO RICO

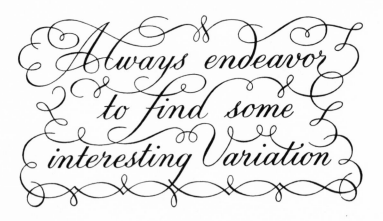

Figure 179. *The formal Script was done first, leaving all ascenders and descenders unfinished. Then flourishes were designed to fit the spaces.*

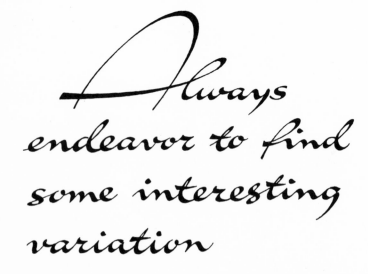

Figure 180. *A characterful piece of informal Script. It could have been written with a plume, but the drawing pen gave finer upstrokes.*

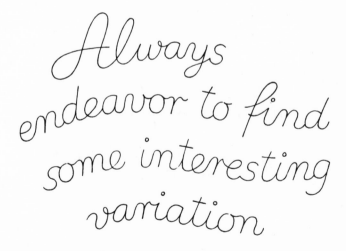

*Always endeavor to find some interesting variation*

Figure 181. *A typical example of brush-written Script, done with no preliminary pencil work. Note the entirely different shape of the bends.*

*Always endeavor to find some interesting variation*

Figure 182. *While looking extremely simple, a great deal of preliminary pencil work was involved.*

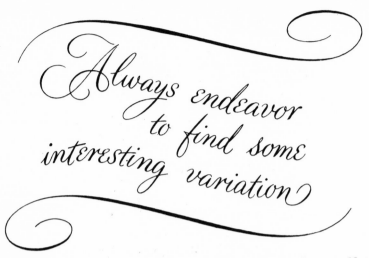

Figure 183. *A charming mixture of formal and informal Script. Note that some words are broken to allow for better letter-spacing.*

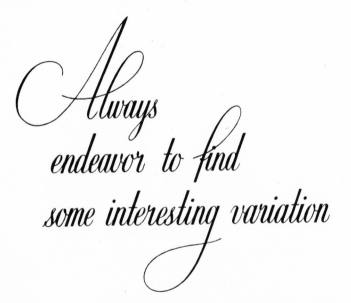

Figure 184. *Well designed and nicely executed, this formal narrow Script needs very little decoration.*

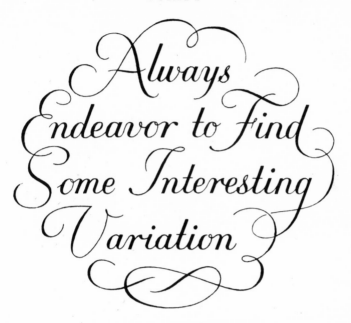

Figure 185.  *Simple round formal Script blends well with many capitals to make a design.*

*Always endeavor to find some interesting variation*

Figure 186.  *A space-saving round hand useful in long texts.*

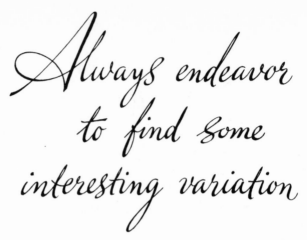

Figure 187. *Apparently done with great speed, this example of informal Script was very carefully pen-drawn to emphasize the irregularity of alignment.*

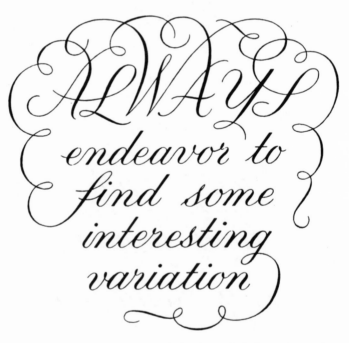

Figure 188. *A Chinese might think this beautiful. But criticize it yourself with the aid of the Formula on page 19.*

*Always endeavor to find some interesting variation*

Figure 189. *Some people may like this. Study it to find out what technique was used, or, better still, try to duplicate it.*

*Always endeavor to find some interesting variation*

Figure 190. *This naturally had to be drawn. While very useful for certain types of work, this style should not be used for long texts.*

251

*Always endeavor
to find some
interesting
variation*

Figure 191. *Compare with Figure 181. In this informal brush-written Script, the upstrokes have the same thickness as the downstrokes. Very little preliminary pencil work was necessary.*

*Always endeavor
to find some inter-
esting variation*

Figure 192. *A freehand pen-drawn version. Compare with 181 and 187.*

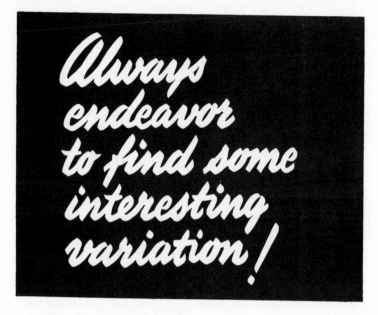

Figure 193. *Compare this typically free brush Script with Figure 191. This example, however, was drawn, working around the letters with black and filling in the background.*

*Always endeavor*
*to find some*
*interesting*
*variation*

Figure 194. *Not too readable because of tight line-spacing. Yet the general effect is pleasing and some letter-forms interesting.*

# BLOCK

# Block

CONSIDERING THE EASE with which Block letters can be formed, and their undeniable versatility, it might appear surprising that they were not "invented" long before they were — which is comparatively recently. That is, as far as our recognizing them by that name is concerned.

The truth is, that Block letters — in the very broadest sense of the word — were used contemporaneously with practically every other style of lettering throughout the ages. The earliest example, within the scope of this book, is the use by the Romans of waxed tablets upon which they scratched their letters with a pointed stylus. Naturally the letters thus formed had no thick and thin strokes, but were uniform throughout, and the use of serifs or embellishments of any kind were superfluous. In fact their use, owing to the effect of light and shade on and in the grooves and burrs, would have made reading less easy.

It is logical to assume that the Roman stonemasons, when "blocking in" their inscriptions preparatory to cutting them, used a simple kind of skeleton outline merely as a guide for SIZE, FORM, LAYOUT and SPACING, and that only apprentices would ever have dreamed of chalking in the serifs.

We cannot use the term Block as a name for a style as we can Roman, Italic, Gothic or Script. In fact it can only be used correctly as an adjective, as for instance:

**BLOCK Roman**
***BLOCK Italic***
*Block Script*

Figure 195

BLOCK

But the two main characteristics are outstanding, namely:

1. The strokes are of uniform thickness.
2. No serifs are used.

The characteristic plume forms of Gothic, with their illusion of thick and thin strokes, do not particularly lend themselves to adaptation as Block letters, and most efforts to do so result in something like this:

Figure 196

Such letters are truly hardly worth the trouble of constructing them, which is the method used in making most Block letters. This does not necessarily mean that Gothic Block letters are an impossibility; for certain decorative purposes they are uniquely suitable. Their very uniqueness, however, will probably demand new designing to fit each individual problem.

## BLOCK MAJUSCULES

The proportions of Block majuscules depend to such a great extent on their stroke thickness, that no hard and fast rule can be made. The "standard" Roman proportions can be applied when making letters with a stroke thickness of 1/7 or less, and the result will be most satisfactory. Anything thicker than this immediately calls for a revision of proportions.

The use of the fraction 1/7 may seem alarming at first. Yet when the great simplicity of the fractional method and its speediness have been explained, I feel sure that a great number of my readers will readily adopt it.

Here is the method: To divide the height between the top and bottom guide lines begin, of course, by drawing the two lines. Let us say they are ¾ of an inch, or 19 millimeters, apart. Obviously you will not be able to find the exact seventh part of these dimensions on any ruler. But you can easily find seven ⅛th inch divisions, or 21 mm., which is seven times 3 mm. So lay your ruler on the paper so that the distance between the two lines now measures ⅞ of an

inch or 21 mm., which is quite simple if you turn it slightly from the right angle. Like this:

Figure 197

Now mark off each ⅛ inch, or 3 mm., whichever you are using.

If you should desire to divide by 5 instead of 7, merely tilt your ruler until you have five easily readable fractions, which would in this case be five ¼ inches or five 5 mm's. It is just as easy to mark the edge of a strip of paper with the desired number of divisions as long as they are identical.

Figure 198

This is the method I invariably use, and for your convenience for quickly visualizing the result of different weights, here is a chart done entirely with ruler and compasses using this method.

Because of the harmonious blending of the Roman proportions

258

# ONE THIRD
# ONE FOURTH
# ONE FIFTH
# ONE SIXTH
# ONE SEVENTH
# ONE EIGHTH
# ONE NINTH
# ONE TENTH
# ONE ELEVENTH

Figure 199. *A convenient diagram for choosing weight or stroke thickness in Block majuscules.*

with the 1/7 stroke thickness in Block majuscules, let us first use the combination of these two factors to demonstrate the simple method of construction.

Figure 200. *The division of seven for majuscules. The bottom five make an ideal division for minuscules. See Figures 225 and 226.*

Note that the letters **E**, **F** and **L** have been combined, as also **C** and **G**, and **O** and **Q**, while two renderings of **W** are given. **J** can be constructed with the wide half circle of **U** or the narrower one of **9**, according to necessity.

It will be seen that to construct most of the alphabet all that is necessary is to draw a number of connecting lines within the eight guide lines, which also serve as a thickness measure and insure uniformity of weight. The proportions of width to height were taken from the canon on page 43 for this sample alphabet. When forming words, however, slight variations are admissible according to what letters become neighbors. **E**, **F**, **L**, **M**, **H**, **Z**, **T** and **P** may be made somewhat narrower, while **R**, **B**, **N**, **A**, **K** and the simple **W** sometimes seem to need a little more width when used near the wider letters. The optical illusion of the round letters — **C**,

**G, O, Q, U, J** and **S** — appearing too small if kept within the guide lines, must be taken care of by allowing them to protrude as usual, but note that the **D** stays within its boundaries.

The still simpler division into fifths gives an exceptionally useful alphabet of Block majuscules:

Figure 201. *The division of five for majuscules. The minuscules for this rather heavy style should take up to four divisions.*

Surprisingly enough, the proportions do not all widen out as might be expected. **S, R, B, A, P, Y** and **W,** as well as the numerals, need more width *to take care of the white spaces within themselves,* but **H, T, U** and **Z** become narrower as if they were trying to *diminish* their white spaces to conform with the other letters. **J,** as usual, is an outsider and generally needs individual attention. Nowhere, other than in heavy Block letters, is the treatment of the white spaces within the letters more important.

At this point, I suggest that you practicing readers try out two alphabets for yourselves, namely with divisions of 4 and 6, to arrive at a better understanding of this fact. The following illustration, if carefully followed, will greatly simplify your endeavors.

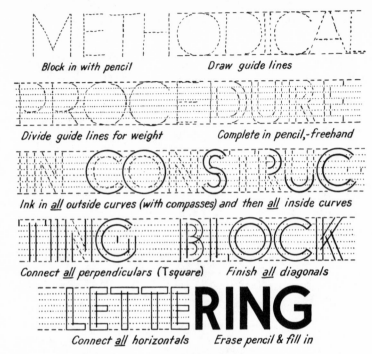

Figure 202

Before turning to other simple forms of mechanically constructed Block majuscules, attention must be drawn to two peculiar optical illusions. Compare the two S's in the following word:

**SLANTS**

Figure 203. *Correction of an optical illusion.*

The first S apparently topples to the left, although the centers of both circles are in a plumb line perpendicular (at right angles) to the guide lines — in other words, mechanically correct. The second S, which appears to be perfectly balanced, has its lower center quite a distance towards the left. The toppling S is a headache to almost every beginner. I hope this hint will remove it and that the

262

following sketch will solve most of his **S** problems:

Figure 204

The second illusion must also be illustrated to be understood. The mechanically correct **5** — that is, with its perpendicular stroke at right angles to the guide lines — will also always topple to the left, the same as the **S**.

**55 55 55**

Figure 205

Another very useful alphabet of Block capitals can be constructed as follows:

Divide the guide lines into six, and then on a strip of paper mark off four of these divisions to serve as a width measure. With this measure you can mark off all twenty-six letters using

  1 square for **I**
  2 squares for **E, F, J** and **L**
  3 squares for **A, B, C, D, G, H, J, K, N, O, P, R, S, T, U, V, Y** and **Z**
  4 squares for **M** and **W**

All the numerals will fit into 3 squares width.

This "recipe" lends itself to a number of variations, three of the most useful of which are shown below. All three were spaced exactly alike in pencil, but the final execution clearly demonstrates the necessity of individual spacing for each style.

K ALWAYS R
SOMETHING
BD NEW QX

Figure 206

As far as legibility goes, this first version will probably be pre-
ferred by the majority. The clearness of the letters with diagonals
as **A, K, N, M, Y** and **W**, and also the rather complicated **G**, make
reading easy. But compare the spacing of the word ALWAYS with
that of the word SOMETHING and it will be seen that the former
is definitely more in harmony with the letters. In other words,
SOMETHING is a little too tightly spaced compared with AL-
WAYS. A further comparison, however, with the other two words
ALWAYS in the following examples will give an interestingly dif-

K ALWAYS R
SOMETHING
BD NEW QX

Figure 207

ferent result. Here, the perpendicular strokes in place of the diagonals give a semi-decorative effect and are at the same time entirely in harmony with the rest of the lettering.

Beginning with the **A**, it will be noticed that the curve connecting the side strokes is a full semicircle with a radius of ½ the width of the letter. This measurement is the same for all letters with curves, except of course **M** and **W**. It is time-saving to remember this when executing letters of this kind; and a most excellent rule in all kinds of constructed letters is to ink the curves with the compasses *before* doing any of the straight lines. It is much easier — and quicker — to fit straight lines onto curves than it is the other way around. Do all your outside curves first — remembering where to protrude when necessary — and then do all the inside ones, using the same center points, and you will have an exact gauge for your connecting straight lines. See Figure 202.

The curves on **M** and **W** are as a rule simpler to do freehand, and it is then more practical to ink the straight lines first. The **S** in this narrower style of Block is also finished freehand after the two semicircles at top and bottom have been inked with the compasses.

The third version, while not particularly artistic, nevertheless has its uses. It is the simplest of all three to construct because only one setting of the compasses is necessary. Here again it is advisable to do the curves first, the center point of which coincides with the square corners inside the letters.

Figure 208

To demonstrate a rather pleasing variation, the four following illustrations were made for quicker comparison. They speak for themselves, and although only weights of one third and one fifth are shown, majuscules of any weight lend themselves well to this less formal treatment.

Figure 209

Figure 210

Before coming to Block minuscules, mention should be made concerning the construction of Block Italic capitals. That mention can be very brief. Put aside your compasses because you will not be able to use them. All curves will have to be done freehand and you will find it simpler and quicker to leave them until last — that

Figure 211

Figure 212

is, until after all the straight lines have been inked. This time it is easier to fit the curves onto the straight lines. The illustration below speaks for itself:

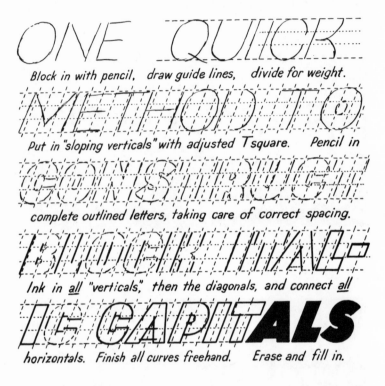

Block in with pencil, draw guide lines, divide for weight.

Put in "sloping verticals" with adjusted T square. Pencil in

complete outlined letters, taking care of correct spacing.

Ink in all "verticals", then the diagonals, and connect all

horizontals. Finish all curves freehand. Erase and fill in.

Figure 213. *A simple step-by-step method for quick and good results.*

A word in general about the sketching in of Block letters is here appropriate. Look at the word QUICK in the above drawing and you will see that the letter **I** has been sketched in with two lines. This was done to roughly indicate its weight, in this case one third of its height. All other letters are sketched in in such a way as *to merely indicate the space they will occupy.* In other words, think of Block letters as blocks and simply draw the outside form to fix their limits — their silhouette, so to say.

This is important when it comes to doing very thick letters, namely, thicker than one third. The word

can be done with strokes of about one half the height, but this thickness is impossible in letters such as **A, B, E, F, G, R & S. A** compromise is possible, however, by drawing the silhouette first and putting in the "holes" afterwards.

The following solution

Figure 215

at least gives a semblance to uniform thickness, and so is, in my opinion, to be preferred to

Figure 216

whose thin lines are structurally out of place.

## EXAMPLES OF BLOCK MAJUSCULES

On the following four pages are a number of examples of straightforward Block majuscules, all of which have been done with ruler and compasses. They show considerable versatility, but by no means exhaust all possibilities.

Figure 217. *An O-filler's contribution. Not all layouts lend themselves to such treatments, but this one may inspire you to experiment.*

Figure 218. *A modern if somewhat unreadable rendering based on the alphabet in Figure 207.*

ALWAYS
ENDEAVOR
TO FIND SOME
INTERESTING
VARIATION

Figure 219

Figure 220. *Excellent division of space. The letters form a pattern with the background. Try the squint test for evenness of color.*

271

Figure 221. *Fine readability with good design. Compare with Figure 220 for Size, Form, Weight, etc.*

ALWAYS
ENDEAVOR
TO FIND SOME
INTERESTING
VARIATION

Figure 222. *The limit in heavy weight. Note that the* **O's** *are also drawn with compasses, using two center points.*

ALWAYS
ENDEAVOR TO
FIND SOME
INTERESTING
VARIATION

Figure 223. *In spite of its apparent playful freedom, this entire job was done with ruler and compasses after careful pencil preparation.*

NARROW
LETTERING
NEEDS WIDER
LETTER-SPACING

Figure 224. *A general rule worth remembering, although it naturally has its exceptions.*

## BLOCK MINUSCULES

Block minuscules, whether straight or slanting, are as simple to construct as majuscules. The division for weight, however, is made between the guide lines of the small letters' body — that is, the letters without ascenders and descenders.

# division of 5 for block minuscules

Figure 225. *What could be simpler? Seven, eight, or nine of these divisions would make ideal capitals.*

The above weight is ideal to show the simplicity of execution, and causes no problems as regards the white spaces within the letters a, e and s. Note the cross stroke of the e; if it were horizontal — in this thickness — the whole letter would appear to fall to the right. The b is based on the plume form, in that the stem is not drawn down to the bottom guide line. Although this is often done, the b illustrated above is to be preferred, if only for its simplicity.

Before leaving the purely mechanically constructed types of Block letters, here is an example of narrow minuscules of the same weight as the above. (Figure 226.)

Although in principle just as easy to make, they entail much more work, because the round letters have straight sides which of course have to be neat tangents to the bottom and top curves. Yet it is a useful and economical alphabet for cramped spaces and exceedingly simple to lay out, because all the letters except i, j, l, m

274

# a narrow style of block, easy to construct :

Figure 226

and w are of practically the same width. This set of minuscules (the missing letters for both the wide and narrow alphabets are given below) naturally goes well with the majuscules * in Figures

# aafighjjpq; &twxyz fl st

Figure 225a

# dghijmpqvxz fi

Figure 226a

* As the weight of these minuscules is one fifth, the height of the majuscules would naturally be eight divisions; that is, five for the small letters plus three for the ascenders. This gives a very well-balanced letter as far as color and readibility go, and the standard Roman proportions are ideal.

200 and 201. They could also be adapted to go with Figure 206.

It is interesting to note that these narrow letters seem smaller than the wider ones in Figures 225 and 225a. The height of both styles is the same, however, and this optical illusion is worth bearing in mind when the question of space is not an important factor.

In constructing the heavy styles of Block minuscules, it will be found that the joining of curves to straight stems gives a clumsy looking result (upper line):

# abdghmpq
# abdghmpq

Figure 227

The lower line shows how this can be avoided, by tapering the curved strokes towards the stem, thus giving a sharper, more clean-cut impression.

## EXAMPLES OF BLOCK MINUSCULES

Concluding these pages on constructed Block minuscules are the following examples for the inspiration of those who like working within the restrictions of T square, compasses and ruler. Also included are a few free-drawn studies.

always
endeavor
to find some
interesting
variation

Figure 228. *Block minuscules with slight serifs. These tend to add crisp sharpness to the corners.*

# Always endeavor to find some interesting variation

Figure 229. *Very readable in spite of tight letter-spacing. A good example of harmony between weight and spacing.*

# always
# endeavor to find
# some interesting
# variation

Figure 230. *Nicely balanced layout together with agreeable distribution of black and white.*

# Always endeavor
# to find
# some interesting
# variation

Figure 231. *Although very similar to Figure 229, the difference in color is remarkable.*

always
endeavor
to find some
interesting
variation

Figure 232. *A little fantasy. Take advantage of such possibilities when designing lettering for packages, trade marks, etc.*

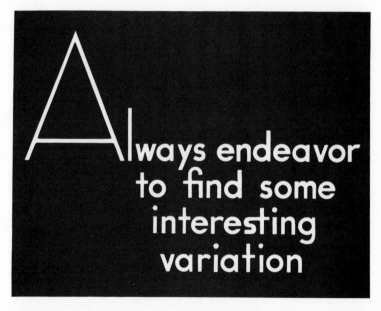

Figure 233. *A combination of simplicity with good layout, resulting in perfect readability.*

# always endeavor to find some interesting variation

Figure 234. *The use of the above* **g** *is permissible when there is little possibility of its being mistaken for* **q**. *The simple form of* **n** *is also quite readable.*

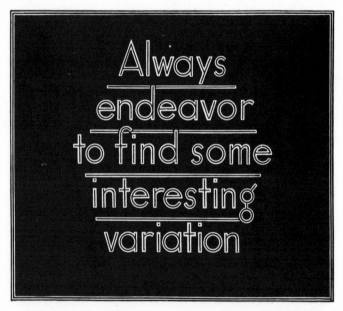

Figure 235. *Careful pencil work, clean craftsmanship and lots of patience were all that were needed for this sparkling job.*

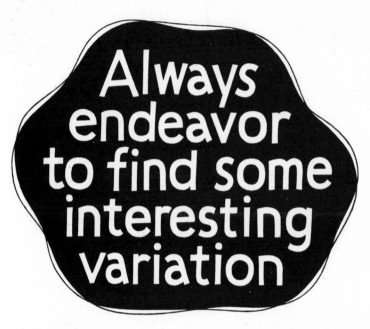

Figure 236. *When possible, make irregular "blurbs" fit the lettering.*

# Always endeavor to find some *interesting* variation

Figure 237. *A good contrasty style for quick readability, as well as a reminder of the use of Italics.*

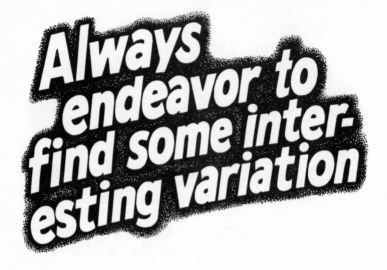

Figure 238. *An unusual background can also be attention-getting, but should not detract from the lettering.*

**Always endeavor to find some interesting variation**

Figure 238a

# *Always en-deavor to find some interest-ing variation!*

Figure 239. *Based on brush-written strokes (Figures 244 and 245), this example was actually drawn to assure crisp sharpness.*

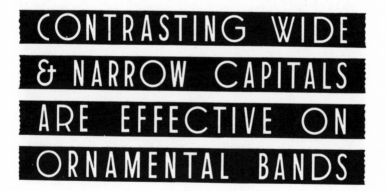

CONTRASTING WIDE
& NARROW CAPITALS
ARE EFFECTIVE ON
ORNAMENTAL BANDS

Figure 239a

handy hints

Handy Hints

Handy Hints

Handy Hints

Handy hints

HANDY HINTS

HANDY HINTS

CHAPTER EIGHTEEN

# *Handy Hints*

THIS CHAPTER deals with a number of subjects which, though somewhat unrelated among themselves, nevertheless do relate to at least a limited degree to each of the previous specialized chapters on styles. Continuity is impossible and unimportant, so the various "hints" will be treated as short separate articles.

## FINDING IDEAS

"How to design a piece of lettering" is often very important, and the preceding title page was done the way it is to show you how easy it is to do just that. It contains only eight renderings of the words "Handy Hints," but it would be a simple matter to make three or four more pages like this and bring the total of "ideas" to forty or more. While doing so one could also adapt all the "Always endeavors . . ." in this book and likewise pick up a little inspiration on pages 10 and 11.

Obviously, one is not always so fortunate as to have so neutral a text as "Handy Hints," but nevertheless it is always good to remember that you have five distinct styles to pick from (all of which are adaptable to an astonishing degree), and that you can double this variety by using majuscules or minuscules. Gothic and Script have their limitations in this last respect, as you already know, but this does not exclude the possibility of such renderings under particular and favorable circumstances.

So if you are ever in doubt as to what style to use, just take a big sheet of paper, and *force yourself* to do at least one sketch of every possibility you can think of. The chances are you will arrive at some idea you hadn't thought of when you were staring at that big white space, and you will suddenly surprise yourself by saying, "Why, *that* sketch lends itself admirably if I do this or that to it!" or words to that effect. An ascender here or a descender there may, with a little exaggeration, help you to form a design; the dots on the I's and their distribution may give you an idea for a playful pattern (see Figures 102, 194, 217 and 232); the very irregularity of your sketch may seem so intriguing that you may want to overdo it for effect's sake; or the words you are writing may even suggest an appropriate treatment — as "speed," for instance, may suggest a quick scribble.

286

You will probably start off with some preconceived notion of your own. Well, do that one by all means and then

> Always endeavor
> to find some
> interesting
> variation

but never be satisfied with your first — and only — effort. There is nearly always a better solution, and it is worth trying to find.

## THE BRUSH AS A LETTERING TOOL

The student's knowledge of how to use a brush has so far been taken for granted. But its use should not be limited to the outlining and filling-in of previously carefully pencil drawn letters.

A good letterer should learn to *wield* his brush — that is, to use it with skill and dexterity and make it become a writing implement in its own right. The Chinese have long set us a high standard worthy of emulation; they have always written with brushes, rather stiffer than ours and with very sharp points, and the amazing range of expression and individual character shown in Chinese writing has led connoisseurs to collect such manuscripts, solely for their beauty's sake.

A good sable brush — sometimes erroneously called a camel's-hair brush (which is quite a different thing, ill suited to most lettering purposes) — is generally judged by its point when wet, which should be sharp and round. It should, however, also be springy and immediately regain its straightness when pressure upon it — while working — is released. Some cheaper brushes, while having excellent points, do not possess this resilience and so are in no way suitable for lettering purposes — that is, as *forming* tools.

The trick of using a good elastic brush is to take advantage of all its good qualities. Not only its point and its springiness, but also the fact that the sides of its bristles are usable almost to their full length. Make this experiment: Dip a brush into India ink (or you may prefer thin tempera black), drain off slightly on the edge of the bottle (or palette) so that it is not overloaded — the point should still be reasonably sharp — and, exerting uniform pressure,

make some strokes like this with the *side* of the brush:

Figure 240

With a little practice you should soon be able to make them quite even in thickness. Then try some curves like this:

((( ((( ((( (((

Figure 241

Next build some **S's**, which will — or should — turn out something like this:

*SSS SS SS SS*

Figure 242

Now experiment with some

## BRUSH-WRITTEN
## BLOCK CAPITALS

Figure 243

Finally do some

**Brush-written small letters**

Figure 244

to get more experience. By this time you will have noticed how interestingly different are the beginnings and endings of these basic strokes. They have an appeal of structure similar to that of plume-written strokes. The slight "italic" slope of these letters tends to give them an air of speediness and informality, yet if carefully done with crisp exactness they can express anything from

Figure 245                    to

Figure 246

All the above examples were done with the same brush and with practically no retouching except on the word "Refinement." A few horizontal guide lines were the only preparation, and for practice purposes even these can be dispensed with.

The whole secret of good brush lettering is a peculiar mixture

of leisure and speed, and can be summed up in one sentence:

> Think carefully how your stroke
> is to look — then paint it quickly!

Or, in other words, know what you want your brush to do and then make it do it.

Brush-script, which is extremely valuable in advertising, calls for still greater dexterity in handling the brush, and here, as in no other style of lettering, is where character and individuality count. This is the sole reason for my not giving any illustrative examples for this particular style of rendering. Having had the great pleasure of teaching many students how to wield their brushes has often resulted in my experiencing a paradoxical feeling of self-satisfaction and disappointment. You may wonder how.

Well, many of those students very soon began to turn out work which looked almost exactly as if I myself had done it. To almost any teacher — a most flattering compliment. But nevertheless I felt a keen disappointment in seeing that my students had — perhaps unwittingly — learned to imitate the ways I held my brush, the way I shaped certain letters and even the way I felt about legibility, layout and even degree of finish. The spirit of experimentation was lacking.

A perfectly shaped brush stroke is a thing of beauty, and whole pages of this book could be filled with examples. The danger in this, however, would be that they might be considered by some to be the only ways of rendering them. I have tried throughout this book not to influence the student by giving him hard and fast forms to copy but rather to help him analyze existing forms and discover new ones for himself. In this way he will learn to master his tools and make them do his bidding.

So here are some further "handy hints" as to what you can make your brush do.

*Write* some words with your brush:

1. Start the strokes thin, thickening them towards the middle and tapering them off again towards the end (see Figure 181).
2. Start off thin and finish thick.
3. Start off thick and finish thin.

Now consider your upstrokes:

1. Make them thin as in pen-written Script.
2. Make them the same thickness as your downstrokes (see Figures 191 and 193).
3. Make them taper off from thick to thin by slowly or quickly relaxing pressure.

And, finally, always remember to treat all the bends in exactly the same manner.

The above hints are useless without practice, and the average beginner will be surprised at how easy such work looks yet how difficult it is to do. But he need not despair. While practicing he will be fascinated by his brush's ability to produce interesting forms, and will soon begin to memorize them. Which is important.

It may take a long time to achieve perfection in informal brush-writing, but here's how you can help yourself in the meantime. Write, with the brush, your message (with or without a preliminary pencil layout) on ordinary layout paper, in the size you need it. Try to write in the mood the message — or its final appearance — wishes to express. If it's a blaring announcement, speed is indicated; a beauty hint or the like may require thoughtful care in graceful forming.

This first effort should be criticized carefully from all angles, and you will be able to see almost immediately what is necessary to improve it. You improve it by covering it with tracing paper and rewriting the whole thing on this tracing paper, shifting your paper to rearrange spacing where necessary, improving letter-forms, exaggerating or changing ascenders or descenders, cross-strokes, etc., etc., thickening or thinning or whatever you wish. Simply repeat this process with new tracing paper on your last sketch until you are satisfied. Then transfer with pencil your final sketch to your job and finish in your favorite technique, remembering of course to faithfully reproduce and perhaps even idealize the original forms your brush had shaped. This may sound like a tedious repetition of effort, but at the beginning it is worth it. With time and practice you will be able to dispense with tracings.

*Note:* The long bristled, square-cut brushes called lettering brushes are generally used for quick showcard work. In the hand of an expert signwriter they can be made to do everything that a plume can do and more. Although very characterful, this kind of lettering hardly ever lends itself to reproduction purposes.

# THE ART OF HAND-LETTERING

## POSITIVE OR NEGATIVE?

These terms are here used in their photographic sense. Positive lettering is generally understood to mean black lettering on a white background, and negative of course means white lettering on a black background. The same terms apply when any dark color is substituted for the black, or any light color for the white.

When to use positive or negative lettering depends generally on the job itself and will not be discussed here. But the use and advantages of negative lettering should always be borne in mind as a possible alternative to positive lettering.

There are many pros and cons in the question of negative or positive lettering.

Visually, negative lettering attracts attention quicker than positive simply because of the unusual contrast of its dark background. This does not mean that white letters on a black background are more easily read. On the contrary, unless they are very simple in form, such as Block, they can appear so unusual, even irritating, that many people will not take the trouble to read them, so that longish — even although important — texts in negative should be strictly avoided.

Esthetically, negative lettering has a remarkable tendency to appear more refined than its positive counterpart. A fact worth remembering when it is chiefly beauty that counts. Naturally a basically well-formed alphabet should be chosen for "reversing," which is the technical term used when photographically done.

But, technically speaking, negative lettering brings up a number of difficulties of which the letterer should at least know something. I am speaking of its reproduction in printing. A lettering artist can achieve the most beautiful effects imaginable by painting with white on a black background, using perhaps hair-fine flourishes or even merely thorn-sharp serifs. But the poor printer will inevitably roll his eyes heavenwards and ask who on earth can expect him to print *that*! Believe me, he is not being difficult; he is merely anticipating the great and almost unsolvable problems the job will probably give him. You see, he has got to print the black background — which needs plenty of black and rather "gooey" ink to cover the surface properly — and the pressure on his printing cylinders is going to make that ink ooze out onto portions of the paper which are supposed to remain white and which un-

fortunately may be your exquisitely done white lettering. And with every impression the situation is liable to grow worse until finally your hair-fine flourishes and delicate serifs no longer exist.

I am not saying that negative lettering is an impossibility and should never be done. I am only warning against its use when technical difficulties — *of which I have mentioned only one* — are liable to arise. A complete list of all printing problems is naturally impossible and out of place in a book of this kind, and if you should imagine that white can be printed on black — which under certain circumstances is quite possible — talk to a printer and allow him to enlighten you!

But negative lettering is nevertheless extremely useful and one should take advantage of its striking contrasts when a job calls for and technically allows it. But which is the best way of doing it?

There are three ways:

1. Doing the job in positive and having it photographically reversed.
2. Painting in white on a black background.
3. Working around the letters with black ink or tempera; in other words, leaving the white of the paper for the letters.

All three have their advantages and disadvantages, but before discussing these I would like to say that I have always found it preferable to submit work to a client in the way it is to be reproduced. That is, if it is to be printed in negative he should be able to see — before printing — what it is going to look like, not in positive but in negative. Your drawing may be larger than it will later appear, but the effect of white on black must be there. This will also effect a saving in printing costs; and where colors are to be used — let us say yellow on dark blue instead of white on black — discuss this point beforehand with your client or, better still, with his printer who will tell you how he wants the drawing made.

Now as to execution:

1. In the case of long texts such as "Directions for Use" on labels or very small company markings or legally necessary information, typesetting is generally used, positive proofs (impressions) are made and then photographically reversed. These negative prints are then cut out and pasted into position on the original artwork.

Yet the artist, while nowadays seldom expected to do large masses of negative lettering, may often find it necessary to do some of the smaller stuff himself, yes, in hand-lettering. Much time can be saved and considerable expense avoided if he does.

Painting tiny white letters on black is exacting work and particularly unpleasant when the execution, which should be sharp and crisp, has to be done with a brush and more or less thick white tempera. It can be done of course, but I invariably prefer to leave the white of the paper for the letters and work around them. This may sound ridiculous, but once you have learned to work in this manner you also will prefer it. Think of it this way: You are retouching your lettering while you are doing it.

First of all it is so much easier to do your preliminary pencil work on white paper, where you can erase and rearrange as often as you wish and, above all, see clearly what you are doing.

Your pencil drawing may look like this:

MADE IN U.S.A.

Now draw two thick ink lines at top and bottom for the height:

MADE IN U.S.A.

With these two simple quickly-drawn lines you have already established uniform height and cleaned up the tops and bottoms of no less than nine letters!

Now ink all your verticals, the majority of which can cross the two horizontals, and notice the neat sharp corners you'll get and which need no further retouching.

MADE IN U.S.A.

Then do your diagonals, with ruler or freehand; followed by the curves:

MADE IN U.S.A.

and fill in.

MADE IN U.S.A.

You will be surprised how much quicker this method is, especially on such letters as **M**, **E** and **W** with their many corners, which take considerable time to paint with a brush and often need a lot of retouching. But remember this hint: you are working up

to the letter's outline and shaping it from the outside. Then you won't go wrong. Above all, the job is done; you have saved type-setting costs, photography costs, the bother of cutting out and pasting, and maybe two or more days of waiting.

2. Painting with white on a black background calls for clean workmanship. Negative Script is invariably done this way when not created photographically. You will find it a great help if you mix your background ink in a palette with a little tempera black. Don't use too much because the ink may curdle! Straight ink often leaves a shiny surface which quickly becomes greasy and will often not take the white paint. The white is also liable to chip off.

The simplest method I know, is to make your drawing on the white paper; then when you are satisfied with layout, etc., make a tracing (with some marks on the edge for later repositioning), and then paint your black background. While this is drying, stroke the back of your tracing with white chalk and rub it in well with your finger. Then, with the background dry, trace each letter through with a very sharp 7H pencil onto your background (be sure your tracing doesn't slip!) and you'll have a perfect job to work on. Stray smudges of chalk on the black are easily picked up with a kneaded eraser when your lettering is dry. You will have a perfect looking job with no shiny pencil marks to mar its beautiful mat black finish.

3. Working around white letters is still my favorite method, as mentioned under 1. All the negative lettering in this book was done that way. Especially when doing Block lettering and thick Script (as on page 253) or heavy Roman (page 90), it is much quicker and definitely crisper, and naturally it cannot chip off — which often happens when two or more coats of white paint are necessary.

And here is a handy hint if you want to make your finished drawing really dazzling. When your pencil drawing is finished, paint over the lettering with a thin wash of white, not letter by letter, but over the whole lettered area. When dry, your pencil will still show through faintly and the suede roughness of the white will form a wonderful foundation with a perfect "grip" for your black. But don't put the white on too thick, and be sure that it is dry before using the black.

By the way, when preparing lettering which is to be printed in

gold, always do it in positive. Gold, or silver, is always printed last and the procedure is generally the following: The lettering is actually printed not with the gold or silver but with a varnish-like ink which dries comparatively slowly; then, while this is still sticky, metallic powder is dusted over it and sticks to the ink. Later, when dry, the superfluous powder is brushed off. So if your design calls for gold lettering on a dark background, finish the design without the lettering and do the lettering on another piece of paper in positive. Naturally I am referring only to art work made ready for reproduction.

## LETTERING IN PERSPECTIVE

This is not half as difficult as it seems, and considering the eye-catching value of perspective you should experiment with it when a particular job calls for special treatment.

Here are three suggestions for quick results:

Block lettering lends itself best for massive and, if called for, three dimensional treatment.

# PERSPECTIVE

Figure 247a. *A flat preliminary sketch to arrive at Figure 247b.*

Remember how easy it was to construct Block capitals of one-fifth (see page 261) and apply the same system in perspective. Of course you don't have to use this division; any other will do.

Once you have drawn your top and bottom guide lines, foreshortened the way you need them, divide the height at the "front" end by five (or whatever you wish to use) with your paper measure, then do the same at the "rear" end, join up the marks and there's your perspective.

Pencil in your letters, remembering that the vertical stroke-thickness will always form an *optical* square within one of the divisions, therefore your vertical strokes will automatically get thinner and thinner. The horizontals will take care of themselves. Round letters may cause you a little trouble at first, but by putting an O in an *optical,* or foreshortened, square and making an S out of two such smaller squares you will soon find them easy enough to construct.

PERSPECTIVE

Figure 247b. *One of many possible results from Figure 247a.*

The above example is not 100 per cent in true perspective. If it were, the last five letters would be much tighter together and hence more difficult to read. Such adjustments must be made for legibility's sake.

Script and Italic in perspective need a little more preparation, and until you are quite sure of yourself it is advisable to first make your drawing "in the flat," like this:

Figure 248a. *Compare with Figure 248b.*

A pencil sketch will do. The extra guide line will prove useful and you should pick out one of the long letters — the **p,** for instance — to define the angle of your sloping vertical.

The outlines of the card in the following example

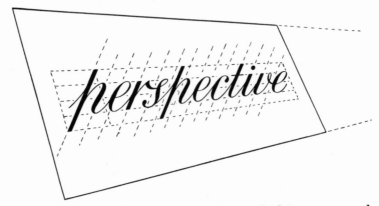

Figure 248b. *The word has been slightly stretched for greater reada-bility. Such concessions must be made at the expense of true perspec-tive, but don't overdo it.*

are a great optical help. If you continue the two long ones to the "horizon" where they will meet and cross, the point where they do can be "fixed" on your drawing board with an ordinary pin. All your horizontal guide lines will meet at that point and all you will have to do is to lightly press one end of your ruler against the pin and glide it up and down at the other free end as your guide for drawing your horizontal lines in perspective.

The left-hand edge of the above card was drawn next, followed by the upright pencil line joining the four guide lines (at the **p**), optically parallel to this edge. Three divisions of this line were then marked off on the top guide line and the second upright (cutting through the **p**) was drawn in. The diagonal of this 4 x 3 rectangle gave the sloping vertical, which with the aid of the ad-justable T square was repeated several times along and across the horizontals.

Sketching in the Script was now a simple matter. (In such a case, an occasional glance at one's first "flat" sketch will facilitate spac-ing.) The right-hand edge of the card next completed the drawing.

This method is also not 100 per cent perspectively correct, but for most purposes it will do and its simplicity will give quick and satisfactory results.

For the most correct construction of lettering in perspective the "checker-board" method is the best.

Figure 249a

This drawing "in the flat" shows how the letters fit perfectly in-
to one and a half large squares. The subdivision into many smaller
squares with their additional diagonals is to simplify the fixing of
a greater number of crossing points — that is, where the outlines
of the letters cross the lines of the squared background (shown in
dotted lines).

Whether you intend to make a "sky view"

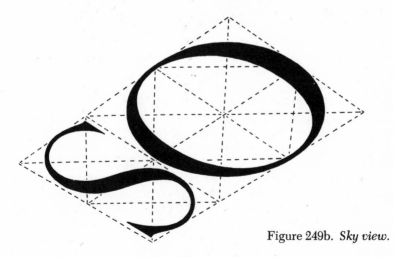

Figure 249b. *Sky view*.

that is, seen from below, or a "bird's-eye view"

299

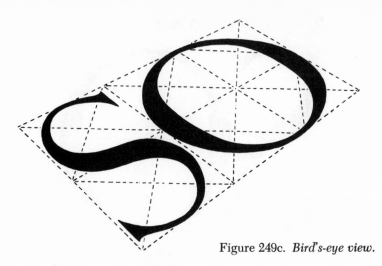

Figure 249c. *Bird's-eye view.*

which would be on the ground far below eye level, or a rather flat "table-top view" (only slightly below eye level)

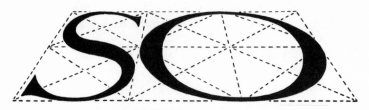

Figure 249d. *Table-top view.*

the basic procedure will always remain the same.

Make your first drawing in the flat and be sure that FORM, WEIGHT, and SPACING are correct. Any errors at this stage will show up as very noticeable distortions in your perspective drawing.

Now cover this drawing with squares as in Figure 249a. This can be done quite arbitrarily, but naturally the squares must all be of the same size. Putting in some or all of the diagonals at this stage is not absolutely necessary, but a great help when there are many curved letters.

Now sketch in *only the squared background* of your lettering on the job itself *in the desired perspective*. This may take considerable time to get exact, but with the help of diagonals which

300

run through more than one square you will soon see where your drawing is off.

Here is a schematic drawing to show you what I mean. The two "flaps" from the central unforeshortened or "flat" square might be called in "wall" perspective.

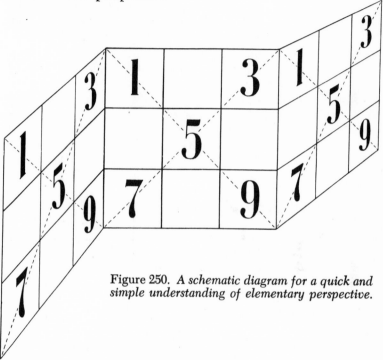

Figure 250. *A schematic diagram for a quick and simple understanding of elementary perspective.*

The diagonals running through the squares 1, 5 and 9, and 7, 5 and 3, will always give you the exact location of these squares' corners. Note the considerable difference in size and shape of the square 7 on the extreme left and the square 3 on the extreme right. But they look perspectively correct and they are.

On your drawing you may prefer to add the diagonals of the squares 2, 4, 6 and 8, and even join their crossing points with more "parallel" horizontal and vertical lines to get still more squares.

The rest is easy. See where the outlines of your lettering cross the background lines and mark these points on your perspective background. Connect these points with straight or curved lines as

301

the case may be, and your pencil drawing is ready for finishing.

Any style of lettering can be drawn in perspective in this way — in fact, any drawing for that matter. But, as previously stated, lettering can tend to become illegible if its perspective is over-exaggerated.

The fact that lettering can be photographed in almost any desired perspective is of course a consolation to artists who only have to pick up a telephone to speak to the commercial photographer and make an appointment. The drawbacks: The photographer will need finished lettering in the flat to begin with, plus an exact layout of the perspective desired. He will also have to charge for his time in working to exacting specifications, focussing at difficult angles and similar extras, and by the time you finally get your print, you will wonder whether it would not have been quicker and a lot cheaper to have drawn it in perspective right from the start yourself.

## LETTERING ON CURVES

For decorative and layout purposes, the use of lettering on curved instead of straight lines is valuable. It looks easy but it definitely isn't.

In fact, if you are striving for perfection, get ready for a struggle; and here a photographer will not be able to help you. Every letter in a curved line of lettering should be made to look optically correct on that curved line.

To understand this, carefully examine the FORM of the letters and their SPACING, in the two following examples:

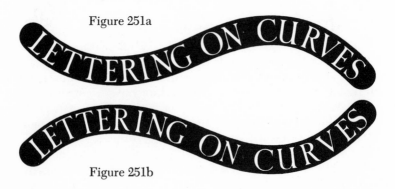

Figure 251a

Figure 251b

302

Both these bands were made in the same way. The letters were drawn first on a straight line, cut out, then pasted on the bands and finally the background was filled in around them. The spacing in both examples is bad, although every effort was made to counteract this.

It must be emphasized that the letters themselves in both 251a and 251b were drawn, with normal proportions and forms, on straight lines and *looked perfect* in that stage — that is, before they were cut apart and rearranged on the bands. Now, some of them are so optically distorted that they appear to have been badly drawn, some of them seemingly too wide at the top or the bottom, while the spacing in places is bad enough even for a layman to notice. It should also be noticed that the direction of the band's curvature influences these distortions differently in the two examples. Some words lend themselves to bending one way and others to another. If it is immaterial which way your bands curve, try out both possibilities before deciding.

There are no short cuts for perfect lettering on curved lines. Where necessary, each letter must be drawn with discriminating distortion to fit the curve *and* the letters which precede and follow. Not only must the axis of each letter appear to be at right angles to the curve, but its whole silhouette must be adjusted to allow for optical illusions. Examine the **E's, N's** and particularly the **U** in the following example by covering up the neighboring

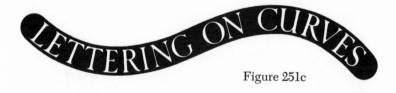

Figure 251c

letters and you will see what I mean. Also, in this particular example, note how the horizontal strokes of the **T's** and **E's** have been curved to become parallel with the band itself, and that even the serifs follow this curved direction.

A deviation from this principle of setting your letters at right angles to the curve may also result in letters of different optical heights. This is particularly and unpleasantly noticeable when it comes to doing Italic and Script in this way. However, here is a

303

very simple method of putting in your sloping verticals — which, for a change, are drawn before you sketch in your lettering — and being sure that your letters are of uniform height and uniform optical slope.

Figure 252

First, draw your parallel guide lines at top and bottom, naturally equidistant from end to end. Across these lines draw your first sloping vertical at the angle you need (see **I** above). Now make yourself one of those handy little paper measures we have so often used, by applying one of its straight edges to this line and marking off the points where the sloping vertical crosses the two guide lines. Use stiff paper for this aid, because it is about to become a ruler. Now move your paper ruler a little to the right so that the marks again coincide with top and bottom lines and draw another sloping vertical along its edge. Continue this at intervals until your whole line is ruled and you can start with your lettering.

Figure 253

With Script, you follow exactly the same procedure except that your sloping vertical is now more slanting, which makes the marking points on your paper ruler wider apart than in Italic.

By the way, here's a handy hint for drawing perfectly parallel curved lines. Draw a single curved line in the direction you need it and consider this the center line of your lettering. It is the solid line in the drawing below. Now take your pencil compasses and,

using this line as center, draw as many circles as you think you will
need. Then simply join the extreme edges of these circles with a
tangent and there are your parallel curves.

Figure 254

# A Tribute to Type

So MUCH HAS BEEN SAID about hand-lettering in this book, that the few mentions which type has received seem like a great injustice.

It must always be remembered — yes, with gratitude — that it was the inventiveness, skill, patience and artistic endeavors of many generations of printers, type founders, engravers, lettering designers, typesetters and all the other artisans connected with this honorable calling, that have made even this modest contribution towards better lettering possible.

And let me add, as a word of inspiration to the aspiring student of lettering, that all the type faces we have today were once originally hand drawn, designed and redesigned, engraved and cast over and over again in untold endeavors to achieve perfection within the specific limitations of the printer's art.

May that student one day experience the thrill of seeing his own work cut in type!

In view of the typesetter's contribution to all this, it is only fitting that I give him the last word, which I do through the inclusion of the following typeset examples using some of the finest type faces at his disposal. The layout, spacing, etc., of these truly fine specimens of typesetting were left entirely to the typesetters. whom I thank for their splendid cooperation.

# Always endeavor to find some interesting variation

36 point CLOISTER BLACK with 72 point LOMBARDIC INITIAL

Always endeavor
to find some
interesting variation

36 point CASLON ANTIQUE with 18 point CABIN ORNAMENT

# ALWAYS ENDEAVOR
☆     TO FIND     ☆
# SOME INTERESTING
☆     VARIATION     ☆

18 point GOUDY BOLD with 72 point WEDGEWOOD CAMEO

*Always*

*endeavor to find*

*some*

*interesting*

*variation*

36 point COMMERCIAL SCRIPT with 48 point ULTRA BODONI INITIAL

309

*Always endeavor*

*to find some interesting*

*variation*

42 point BERNHARD CURSIVE BOLD with SEA GULL ORNAMENTS

# ALWAYS ENDEAVOR TO FIND SOME INTERESTING VARIATION

24 point FRANKLIN GOTHIC

*Always endeavor to find some interesting variation*

36 point BRUSH with 72 point CLOISTER CURSIVE HANDTOOLED INITIAL

# Always endeavor to find some interesting variation

36 point CASLON No. 540, roman and italic, with 60 point CASLON 540 INITIAL

14 point CARTOON LIGHT with CLOUD ORNAMENTS No. 1

ALWAYS

ENDEAVOR

TO FIND SOME

INTERESTING

VARIATION

18 point HADRIANO with 12 point DELLA ROBBIA BORDER No. 1

18 point FORUM TITLE with 6 point CLELAND BORDER No. 632

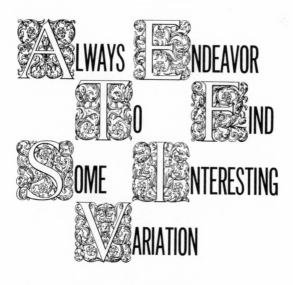

48 point TORY INITIALS and 30 point NEWS GOTHIC EXTRA CONDENSED

THE ART OF HAND-LETTERING

*Always*

*Endeavor to Find*

*Some Interesting*

*Variation*

48 point BANK SCRIPT

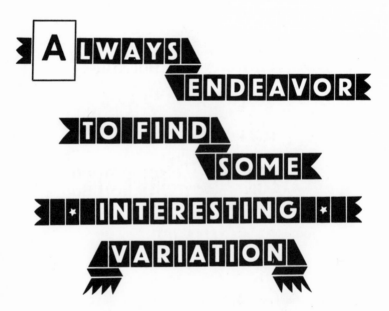

**ALWAYS ENDEAVOR TO FIND SOME ✶ INTERESTING ✶ VARIATION**

20 point LUCINA with 30 point FUTURA DEMI BOLD INITIAL

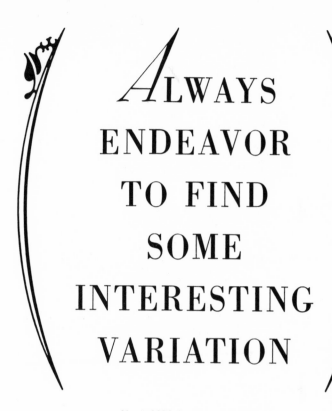

# Always ENDEAVOR TO FIND SOME INTERESTING VARIATION

30 point BODONI with No. A2 VANITY INITIAL

*The foregoing examples*
*were hand-set by master typographers*
*in the composing room of*
*Alex. G. Highton*
*Newark, N. J.*
*in 1952*

# Index

A CATALOGUE OF SELECTED DOVER BOOKS
IN ALL FIELDS OF INTEREST

# A CATALOGUE OF SELECTED DOVER BOOKS
## IN ALL FIELDS OF INTEREST

THE NOTEBOOKS OF LEONARDO DA VINCI, edited by J.P. Richter. Extracts from manuscripts reveal great genius; on painting, sculpture, anatomy, sciences, geography, etc. Both Italian and English. 186 ms. pages reproduced, plus 500 additional drawings, including studies for Last Supper, Sforza monument, etc. 860pp. 7⅞ x 10¾.                    USO 22572-0, 22573-9 Pa., Two vol. set $15.90

ART NOUVEAU DESIGNS IN COLOR, Alphonse Mucha, Maurice Verneuil, Georges Auriol. Full-color reproduction of Combinaisons ornamentales (c. 1900) by Art Nouveau masters. Floral, animal, geometric, interlacings, swashes — borders, frames, spots — all incredibly beautiful. 60 plates, hundreds of designs. 9⅜ x 8¹/₁₆ .                    22885-1 Pa. $4.00

GRAPHIC WORKS OF ODILON REDON. All great fantastic lithographs, etchings, engravings, drawings, 209 in all. Monsters, Huysmans, still life work, etc. Introduction by Alfred Werner. 209pp. 9⅛ x 12¼.                    21996-8 Pa. $6.00

EXOTIC FLORAL PATTERNS IN COLOR, E.-A. Seguy. Incredibly beautiful full-color pochoir work by great French designer of 20's. Complete Bouquets et frondaisons, Suggestions pour étoffes. Richness must be seen to be believed. 40 plates containing 120 patterns. 80pp. 9⅜ x 12¼.                    23041-4 Pa. $6.00

SELECTED ETCHINGS OF JAMES A. McN. WHISTLER, James A. McN. Whistler. 149 outstanding etchings by the great American artist, including selections from the Thames set and two Venice sets, the complete French set, and many individual prints. Introduction and explanatory note on each print by Maria Naylor. 157pp. 9⅜ x 12¼.                    23194-1 Pa. $5.00

VISUAL ILLUSIONS: THEIR CAUSES, CHARACTERISTICS, AND APPLICATIONS, Matthew Luckiesh. Thorough description, discussion; shape and size, color, motion; natural illusion. Uses in art and industry. 100 illustrations. 252pp.
21530-X Pa. $2.50

TEN BOOKS ON ARCHITECTURE, Vitruvius. The most important book ever written on architecture. Early Roman aesthetics, technology, classical orders, site selection, all other aspects. Stands behind everything since. Morgan translation. 331pp.
20645-9 Pa. $3.50

THE CODEX NUTTALL. A PICTURE MANUSCRIPT FROM ANCIENT MEXICO, as first edited by Zelia Nuttall. Only inexpensive edition, in full color, of a pre-Columbian Mexican (Mixtec) book. 88 color plates show kings, gods, heroes, temples, sacrifices. New explanatory, historical introduction by Arthur G. Miller. 96pp. 11⅜ x 8½.                    23168-2 Pa. $7.50

CATALOGUE OF DOVER BOOKS

Austrian Cooking and Baking, Gretel Beer. Authentic thick soups, wiener schnitzel, veal goulash, more, plus dumplings, puff pastries, nut cakes, sacher tortes, other great Austrian desserts. 224pp.                USO 23220-4 Pa. $2.50

Cheeses of the World, U.S.D.A. Dictionary of cheeses containing descriptions of over 400 varieties of cheese from common Cheddar to exotic Surati. Up to two pages are given to important cheeses like Camembert, Cottage, Edam, etc. 151pp.                                                        22831-2 Pa. $1.50

Tritton's Guide to Better Wine and Beer Making for Beginners, S.M. Tritton. All you need to know to make family-sized quantities of over 100 types of grape, fruit, herb, vegetable wines; plus beers, mead, cider, more. 11 illustrations. 157pp.                                              USO 22528-3 Pa. $2.25

Decorative Labels for Home Canning, Preserving, and Other Household and Gift Uses, Theodore Menten. 128 gummed, perforated labels, beautifully printed in 2 colors. 12 versions in traditional, Art Nouveau, Art Deco styles. Adhere to metal, glass, wood, most plastics. 24pp. 8¼ x 11.   23219-0 Pa. $2.00

Five Acres and Independence, Maurice G. Kains. Great back-to-the-land classic explains basics of self-sufficient farming: economics, plants, crops, animals, orchards, soils, land selection, host of other necessary things. Do not confuse with skimpy faddist literature; Kains was one of America's greatest agriculturalists. 95 illustrations. 397pp.                                       20974-1 Pa. $3.00

Growing Vegetables in the Home Garden, U.S. Dept. of Agriculture. Basic information on site, soil conditions, selection of vegetables, planting, cultivation, gathering. Up-to-date, concise, authoritative. Covers 60 vegetables. 30 illustrations. 123pp.                                           23167-4 Pa. $1.35

Fruits for the Home Garden, Dr. U.P. Hedrick. A chapter covering each type of garden fruit, advice on plant care, soils, grafting, pruning, sprays, transplanting, and much more! Very full. 53 illustrations. 175pp.          22944-0 Pa. $2.50

Gardening on Sandy Soil in North Temperate Areas, Christine Kelway. Is your soil too light, too sandy? Improve your soil, select plants that survive under such conditions. Both vegetables and flowers. 42 photos. 148pp.
                                                        USO 23199-2 Pa. $2.50

The Fragrant Garden: A Book about Sweet Scented Flowers and Leaves, Louise Beebe Wilder. Fullest, best book on growing plants for their fragrances. Descriptions of hundreds of plants, both well-known and overlooked. 407pp.
                                                        23071-6 Pa. $4.00

Easy Gardening with Drought-Resistant Plants, Arno and Irene Nehrling. Authoritative guide to gardening with plants that require a minimum of water: seashore, desert, and rock gardens; house plants; annuals and perennials; much more. 190 illustrations. 320pp.                              23230-1 Pa. $3.50

## CATALOGUE OF DOVER BOOKS

HOUDINI ON MAGIC, Harold Houdini. Edited by Walter Gibson, Morris N. Young. How he escaped; exposés of fake spiritualists; instructions for eye-catching tricks; other fascinating material by and about greatest magician. 155 illustrations. 280pp. 20384-0 Pa. **$2.75**

HANDBOOK OF THE NUTRITIONAL CONTENTS OF FOOD, U.S. Dept. of Agriculture. Largest, most detailed source of food nutrition information ever prepared. Two mammoth tables: one measuring nutrients in 100 grams of edible portion; the other, in edible portion of 1 pound as purchased. Originally titled Composition of Foods. 190pp. 9 x 12. 21342-0 Pa. $4.00

COMPLETE GUIDE TO HOME CANNING, PRESERVING AND FREEZING, U.S. Dept. of Agriculture. Seven basic manuals with full instructions for jams and jellies; pickles and relishes; canning fruits, vegetables, meat; freezing anything. Really good recipes, exact instructions for optimal results. Save a fortune in food. 156 illustrations. 214pp. 6⅛ x 9¼. 22911-4 Pa. $2.50

THE BREAD TRAY, Louis P. De Gouy. Nearly every bread the cook could buy or make: bread sticks of Italy, fruit breads of Greece, glazed rolls of Vienna, everything from corn pone to croissants. Over 500 recipes altogether. including buns, rolls, muffins, scones, and more. 463pp. 23000-7 Pa. $3.50

CREATIVE HAMBURGER COOKERY, Louis P. De Gouy. 182 unusual recipes for casseroles, meat loaves and hamburgers that turn inexpensive ground meat into memorable main dishes: Arizona chili burgers, burger tamale pie, burger stew, burger corn loaf, burger wine loaf, and more. 120pp. 23001-5 Pa. $1.75

LONG ISLAND SEAFOOD COOKBOOK, J. George Frederick and Jean Joyce. Probably the best American seafood cookbook. Hundreds of recipes. 40 gourmet sauces, 123 recipes using oysters alone! All varieties of fish and seafood amply represented. 324pp. 22677-8 Pa. $3.50

THE EPICUREAN: A COMPLETE TREATISE OF ANALYTICAL AND PRACTICAL STUDIES IN THE CULINARY ART, Charles Ranhofer. Great modern classic. 3,500 recipes from master chef of Delmonico's, turn-of-the-century America's best restaurant. Also explained, many techniques known only to professional chefs. 775 illustrations. 1183pp. 6⅝ x 10. 22680-8 Clothbd. $22.50

THE AMERICAN WINE COOK BOOK, Ted Hatch. Over 700 recipes: old favorites livened up with wine plus many more: Czech fish soup, quince soup, sauce Perigueux, shrimp shortcake, filets Stroganoff, cordon bleu goulash, jambonneau, wine fruit cake, more. 314pp. 22796-0 Pa. $2.50

DELICIOUS VEGETARIAN COOKING, Ivan Baker. Close to 500 delicious and varied recipes: soups, main course dishes (pea, bean, lentil, cheese, vegetable, pasta, and egg dishes), savories, stews, whole-wheat breads and cakes, more. 168pp.
USO 22834-7 Pa. $1.75

THE MAGIC MOVING PICTURE BOOK, Bliss, Sands & Co. The pictures in this book move! Volcanoes erupt, a house burns, a serpentine dancer wiggles her way through a number. By using a specially ruled acetate screen provided, you can obtain these and 15 other startling effects. Originally "The Motograph Moving Picture Book." 32pp. 8¼ x 11.                23224-7 Pa. $1.75

STRING FIGURES AND HOW TO MAKE THEM, Caroline F. Jayne. Fullest, clearest instructions on string figures from around world: Eskimo, Navajo, Lapp, Europe, more. Cats cradle, moving spear, lightning, stars. Introduction by A.C. Haddon. 950 illustrations. 407pp.                20152-X Pa. $3.50

PAPER FOLDING FOR BEGINNERS, William D. Murray and Francis J. Rigney. Clearest book on market for making origami sail boats, roosters, frogs that move legs, cups, bonbon boxes. 40 projects. More than 275 illustrations. Photographs. 94pp.
20713-7 Pa. $1.25

INDIAN SIGN LANGUAGE, William Tomkins. Over 525 signs developed by Sioux, Blackfoot, Cheyenne, Arapahoe and other tribes. Written instructions and diagrams: how to make words, construct sentences. Also 290 pictographs of Sioux and Ojibway tribes. 111pp. 6⅛ x 9¼.                22029-X Pa. $1.50

BOOMERANGS: HOW TO MAKE AND THROW THEM, Bernard S. Mason. Easy to make and throw, dozens of designs: cross-stick, pinwheel, boomabird, tumblestick, Australian curved stick boomerang. Complete throwing instructions. All safe. 99pp.                23028-7 Pa. $1.75

25 KITES THAT FLY, Leslie Hunt. Full, easy to follow instructions for kites made from inexpensive materials. Many novelties. Reeling, raising, designing your own. 70 illustrations. 110pp.                22550-X Pa. $1.25

TRICKS AND GAMES ON THE POOL TABLE, Fred Herrmann. 79 tricks and games, some solitaires, some for 2 or more players, some competitive; mystifying shots and throws, unusual carom, tricks involving cork, coins, a hat, more. 77 figures. 95pp.                21814-7 Pa. $1.25

WOODCRAFT AND CAMPING, Bernard S. Mason. How to make a quick emergency shelter, select woods that will burn immediately, make do with limited supplies, etc. Also making many things out of wood, rawhide, bark, at camp. Formerly titled Woodcraft. 295 illustrations. 580pp.                21951-8 Pa. $4.00

AN INTRODUCTION TO CHESS MOVES AND TACTICS SIMPLY EXPLAINED, Leonard Barden. Informal intermediate introduction: reasons for moves, tactics, openings, traps, positional play, endgame. Isolates patterns. 102pp. USO 21210-6 Pa. $1.35

LASKER'S MANUAL OF CHESS, Dr. Emanuel Lasker. Great world champion offers very thorough coverage of all aspects of chess. Combinations, position play, openings, endgame, aesthetics of chess, philosophy of struggle, much more. Filled with analyzed games. 390pp.                20640-8 Pa. **$4.00**

HOW TO SOLVE CHESS PROBLEMS, Kenneth S. Howard. Practical suggestions on problem solving for very beginners. 58 two-move problems, 46 3-movers, 8 4-movers for practice, plus hints. 171pp. 20748-X Pa. $2.00

A GUIDE TO FAIRY CHESS, Anthony Dickins. 3-D chess, 4-D chess, chess on a cylindrical board, reflecting pieces that bounce off edges, cooperative chess, retrograde chess, maximummers, much more. Most based on work of great Dawson. Full handbook, 100 problems. 66pp. 7⅞ x 10¾. 22687-5 Pa. $2.00

WIN AT BACKGAMMON, Millard Hopper. Best opening moves, running game, blocking game, back game, tables of odds, etc. Hopper makes the game clear enough for anyone to play, and win. 43 diagrams. 111pp. 22894-0 Pa. $1.50

BIDDING A BRIDGE HAND, Terence Reese. Master player "thinks out loud" the binding of 75 hands that defy point count systems. Organized by bidding problem—no-fit situations, overbidding, underbidding, cueing your defense, etc. 254pp. EBE 22830-4 Pa. $3.00

THE PRECISION BIDDING SYSTEM IN BRIDGE, C.C. Wei, edited by Alan Truscott. Inventor of precision bidding presents average hands and hands from actual play, including games from 1969 Bermuda Bowl where system emerged. 114 exercises. 116pp. 21171-1 Pa. $1.75

LEARN MAGIC, Henry Hay. 20 simple, easy-to-follow lessons on magic for the new magician: illusions, card tricks, silks, sleights of hand, coin manipulations, escapes, and more —all with a minimum amount of equipment. Final chapter explains the great stage illusions. 92 illustrations. 285pp. 21238-6 Pa. $2.95

THE NEW MAGICIAN'S MANUAL, Walter B. Gibson. Step-by-step instructions and clear illustrations guide the novice in mastering 36 tricks; much equipment supplied on 16 pages of cut-out materials. 36 additional tricks. 64 illustrations. 159pp. 6⅝ x 10. 23113-5 Pa. $3.00

PROFESSIONAL MAGIC FOR AMATEURS, Walter B. Gibson. 50 easy, effective tricks used by professionals —cards, string, tumblers, handkerchiefs, mental magic, etc. 63 illustrations. 223pp. 23012-0 Pa. $2.50

CARD MANIPULATIONS, Jean Hugard. Very rich collection of manipulations; has taught thousands of fine magicians tricks that are really workable, eye-catching. Easily followed, serious work. Over 200 illustrations. 163pp. 20539-8 Pa. $2.00

ABBOTT'S ENCYCLOPEDIA OF ROPE TRICKS FOR MAGICIANS, Stewart James. Complete reference book for amateur and professional magicians containing more than 150 tricks involving knots, penetrations, cut and restored rope, etc. 510 illustrations. Reprint of 3rd edition. 400pp. 23206-9 Pa. $3.50

THE SECRETS OF HOUDINI, J.C. Cannell. Classic study of Houdini's incredible magic, exposing closely-kept professional secrets and revealing, in general terms, the whole art of stage magic. 67 illustrations. 279pp. 22913-0 Pa. $2.50

DECORATIVE ALPHABETS AND INITIALS, edited by Alexander Nesbitt. 91 complete alphabets (medieval to modern), 3924 decorative initials, including Victorian novelty and Art Nouveau. 192pp. 7¾ x 10¾.                    20544-4 Pa. $4.00

CALLIGRAPHY, Arthur Baker. Over 100 original alphabets from the hand of our greatest living calligrapher: simple, bold, fine-line, richly ornamented, etc. —all strikingly original and different, a fusion of many influences and styles. 155pp. 11⅜ x 8¼.                    22895-9 Pa. $4.50

MONOGRAMS AND ALPHABETIC DEVICES, edited by Hayward and Blanche Cirker. Over 2500 combinations, names, crests in very varied styles: script engraving, ornate Victorian, simple Roman, and many others. 226pp. 8⅛ x 11.

22330-2 Pa. $5.00

THE BOOK OF SIGNS, Rudolf Koch. Famed German type designer renders 493 symbols: religious, alchemical, imperial, runes, property marks, etc. Timeless. 104pp. 6⅛ x 9¼.                    20162-7 Pa. $1.75

200 DECORATIVE TITLE PAGES, edited by Alexander Nesbitt. 1478 to late 1920's. Baskerville, Dürer, Beardsley, W. Morris, Pyle, many others in most varied techniques. For posters, programs, other uses. 222pp. 8⅜ x 11¼.    21264-5 Pa. **$5.00**

DICTIONARY OF AMERICAN PORTRAITS, edited by Hayward and Blanche Cirker. 4000 important Americans, earliest times to 1905, mostly in clear line. Politicians, writers, soldiers, scientists, inventors, industrialists, Indians, Blacks, women, outlaws, etc. Identificatory information. 756pp. 9¼ x 12¾. 21823-6 Clothbd. $30.00

ART FORMS IN NATURE, Ernst Haeckel. Multitude of strangely beautiful natural forms: Radiolaria, Foraminifera, jellyfishes, fungi, turtles, bats, etc. All 100 plates of the 19th century evolutionist's Kunstformen der Natur (1904). 100pp. 9⅜ x 12¼.                    22987-4 Pa. $4.00

DECOUPAGE: THE BIG PICTURE SOURCEBOOK, Eleanor Rawlings. Make hundreds of beautiful objects, over 550 florals, animals, letters, shells, period costumes, frames, etc. selected by foremost practitioner. Printed on one side of page. 8 color plates. Instructions. 176pp. 9³⁄₁₆ x 12¼.                    23182-8 Pa. $5.00

AMERICAN FOLK DECORATION, Jean Lipman, Eve Meulendyke. Thorough coverage of all aspects of wood, tin, leather, paper, cloth decoration — scapes, humans, trees, flowers, geometrics — and how to make them. Full instructions. 233 illustrations, 5 in color. 163pp. 8⅜ x 11¼.                    22217-9 Pa. $3.95

WHITTLING AND WOODCARVING, E.J. Tangerman. Best book on market; clear, full. If you can cut a potato, you can carve toys, puzzles, chains, caricatures, masks, patterns, frames, decorate surfaces, etc. Also covers serious wood sculpture. Over 200 photos. 293pp.                    20965-2 Pa. $3.00

EAST O' THE SUN AND WEST O' THE MOON, George W. Dasent. Considered the best of all translations of these Norwegian folk tales, this collection has been enjoyed by generations of children (and folklorists too). Includes True and Untrue, Why the Sea is Salt, East O' the Sun and West O' the Moon, Why the Bear is Stumpy-Tailed, Boots and the Troll, The Cock and the Hen, Rich Peter the Pedlar, and 52 more. The only edition with all 59 tales. 77 illustrations by Erik Werenskiold and Theodor Kittelsen. xv + 418pp. 22521-6 Paperbound **$4.00**

GOOPS AND HOW TO BE THEM, Gelett Burgess. Classic of tongue-in-cheek humor, masquerading as etiquette book. 87 verses, twice as many cartoons, show mischievous Goops as they demonstrate to children virtues of table manners, neatness, courtesy, etc. Favorite for generations. viii + 88pp. 6½ x 9¼. 22233-0 Paperbound **$2.00**

ALICE'S ADVENTURES UNDER GROUND, Lewis Carroll. The first version, quite different from the final *Alice in Wonderland,* printed out by Carroll himself with his own illustrations. Complete facsimile of the "million dollar" manuscript Carroll gave to Alice Liddell in 1864. Introduction by Martin Gardner. viii + 96pp. Title and dedication pages in color. 21482-6 Paperbound **$1.50**

THE BROWNIES, THEIR BOOK, Palmer Cox. Small as mice, cunning as foxes, exuberant and full of mischief, the Brownies go to the zoo, toy shop, seashore, circus, etc., in 24 verse adventures and 266 illustrations. Long a favorite, since their first appearance in St. Nicholas Magazine. xi + 144pp. 6⅝ x 9¼. 21265-3 Paperbound **$2.50**

SONGS OF CHILDHOOD, Walter De La Mare. Published (under the pseudonym Walter Ramal) when De La Mare was only 29, this charming collection has long been a favorite children's book. A facsimile of the first edition in paper, the 47 poems capture the simplicity of the nursery rhyme and the ballad, including such lyrics as I Met Eve, Tartary, The Silver Penny. vii + 106pp. (USO) 21972-0 Paperbound **$2.00**

THE COMPLETE NONSENSE OF EDWARD LEAR, Edward Lear. The finest 19th-century humorist-cartoonist in full: all nonsense limericks, zany alphabets, Owl and Pussycat, songs, nonsense botany, and more than 500 illustrations by Lear himself. Edited by Holbrook Jackson. xxix + 287pp. (USO) 20167-8 Paperbound **$3.00**

BILLY WHISKERS: THE AUTOBIOGRAPHY OF A GOAT, Frances Trego Montgomery. A favorite of children since the early 20th century, here are the escapades of that rambunctious, irresistible and mischievous goat—Billy Whiskers. Much in the spirit of *Peck's Bad Boy,* this is a book that children never tire of reading or hearing. All the original familiar illustrations by W. H. Fry are included: 6 color plates, 18 black and white drawings. 159pp. 22345-0 Paperbound **$2.75**

MOTHER GOOSE MELODIES. Faithful republication of the fabulously rare Munroe and Francis "copyright 1833" Boston edition—the most important Mother Goose collection, usually referred to as the "original." Familiar rhymes plus many rare ones, with wonderful old woodcut illustrations. Edited by E. F. Bleiler. 128pp. 4½ x 6⅜. 22577-1 Paperbound **$1.50**

COOKIES FROM MANY LANDS, Josephine Perry. Crullers, oatmeal cookies, chaux au chocolate, English tea cakes, mandel kuchen, Sacher torte, Danish puff pastry, Swedish cookies — a mouth-watering collection of 223 recipes. 157pp.
22832-0 Pa. $2.00

ROSE RECIPES, Eleanour S. Rohde. How to make sauces, jellies, tarts, salads, pot-pourris, sweet bags, pomanders, perfumes from garden roses; all exact recipes. Century old favorites. 95pp.
22957-2 Pa. $1.25

"OSCAR" OF THE WALDORF'S COOKBOOK, Oscar Tschirky. Famous American chef reveals 3455 recipes that made Waldorf great; cream of French, German, American cooking, in all categories. Full instructions, easy home use. 1896 edition. 907pp. 6⅝ x 9⅜.
20790-0 Clothbd. $15.00

JAMS AND JELLIES, May Byron. Over 500 old-time recipes for delicious jams, jellies, marmalades, preserves, and many other items. Probably the largest jam and jelly book in print. Originally titled May Byron's Jam Book. 276pp.
USO 23130-5 Pa. $3.00

MUSHROOM RECIPES, André L. Simon. 110 recipes for everyday and special cooking. Champignons à la grecque, sole bonne femme, chicken liver croustades, more; 9 basic sauces, 13 ways of cooking mushrooms. 54pp.
USO 20913-X Pa. $1.25

FAVORITE SWEDISH RECIPES, edited by Sam Widenfelt. Prepared in Sweden, offers wonderful, clearly explained Swedish dishes: appetizers, meats, pastry and cookies, other categories. Suitable for American kitchen. 90 photos. 157pp.
23156-9 Pa. $2.00

THE BUCKEYE COOKBOOK, Buckeye Publishing Company. Over 1,000 easy-to-follow, traditional recipes from the American Midwest: bread (100 recipes alone), meat, game, jam, candy, cake, ice cream, and many other categories of cooking. 64 illustrations. From 1883 enlarged edition. 416pp.
23218-2 Pa. $4.00

TWENTY-TWO AUTHENTIC BANQUETS FROM INDIA, Robert H. Christie. Complete, easy-to-do recipes for almost 200 authentic Indian dishes assembled in 22 banquets. Arranged by region. Selected from Banquets of the Nations. 192pp.
23200-X Pa. $2.50